Dear Marjorie,
Enjoy as much as I do
Geoff

HAL FOSTER

Marjorie,
Best wishes!
Brian

HaL FoSTeR

Prince of Illustrators

Father of the
Adventure Strip

Brian M. Kane 2001

WRITTEN AND COMPILED BY
BRIAN M. KANE

EDITED BY
J. David Spurlock

PUBLISHED BY VANGUARD PRODUCTIONS

This book is lovingly dedicated to my very own
Queen of the Misty Isles and our twin princes of Thule:

Kathy, Quinton, & Ryan

Special thanks to:

The Foster family: Errol Edward Foster, Robert James Foster, Lucy Ann Foster, Mary Margaret McAskin, and Marie Foster Sasaninejad, and the Bergman Family: Norma Bergman and Karen Paul for all their contributions to this book.

Thanks also to:

Geoffrey K. Mawby, Robert R. Barrett, Katherine Collins (Arn Saba), Danton Burroughs, Frederick "Rick" Norwood, George Wildman, R.C. Harvey, Bill Crouch, Jr., Jud Hurd, Murray Tinkelman, Jimmy Bama, Dorthee A. Battiato, George M. Kane, Ann S. Kane, William Barwinski, Karen Barwinski, Adam Barwinski, Harriet Barwinski, James Shirley, Carol Shirley, Clay Benton, Brad Holland, Al Williamson, Gary Gianni, Jim Vadeboncoeur, Jr., John Cullen Murphy, Cullen Murphy, Neal Adams, Cory Adams, Jim Steranko, Roy Thomas, Michael T. Gilbert, Will Eisner, Bob Lubbers, Mark Schultz, Mort Walker, C. F. Payne, Gray Morrow, Murphy Anderson, William Stout, Tom Yeates, Charles Vess, Joe Kubert, Carmine Infantino, James Warren, Dave Sim, Barry Windsor-Smith, John W. Waxman, Beryl Mann, Edith Sachs, Stephanie Cassidy, Kay Lind, Nancy E. Dillow, Walter King, Stewart McKissick, Steve Boreman, Barbara Blaisdell, Lee Marrs, Todd Goldberg, Jeff Walters, J. Christian Youngblood, Damon Q. Thomas, Christian Larsen, Vaughn Gurganian, Andrew Feighery, David Macerelli, Jay Nigro, Pat Binder and Greg Fink. Lucy Caswell and Dennis Toth of the Ohio State University Cartoon Library. Carolyn Davis, Diane Cooter, Paul Barfoot, and William "Bill" Lee of the Syracuse University Department of Special Collections. Randy Scott of the Michigan State University Comic Art Collection. Mary Jo Hughes, Curator, Historical Art, The Winnipeg Art Gallery. Lorraine Slopek of the Anglican Diocese of Nova Scotia and Prince Edward Island. Elizabeth Blight and Debra Moore of the Provincial Archives of Manitoba. Alfreda Withrow—Halifax Historian. Dwight Radford—Genealogist. Helen Stauderman—Director of The Mark Twain Library, Redding Connecticut. Peter F. Spooner, Curator, Tweed Museum of Art, University of Minnesota, Duluth.

The publisher also thanks his father, James B. Spurlock, who was the first man to teach him about the pulps, radio theatre, movie serials, the Golden Age of comic books and who always subscribed to the paper that ran *Prince Valiant*.

Designed by Meredith Pratt and Brian M. Kane.
Consulting Editor, Dorthee A. Battiato.

Published by Vanguard Productions
59A Philhower Road, Lebanon, New Jersey 08833
First Printing—September 2001.

Limited Edition Deluxe Hardcover ISBN 1-887591-48-6 $49.95
Trade Hardcover ISBN 1-887591-49-4 $29.95
Trade Paperback ISBN 1-887591-25-7 $19.95

Printed in China

CONTENTS

one
Hal from Halifax • 7

two
Portaging Canada • 15

special gallery
Companions in Adventure • 27

three
Helen the Fair • 37

four
Knight Errant • 49

five
"We Ate Ape" • 61

six
In the Days of King Arthur • 75

seven
Father of the Adventure Strip • 89

Hal Foster: A Color Gallery • 97

eight
The Bard of Avalon • 113

nine
Voice from Val-Hal-En • 123

ten
A Canadian Yankee in King Arthur's Court • 141

eleven
The Spoils of War • 151

twelve
Beyond Camelot • 163

thirteen
The Royal Family • 171

fourteen
Knights of the Drawing Table • 185

fifteen
Passing of the King • 193

tributes
A Knight to be Remembered • 202

INTRODUCTION

What an honor it is to have been asked to write the introduction for this book. My first memories of Hal Foster go back to 1932, when I was six years old. *Tarzan* was my first Sunday comic strip hero. Great apes, crocodiles, panthers, elephants, lions, prehistoric animals—what excitement! To this day, 69 years later, I still remember the Egyptian city, the river of crocodiles and Tarzan swimming it hidden in one of their skins.

This was a wonderful era to be a young boy—*Tarzan, Flash Gordon, Mandrake the Magician, the Phantom, Terry and the Pirates,* comic books and Big Little Books. There were movies too like: *Frankenstein, Dracula, The Mummy, The Invisible Man, and King Kong.*

But it all began with *Tarzan* and Hal Foster.

Then *Prince Valiant* came riding into my life in 1937, another hero to inspire me and fan my imagination. I went to Macy's department store every Christmas to buy lead models of knights in armor. I had quite a collection and staged mock battles. The Medieval period is still my favorite one. Again, remembering vividly the dragon in the fen and Prince Valiant snaring it in a net and then killing it. I copied all these Sunday comics and honed my drawing skills, which have served me well.

Hal Foster was not just a cartoonist. He was a great pen-and-ink illustrator. His heroic scenes of Camelot and other castles, knights in battle and ships at sea are all classics. He captured the pageantry of the period in the manner of Howard Pyle. These drawings have never been equaled, except perhaps by Edwin Austin Abbey. The research he did was incredible—nothing ever looked faked.

I've been a professional artist for forty-two years, twenty-two of them as an illustrator in New York. I had all sort of research and props and costumes available and yet couldn't begin to do what Hal Foster did.

Give this man his due: he was great.

—Jimmy Bama
February 10, 2001

PREFACE

Five decades ago I was introduced to Hal Foster at a National Cartoonists Society meeting at the Society of Illustrators' club in Manhattan. It was a raw rookie's dream...shaking the hand of the greatest comics illustrator of all time. An icon. My idol. He was the apex of the Foster, Raymond, Caniff triumvirate that ruled the era.

In that hall of illustrators...the likes of N.C. Wyeth, Dean Cornwell and the others...stood Hal Foster. He could have been the greatest of all of them had he chosen to vent his passion as a full-oil-painting book illustrator...but then we'd have seen his masterworks only sporadically. Thank our stars he wanted to use mere pen, brush and ink as his medium, and the weekly Sunday comics as his venue. We were treated to his wondrous art fifty two times every year...eight or ten glorious illustrations every week. The tear sheets I saved from the New York Journal American, browned and brittled now, and tinged with nostalgia, are still inspiring when I bring them out for refreshment.

We'll never know how many artists he inspired. We do know that none were ever to achieve his stature. His painstaking, rarefied work with his common tools, his dedicated research, unparalleled talent and wholesome spirit, brought to life for us Burroughs' *Tarzan*, and then the magic of Prince Valiant's world of swords and sorcery...untarnished by the cheap titillations we see today in every form of art. Hal Foster will always be the prince of illustrators. His work endures and it will never be matched.

The Golden Days of newspaper comics have passed, but Hal Foster's works will be treasured forever for what they were...the most dazzling, inspiring, untainted story-telling in black and white and Benday color that we will ever see. His full-color full-page Sunday comics illustrations reached levels of artistry that surpassed all others, and brought him immortality.

—Bob Lubbers

DC

DEAN CORNWELL
33 WEST 67th STREET,
NEW YORK (23)

Oct. 23ʰ 52.

My dear Hal Foster:

It is a privilege indeed to be able to add my name to the many rightfully honoring you on the occasion of the sixth annual Award of "THE LADY", to be given you for your beautifully drawn and conceived page — "PRINCE VALIANT".

You are an artist after after my own heart! What you have succeeding in achieving, is what I have always tried to do.

My warmest congratulations.

Dean Cornwell

*"My mind is like the attic of my old home in Halifax,
where the seafaring men had brought their curios, ship's
logs and lists of cargo."*

—Hal Foster

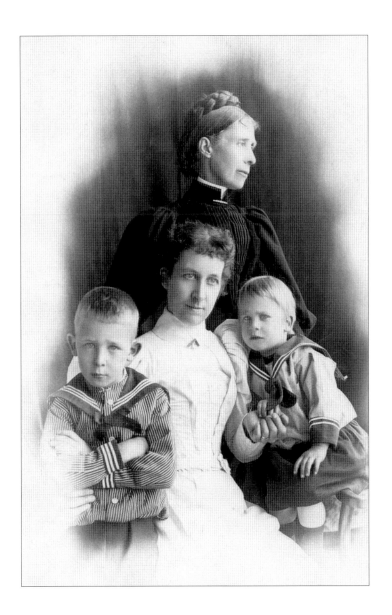

O • N • E

HAL

from

HALIFAX

Harold Rudolf Foster

Harold Rudolf Foster's life was an adventure only equaled by those of the characters he drew. "Hal" was born in Halifax, Nova Scotia, Canada, of a ship-owning, sea-faring, English / Prussian / Irish family. Hal's ancestors had once enjoyed social position and wealth but through reversals of fortune slowly descended into "shabby gentility."

> *From the Journal of Leonard Christofer Rudolf, Esq.*
> *(Hal Foster's great great great grandfather)*
>
> I, Leonard Christofer Rudolf, by birth a gentleman, was born the 6th September A.D. 1710 in a village called Illesheim situated about three English miles from the Imperial City of Windsheim in the County or Circle of Fracony in Germany, at which place my father was, what they call in English, a steward for the ancient Free Barons of the Empire Von Berlichingen.
>
> In the year 1751 on the persuasion of my friend Doctor Erad, I went with him and family over to Nova Scotia under the protection of Lord Halifax, to whom we were recommended by the reigning Marogoaff Carl Friedrich of Baden.
>
> At Halifax we were well received by the Governor Edward Cornwallis and by him both employed, myself as an overseer over a party of foreigners and [Erad] as a doctor of the same.

Hal's father, Edward Lusher Foster was born in 1851, in Ontario, Canada and grew up in Montreal. His father, Abram was a farmer and his mother, Mary, kept house. Hal's

PREVIOUS PAGE: *Hal's mother holding Gerald (left) and Harold.*
Harold's grandmother, Kate (nee Stevens) Rudolf is standing behind them.

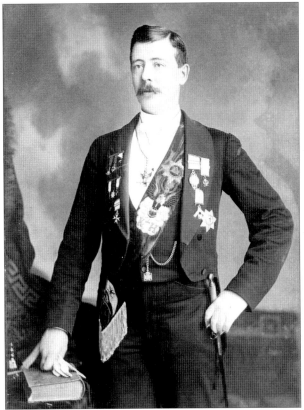

Hal's father, Edward Lusher Foster

Hal's mother, Jeannette Grace (nee Rudolf) Foster

mother, Jeannette Grace Rudolf was born on December 19, 1864, in Brooklyn, New York to Captain Edward and Catherine "Kate" (nee Stevens) Rudolf. The Rudolfs were probably staying in New York due to Captain Rudolf's job at the time Jeannette was born. Captain Edward Rudolf was a Master seaman and one of only eight survivors of the wreck of the "Blake."

Excerpt from the Diary of Adolphus Gates
April 26, 1856

St. Johns' [Newfoundland] papers were received here today containing detailed accounts of the awful wreck of the British Barque "Blake" of 800 tons. Edward Rudolf was Master, and J. George Rudolf, Mate. These two young men are cousins, and both natives of this place. This vessel sailed in excellent order, on the 8th February from Ship Island harbor, Mississippi, bound for Cork.

When near the middle of the Atlantic she encountered a series of terrific gales, or rather one continued Hurricane lasting from 4th March until 19th. But long before this latter date the vessel became waterlogged, her sails and spars had been blown away, and every heavy sea made a clear breach over her decks. Several of her crew had already been swept away and those that remained were enduring the most extreme suffering from cold, hunger and fatigue.

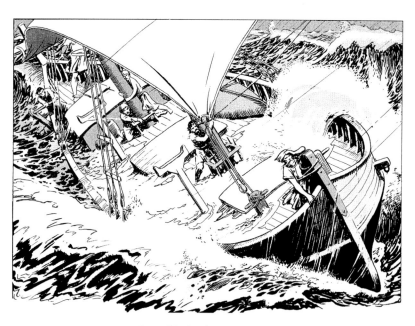

The gale began to abate on the 19th. For thirteen days the wretched survivors remained upon the wreck without tasting a morsel of food, except one rat, which was divided among them.

The account of their suffering during this time, as given by the Master himself is quite harrowing. On the 13th day one of the crew, the second one who had done so sank under his sufferings and died.

Scenes like this from Prince Valiant *were inspired by stories Hal heard in Halifax as a child.*

The body was not thrown overboard. It served as food for the survivors, until four days afterwards, on the 29th, the sufferers were taken from the wreck by a Schooner bound for St. John's, Newfoundland.

It is not known when Edward Foster moved to Halifax or how he and Jeannette met but the two were married by license by the Church of England on the fifteenth of December 1885. Three children quickly followed: Mary on September 28, 1886, Gerald on December 15, 1888, and Harold on August 16, 1892. While there is no formal notice, Mary disappears from the family record between 1890 and 1894 and is presumed to have

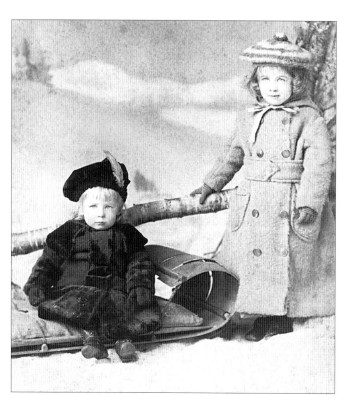

died. Only two pictures remain of her and neither is with Hal. All three of the children had the family name, Rudolf as their middle name. A typographical error early in Hal's career misspelled his middle name as Rudol*ph* and except for his listing in *Who's Who* that was supplied by Foster, the mistake has been perpetuated for over sixty years in almost every article where his full name was used.

The Foster's lived at No. 1 Lower Water Street, Halifax. The house had been in the Stevens family for over a hundred years and it was where Hal's maternal great-grandfather, Francis Stevens was born. From their front porch they could watch the ships coming up

Hal's older brother, Gerald Rudof Foster (left) and sister, Mary Rudolf Foster. Mary died not long after this picture was taken.

the harbor. The family held a comfortable position in local society and attended St. Luke's Cathedral, an upper crust Anglican rite church within the neighborhood.

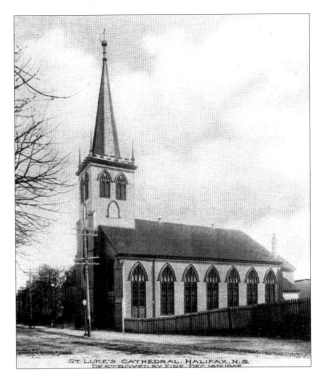

St. Luke's Cathedral

Edward, who originally worked as a commercial salesman, took over the Stevens' family grocery store, just up the street from Lower Water, on the corner of Hollis and Sackville Streets. The store was originally started by Francis Stevens and was built on land his father owned. Edward prospered and by the time he was thirty-five years old he had been made a 33rd degree Mason. While any Mason can attain the 32nd degree through their own works only the Masonic Lodge can bestow the 33rd degree upon someone. Usually the honor is reserved for a person's lifetime achievement and to receive it at such a young age is a testament to the level of respect Edward held within the community.

In 1896 Edward Lusher Foster died. The cause of his death is unrecorded but at 45 years old it was probably not expected. He was buried in the Rudolf family plot in the prosperous shipbuilding city of Lunenburg, a town that Leonard Christofer Rudolf helped found and build,* located south of Halifax. Edward's passing left Jeannette with two small boys and the family store to run. During this time Hal began showing the first signs of his interest in drawing. Hal and Gerald used to draw pictures of the harbor with boats, lighthouses, birds, strange underwater creatures, and huge crabs coming out of the water and grabbing people. Even though many of the sketches were fantasy-based they were mainly of the sea, an element Hal would continually come back to in his own works. From the beginning the harbor was their life.

One of the few surviving pieces of artwork done done by Gerald R. Foster, Hal's brother. The drawing is of Her Majesty's Royal Yacht, Ophir, from its October 1901 trip to Halifax.

* Leonard Christofer Rudolf joined a Militia Regiment and was made a Major by Cornwallis' successor, General Hopson. When the Foreign Protestants (Germans, Swiss and Montpeillards) were sent to found the town of Lunenburg in 1753, Rudolf was the second proprietor to sign the original land grant.

SUNNY DAYS AND FAIR WINDS CARRY
THEM THE LENGTH OF THE AEGEAN SEA.

"Halifax harbor was such a romantic place. On a summer day [you could] look up the harbor and [it] was covered with white canvas—square-riggers, and schooners, and dirty little coasting ships. I was always down at the shore, so many interesting things. Life on the shore, the tides, the wind always meant something to me. I could tell [where] every ship, every schooner, every coaster came from by the smell. Jamaica would come in with a delicious smell of rum mixed with bilge water, sugar from Baja, molasses from the West Indies, hides from Argentina, and wine from Spain. I spent so much time on the waterfront that I still exhale a pungent aroma of tarred rope and dried codfish."

This picture was taken about the time Hal sailed in front of the Cunard ocean liners. His raft can be seen in the background. The Cunard line was founded by fellow Halagonian, Samuel Cunard, in 1840. Among her most famous ocean liners were the Britannia, Lusitania, Mauretania, Queen Mary, and the Queen Elizabeth.

The sea was in Hal's blood and he would paddle a 12-foot raft made out of wooden planking around the shore of the harbor. One day in 1899, the young 8 year old made a mistake in judging the tides and drifted out into the shipping lanes to the frustration of the captains of several ocean liners.

"I'd crossed the harbor on [the] raft and the same time ocean liners of the Cunard fleet were coming up the harbor. I didn't hasten. I don't know if the boat stopped or if we missed each other. Mother and Grandmother were on the porch looking out over the harbor and Mother said, 'Look at that little boy out there on that raft. You'd think his parents wouldn't allow that.' And Grandmother, taking out the binoculars came out; saw little Harold with his wet ass sitting on this little craft. She put the glasses away; never said anything on it to Mother."

By the age of ten he was skippering a 30-foot sloop in the waters of the Atlantic. Hal never became seasick. "It was the sea," he insisted, "that became Foster-sick." It was this attitude about life that would drive him and would become the philosophical foundation for his greatest creation.

Jeannette remarried Joseph Piert Cox on April 3, 1903 at St. Matthew's Presbyterian Church, Halifax and a year later on April 10, 1904 Joseph Rudolf

RIGHT: Even at the age of eleven Hal paid close attention to detail Compare this with the ship on the previous page. Note the pitch of the ships and how they sit in the water.

OPPOSITE: A panel from Prince Valiant, printed actual size. Hal carried his love of the sea with him through his entire life.

ON THE HOME-WARD BOUND

"Rollie" Cox was born. J.P. Cox had been a Commissioner Merchant with offices in the Pickford and Blacks building where he sold flour. After the marriage Joseph was given full responsibility to run the family's grocery store but he unfortunately lacked the business sense to support it.

"When he went to work," recalled Foster, "we expected to be fifty or sixty dollars poorer when he came home." Cox's only claim to fame was that he was the first person to import Bermuda onions to the East Coast. The onions were a sensation but due to his lack of managerial skills Cox lost out on the deal and all he had to show for it was the lingering smell of onions. Within two years the family's finances were in ruins and Cox had to find another way to support his wife and children.

Hal learned to ride at an early age. Hal was born the same year as Dean Cornwell, William Andrew Loomis, Robert Lawson, and two years before Norman Rockwell.

Stories of sea monsters eventually found their way into Prince Valiant.

Hal's stepfather, Joseph Piert Cox

*"I always credited my natural stupidity for putting me
in the way of learning and experiencing things."*

—Hal Foster

T • W • O

PORTAGING

CANADA

With his business bankrupt, Joseph P. Cox decided, in 1905, to relocate the family to Winnipeg, Manitoba in the hopes of rebuilding the family fortune in the western land boom. Hal was 13 and had to leave school, ending his formal education at the sixth grade. Along with his mother and brothers, he spent that winter in a hotel in Elmsdale, Nova Scotia waiting to move. In two short years, Cox had imbued Gerald and Harold with a love of the outdoors and taught them how to hunt and fish, especially in the untamed wilds around Halifax. Bored with the long wait, the older brothers hunted partridges and trapped rabbits to help support the family. "I traded a pair of rabbits for a gallon of hard cider at the general store in Elmsdale," wrote Foster, "and you know the rest. At thirteen too, shame! I knew all the swear words and had enough deep-sea fishing to provide material for fish stories for years."

In a weird twist of fate loosing the business and moving away from Halifax may have actually saved everyone's lives. On the morning of December 6, 1917 the French munitions ship, SS Mont Blanc, collided with the Norwegian steamer, SS Imo, in the Narrows between the harbor and Bedford Basin. The Mont Blanc was loaded with 2,300 tons of wet and dry picric acid (used for making lyddite for artillery shells), 200 tons of TNT, 300 rounds of ammunition, 10 tons of gun cotton, and 35 tons of high-octane fuel (Benzol) in drums stacked on her decks. Sparks ignited by the collision set fire to the Benzol that had broken open and spilled across the Mont Blanc's deck. The crew immediately abandoned ship, but the tide carried the burning vessel all the way to Pier 6 on the North End of Halifax, where it exploded.

The "Halifax Explosion" was the greatest man-made blast until the atomic bomb was dropped on Hiroshima in 1945. It leveled Halifax's North End, killing almost 2,000 people, injuring 9,000 others and leaving 6,000 homeless. The resulting shock wave was felt all the way to Sydney, Cape Breton 270 miles to the northeast. It shattered windows up

to 50 miles away and the flying glass blinded hundreds of people who had been standing, watching the event from the apparent safety of their homes. Ships were tossed like driftwood and homes within a 2-mile radius were flattened. The barrel of one of Mont Blanc's cannons landed three and a half miles to the north near, Alboro Lake, while the shank of her anchor, weighing over half a ton, flew two miles to the south. The detonation occurred at 9:06 a.m. and the fires from the coal and wood-burning stoves of the leveled houses ravaged the city until midnight when an early winter storm proceeded to dump 16 inches of snow on the devastation.

Had Cox been able to prosper and the family stayed in Halifax harbor, they would probably have either been injured or killed in the catastrophe. It was this type of providence that Hal would refer to through his life as the "Foster luck."

On February 12, 1906, Hal's grandmother, Catherine Rudolf passed away; further severing the family's ties to Halifax. Soon Cox called for them and they traveled west by way of Montreal, where they briefly stayed with relatives of Hal's natural father, probably his uncle, W.B. Foster. Hal had a cousin, Philip Foster, and the two boys had been born within weeks of each other. "[We] stayed long enough in Montreal [for me] to translate into French Canadian all the more expressive curse words learned in Halifax." When Hal arrived in Winnipeg he immediately found out that his mild manners and eastern Canadian accent didn't mix well with the local bullies. After numerous beatings he took up boxing and studied the sport at a local gym. "During that three years every

Hal Foster, age 20

pug, instructor and prelim boy took an honest wallop at [me]" Hal once wrote. When he was 18 he boxed in one professional match and after that bout decided to scrap boxing as a career choice because, in his own words, he was "yellow." A friend later told him: "I saw the match, Hal, and as far as I'm concerned you haven't lost your amateur standing."

"My athletic career was a lot of mediocrity," Foster recounted, "but it was enjoyable." He loved playing lacrosse, hockey, rugby football, and was considered a remarkable baseball player although he couldn't throw to first base. Hal played sports in Winnipeg for six years until 1912, when a run-in with a "Manitoba half-breed Indian inflamed by drink and fancied wrongs, opened fire with a shotgun." The incident left Foster with a few pellets of #7 buckshot

HAL FOSTER ON HIS BOXING CAREER

Of all the many campaigns I have inaugurated, the one aiming at my first million [dollars] bore the most fruit. Professional boxing!

Boxing was forced upon me. As a mild, anti-social boy I was the target for anyone who wished to practice, in comparative safety, for more important fist fights. I developed a unique form of self-defense. Pride would not permit me to run so I'd wrap both arms about my head and whimpered bravely. This style is not recommended as visibility is nil and I often suspected that some of the bystanders took advantage of the fact and got in some free throws.

Something had to be done, so I joined a boxing club where the local pros used to train and for three years painstakingly labored towards perfection. Oftimes I'd lay on my back and, gazing at the ceiling, wonder if I hadn't missed a lesson somewhere, but as the lumps went by I gained confidence and became quite a personality in the gym. Not that I could hurt anyone but no one could lay a glove on me!

Then came the day of days, the Payoff! A promoter came to the gym seeking talent and my grace and agility completely seduced him. He called me over: "How would you like to be on the card of the next Boxing Show?" he asked. I demurred; my amateur standing would be at stake. He gave me a look that clearly said "chicken". "Stay amateur with your ability?" he cried aghast. "You weigh 160 pounds and only one good man stands between you and the middle weight crown, Michael Gibbons, and he is getting old!" Before I succumbed, I asked a canny question, who would I fight? When he named the preliminary boy I had often licked in the gym my courage boiled over. "I'll do it!" I cried rushing out to buy a turtle neck sweater.

I walked toward the ring on fight night in a blue funk, with a stomach that did flip-flops. For this was not the familiar, friendly gym. This was a smoke filled abattoir crowded with Neanderthal men who cried for blood! My blood! I was not skinny in those days, just sinewy, lithe. But a rude voice asked, "Wh's expectin' the stork?"

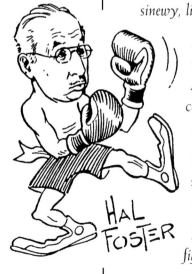

At the clang of the bell I led with a stinging left, followed by an overhand right and my opponent countered with a left upper-cut and a murderous right. As neither one of us as yet left his corner, no real harm was done, unless, of course, it is understood that stage fright can be fatal.

The fight ended at last, no potential contenders for the middle weight title emerged, not a drop of blood was shed, yet the crowd was inspired, inspired to such heights of humor, cat calls and assorted wise cracks as no other preliminary bout had achieved before.

I received my pay, lost my amateur standing and so became a professional fighter. If my friends wish to call me Battling Harold or Kid Foster they may.

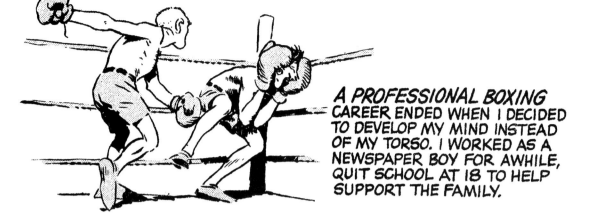

A PROFESSIONAL BOXING CAREER ENDED WHEN I DECIDED TO DEVELOP MY MIND INSTEAD OF MY TORSO. I WORKED AS A NEWSPAPER BOY FOR AWHILE, QUIT SCHOOL AT 18 TO HELP SUPPORT THE FAMILY.

in his leg. The only thing that saved Hal from being killed was that he was able to return fire and "winged" the Indian "with an effective, but not mortal, shot." Though Foster claimed he was "never brilliant" when he played, his love of sports and athletic ability later aided him in developing a sense of naturalism to his action sequences that was both original and unprecedented.

On September 10, 1908 Joseph Percy Cox was born adding another mouth to feed and stretching the family's finances even more. "I tried to finish schooling in Winnipeg," Foster recalled, "but as the wolf was making a permanent home on the family doorstep*

Hal gets ready to play Rugby football—he is the fourth from the right. His two half-brothers, Joseph "Percy" Cox and Joseph "Rollie" Cox are standing behind him (third and second from the right respectively).

*The "wolf on the doorstep" is a euphemism for "the family was starving."

Another example of Hal's experiences making their way into Prince Valiant.

I had to quit school and go to work—I won no prizes in scholarship! The highest praise I ever got was when a teacher remarked: 'He's not exactly stupid but—'." Shortly after that an aunt who Foster thoroughly disliked said to his mother. "Isn't it too bad Harold won't get an education." It was a snide comment but Foster's reaction was quick and decisive, "The hell I won't!" he retorted. The Winnipeg Carnegie Library became a haven where he immediately began a course of self-education. "Being broke during the middle of winter when you know all your school friends are going to dances, going skating, to toboggan parties, social parties, and you have to stay at home, there is only one occupation you can enjoy and that's reading."

Hal worked as a newspaper boy and though it didn't pay much he earned enough to send himself to business school where he learned shorthand and typewriting. "I was pitch-forked into a business career. My artistic talents hadn't been developed enough to be of any use, and my school education wasn't of much use either because I hadn't gone far enough, so I became a…well, an office slave. Oh, that used to gripe me. Everything was so cold, dusty, and all figures—all you could hear was business, business, business, as if there is nothing else in the world but that particular business. I never envied those that had a good job in business because it seemed so curtailed there, they couldn't think of anything else, they didn't know any of the useless things I used to enjoy."

Foster took a job as a stenographer for the treasurer of a large mercantile bank but had trouble acclimating to the business world because it interfered with his hunting and fishing. "All of my available time was spent as chauffeur to a single-barreled shotgun. Oh those big prairie chickens of the Manitoba stubble fields! The fat partridges at lower Fort Garry—and the clouds of ducks on the lower Red River!" On one occasion, a friend told Foster that the ducks were covering the bull marshes by the millions; so, he left his job as a stenographer and went hunting. "[I paddled] down the Red River to the bull marshes. I had a wonderful time, I came back with enough ducks to put them in the freezer so that the folks could have duck dinners for a month." After a few days, the happy 18-year-old hunter returned to work and was confronted by his boss. "You seem to think that duck hunting is more important than business." He scowled, to which Foster simply and

honestly replied, "Yes." The answer ended his business career but the bull rushes would one day become King Aguar's fens in which a young Prince Valiant would hunt for duck.

Foster's earliest artistic influences were E.A. Abbey (1852), Howard Pyle (1853), Arthur Rackham (1867), Maxfield Parrish (1870), J.C. Leyendecker (1874), James Montgomery Flagg (1877), and N.C. Wyeth (1885). Hal started drawing seriously when he was 16 but the family couldn't afford many luxuries so in order to learn anatomy he would go to his room and stand nude in front of an old cracked mirror and sketch himself. Out of necessity he got fast because once his body turned blue he had to stop. "You learn to quicksketch," said Foster, "because it's 20 to 30 [degrees] below zero." It wasn't long before Hal entered a local art competition. "At [that] time I was almost ruined by taking prizes at a drawing exhibit—my head finally came back to its normal size again but left me with the absurd notion that I was an artist in the bud."

In 1910, Foster secured a job with the Hudson Bay Company as a staff clerk earning $17.50 a week. He was later hired to draw sketches of women's intimate apparel, the kind with numerous buttons and lace, for the mail order catalogue. "I put my whole soul into that work. I don't know when I'd been more interested. I was very naive in those days, and to make these discoveries that ladies undergarments were so charming, so..." He kept the job until Canada's pre-war depression in 1913 forced him out.

Through it all Foster kept drawing. His son, Arthur would later recount: "My father was talented but I always thought his success came from working hard and working constantly during his learning years, not waiting like most of the [Frank] Reilly students, till they knew how to draw and paint before they started to make pictures."

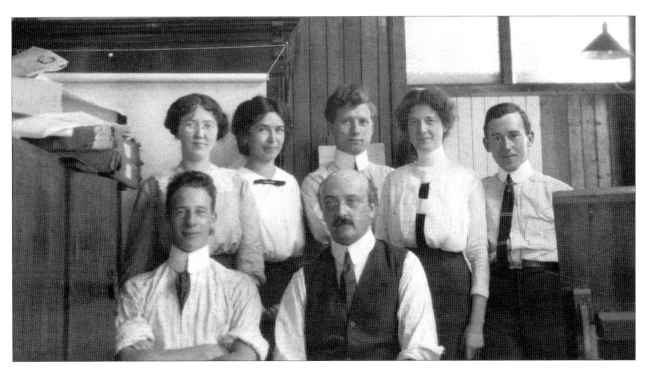

This photo of Hal may have been taken around the time he was working for Hudson Bay Company; however, the room and the other people cannot be matched to any catalogued images to confirm this.

Foster was known as "the best wrinkle artist in Winnipeg" because of his ability to draw women in unwrinkled long underwear and dainty white wear. In 1914 that ability landed him a job with Brigdens Limited of Winnipeg. Brigdens had just expanded from Toronto to establish a local studio in 1913, and it was for them that Foster had the "honor" of illustrating the last lace-trimmed bloomers with a built-in tailboard. Brigdens had the enviable contract to publish Eaton's mail order catalogues. Since the catalogue only came out in the spring and fall it was seasonal work, but there was plenty of paid overtime; most days lasting from dawn until dusk.

In the art department, the artists were expected to include the most minute details of the design and construction of items offered for sale. Customers ordering from the catalogue did not appreciate surprises, no mater how small or insignificant, and did not hesitate to write and draw attention to the omissions in the illustrations. It was exacting work, demanding careful observation.[1]

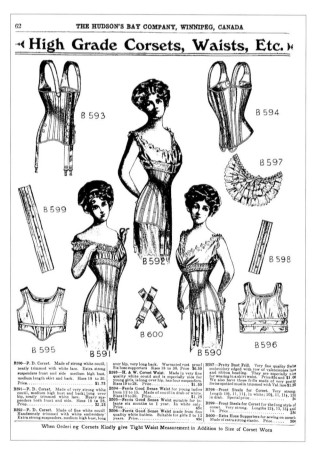

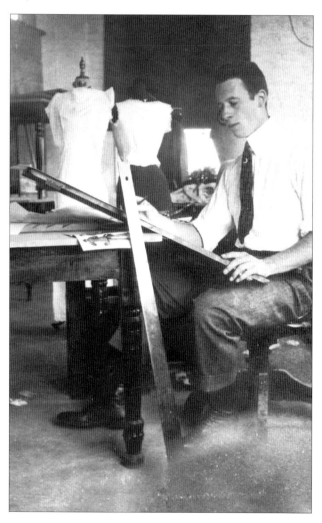

ABOVE: Hal does catalogue work at Brigdens Limited. Note the mannequins of ladies clothing, and the magazine on the table under Hal's board is the May 2, 1914, issue of The Saturday Evening Post, open to a J.C. Leyendecker Kuppenheimer suits advertisement.

LEFT: While the illustrations in the catalogues weren't credited, this page from the 1910-1911 Hudson Bay Company's Autumn and Winter Catalogue (No. 58), is a good example of the work Hal would have been doing. The image is provided courtesy of the Provincial Archives of Manitoba.

1 <u>Transformation of Vision: The Works of H. Eric Bergman</u>, Nancy E. Dillow, The Winnipeg Art Gallery, 1983 [p. 6].

Tom W. Mc Lean, Hal's boss at Brigdens Limited. Photo is provided courtesy of the Provincial Archives of Manitoba.

Tom W. McLean was the head of the art department at Brigdens Limited of Winnipeg from the start, having come from Toronto where he worked at Grip Limited. McLean was part of a core group at Grip that included Tom Thompson, J.E.H. MacDonald, Arthur Lismer, and Frederick H. Varley. MacDonald, Lismer and Varley along with A.Y. Jackson, Frank Carmichael, Lawren S. Harris, and Frank "Franz" Johnston, would later go on to found the *Group of Seven* in 1920 and help chart the direction of the Canadian art movement of the early twentieth century. The creative atmosphere McLean tried to create at Brigdens was not unlike that at his former employer's and though the work may have sometimes been tedious and laborious it helped to hone each artist's skills. The uneven, seasonal schedule also allowed artists to freely pursue their own interests during the off times.

The studio was filled with like-minded, promising young artists such as William Winter, Charles F. Comfort (who became a famous Canadian artist), Charlie Thorson (who later went on to help design *Bugs Bunny* for Warner Brothers), Loudon "Low Down" Guthrie Wilson (who moved to Detroit and made a name for himself with his drawing of new cars for all the big automotive companies), and Foster's life-long friend, H. Eric Bergman.[2] Eric arrived in Winnipeg on March 20, 1914 just in time for the spring catalogue. Born in Dresden, Germany he came to Brigdens with a Diploma of Merit, from his three years at the Art and Trade School of Dresden. On July 3, 1914, after the catalogue was done, Hal and Eric became "voyageurs" and began "portaging" Canada.[3] For fifteen days they canoed, hiked and fished their way through the Lake of the Woods, the Winnipeg and Indian Rivers, and down the Dalles and White Dog Rapids. The trip galvanized a friendship that would last until Eric's untimely death, as the result of a massive heart attack on February 8, 1958.

Another event that occurred in 1914 that changed Hal and Eric's lives was the arrival of noted English painter, Alexander J. Musgrove to Winnipeg's School of Art located in the Winnipeg Industrial and Board of Trade Building. Not only did Musgrove become the Art School's director, he also founded the Winnipeg Art Students Sketch Club that same year. Both Hal and Eric gravitated to Musgrove who became their teacher.

Brigdens indirectly subsidized the School of Art by paying for classes for their employees. Evening classes were offered for working commercial artists who wished to

2 After coming to Canada Heinrich Erich Bergmann anglicized his name to Henry Eric Bergman. He is usually listed as H. Eric Bergman, which is how he signed his work. Many of his original prints simply show his initials, HEB.

3 Voyageurs is the French-Canadian term used for anyone who travels through the wilderness primarily by canoe.

broaden their skills. The school also housed a branch of the Carnegie Library with over 200 volumes of art, history, biography, criticism and techniques. James Dunlop's, textbook, <u>Anatomical Diagrams</u>, was a major reference book and the school offered a very impressive curriculum.

<u>PROSPECTUS</u>:
WINNIPEG SCHOOL OF ART

Elementary and advanced classes (which focused on antique and life drawing); modeling, design, and outdoor landscape sketching; life sketch class (for professional artists); composition, illustration, poster design, artistic anatomy and animal drawing classes.[4]

4 <u>The Winnipeg School of Art: The Early Years</u>, Marilyn Baker, The University of Manitoba Press, 1984 [pp. 34 - 36].

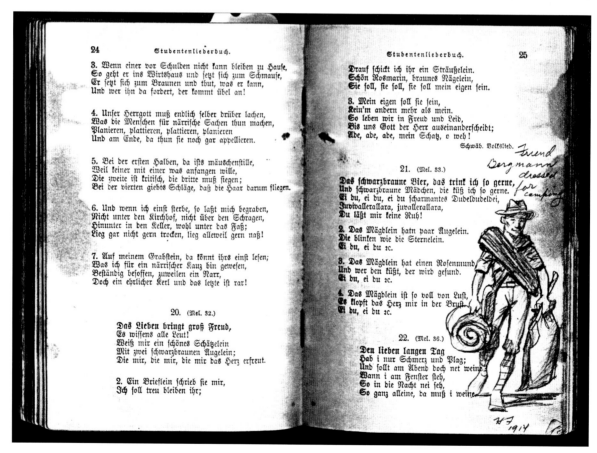

RIGHT: H. Eric Bergman

ABOVE: Eric Bergman's book of poetry, which he took with him while camping. Hal drew two pictures in the margins—the second one appears in a gallery of cartoons following this chapter. The other interesting thing about this two-page spread is the black blotch at the center of the book. It is all that is left of one of the thousands of mosquitoes that joined them on their canoe trip.

While Hal never mentioned The Winnipeg School of Art in any interview, essay or correspondence the school's 1917 class roster includes both Foster and Bergman as students. The work at Brigdens Ltd. and classes at the School of Art helped sharpen both artists' powers of observation and forced them to be sensitive to the subtleties of each individual line.

> In later years when preparing notes for a series of art classes [Bergman] listed as topics for discussion "the power of seeing things in correct proportion", "careful planning", a "keen sense of observation", "the power of quick decision", and "the power of observation and memory". All reflect the lessons he had learned through many years of work at Brigdens and found essential to his art.[5]

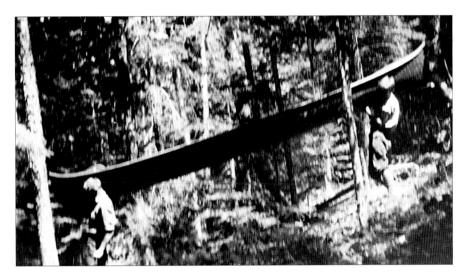

TOP: *Portaging one of the falls.*

ABOVE: *Hal and Eric take a break.*

5 Dillow [p. 7].

This too was Foster's mantra. How many nights around a campfire under the stars did Hal and Eric discuss these very topics? These are the areas of expertise that Hal would later incorporate into his art. He would own them and live them and use them like very few other artists could. At Brigdens Hal learned his craft and became an accomplished draftsman but somewhere in the tedium, pressure, sweat, and swirling smoke he also learned the skills that would make him a great illustrator.

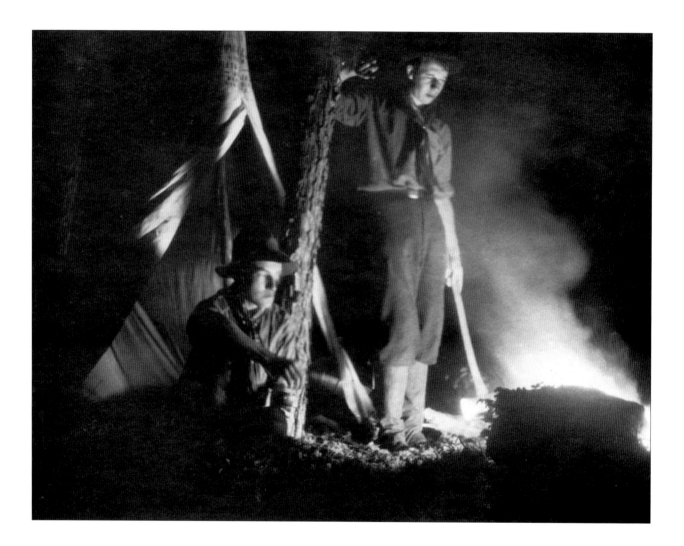

I remember the campfires on Rice Lake—the rapids on the rivers—and the wonderful adventures when we were young.

—Eric Bergman

COMPANIONS *in* ADVENTURE

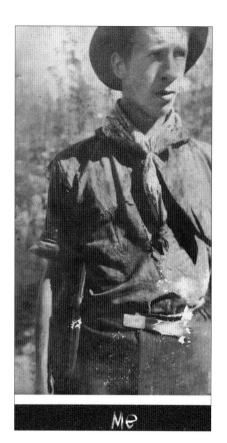

Me

H. R. FOSTER.

WINNIPEG
1914

The following is a gallery of cartoons drawn by Hal Foster of his canoe trips with his friend, Eric Bergman. The text is taken from Eric's daily journal, which he kept on the trip. The journal is provided courtesy of the Bergman family. Some of the cartoons on these pages are provided courtesy of The Provincial Archives of Manitoba.

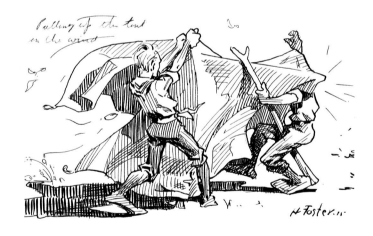

"I made this trip with my Canadian friend, Harry Foster. We made our preparations for the trip on Thursday and left Winnipeg on Friday morning at 7:30. My friend, Harold had the tent strapped to his back, the sleeping bag, wrapped in a black oilcloth, which at night would protect us from the damp, he had rolled and hung over the shoulder. We had a large cloth slung about our necks to protect us against sunburn and we both wore a hat with a large brim such as the cowboys wear. The camera completed our equipment."

NOTE: To pick out Hal Foster just remember that he always paddles stern in the canoe, and that Eric is the one with the blond hair.

DIARY
Memories of a Journey
Eric Bergman

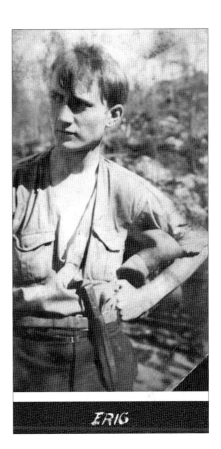

ERIC

"We took with us: rice, macaroni, raisins, cheese, potatoes, sugar, bacon, biscuits instead of bread, salt and concentrated milk. Harold asked me how much cheese we should buy and I replied in fun, 'Oh, about ten pounds.' He said, 'Oh, I think five should be enough,' but he only ordered one. The shopkeeper could not have understood him correctly for when we got back to our canoe we discovered a five pound block of cheese."

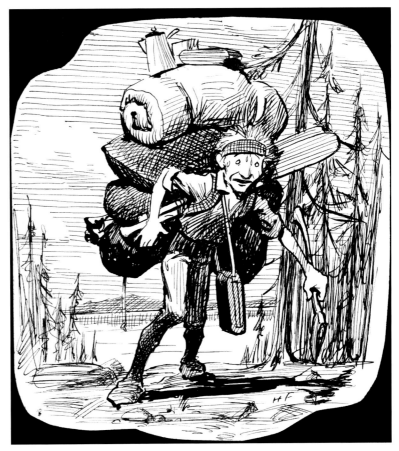

MY IDEA OF NO FUN AT ALL!

"We had probably traveled three miles when a water-fall forced us to land and portage all our gear. The sun laughed down at us and we were sweating like two racehorses after the race. I was already cursing but this was only a hors d'oeuvre to the bliss to come, and comparatively easy to that which was to follow. After half an hour we were ready to continue our trip beyond the falls. We had the misfortune to leave behind our coffee cans, which we bought in Kanora."

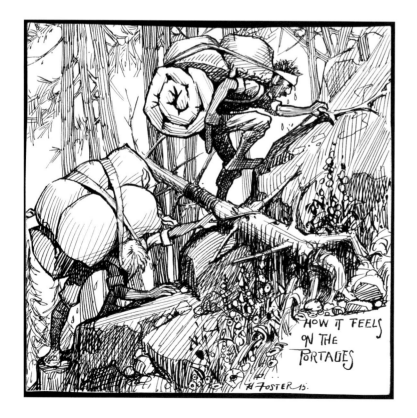

HOW IT FEELS ON THE PORTAGES

"HUSTLE THAT WOOD ERIC,— FIRES' GOING OUT!"

"We had probably traveled an hour when a huge cloud of rain with thunder descended on us. We were in the middle of a large lake when Harold told me I should spread out the waterproof sheet over our luggage. I took my time and looked up at the sky out of which the sun was still peeping. Only when my friend roared at me and said: 'Hurry up, you son of a gun, the rain will be here in a minute,' did I make haste. We were wet to the skin."

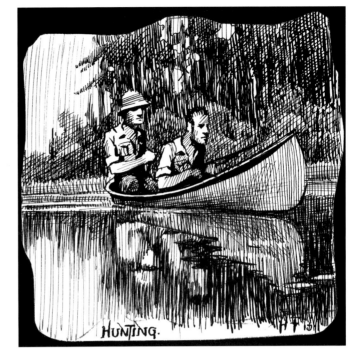

HUNTING.

Rain

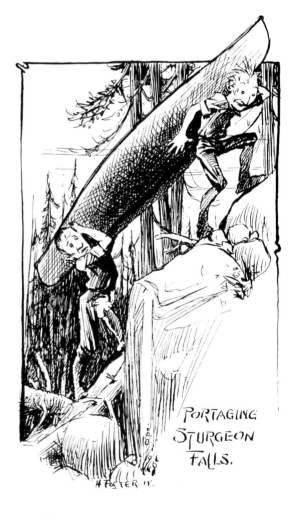

PORTAGING STURGEON FALLS.

"Night came and we turned in. In five minutes the concert began. Once more our friend the mosquito visited us. We got up again and burned grass and smoked out the tent. We could hardly breathe but at least we thought there would be no more mosquitoes. Indeed, one should hope not."

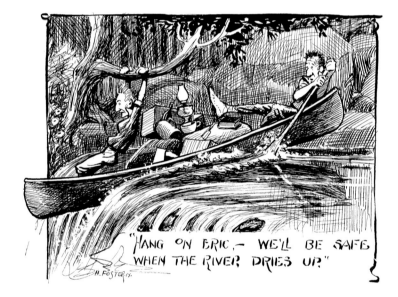

"HANG ON ERIC, — WE'LL BE SAFE WHEN THE RIVER DRIES UP."

"We had steered right into a cauldron of foaming water. We tried to steer right but it was too late, the opposite current brought us ever nearer and nearer to the falls. It was here that my friend showed his true dexterity with the canoe."

"We were using all our muscles for now we could not stop because of the opposing current. After one and a half hours of really hard going we reached our goal. We shook hands."

RICE LAKE WAS AS BUSY AS OLD RIP VAN WINKLE BEFORE THEY SPRANG THE ALARM CLOCK ON HIM

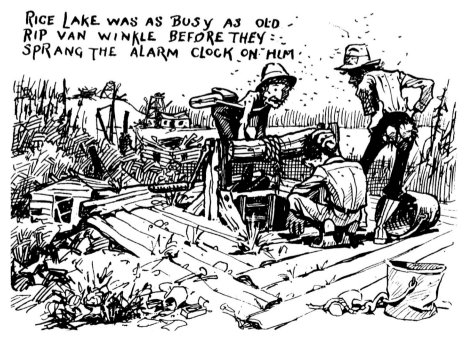

"It was so quiet that we could hear the buzzing of thousands of insects. There were so many mosquitoes in our tent that it was impossible to sleep and I was therefore glad when morning came."

"Whenever I woke up I was just in time to squash one of my friends which had firmly settled on my nose."

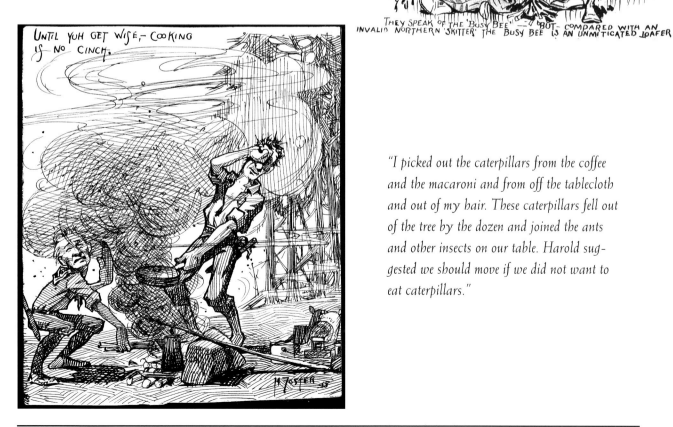

THEY SPEAK OF THE 'BUSY BEE' — BUT—COMPARED WITH AN INVALID NORTHERN 'SKITTER' THE BUSY BEE IS AN UNMITIGATED LOAFER

UNTIL YUH GET WISE,—COOKING IS NO CINCH.

"I picked out the caterpillars from the coffee and the macaroni and from off the tablecloth and out of my hair. These caterpillars fell out of the tree by the dozen and joined the ants and other insects on our table. Harold suggested we should move if we did not want to eat caterpillars."

DRIVING OUT THE NATIVES BEFORE RETIRING

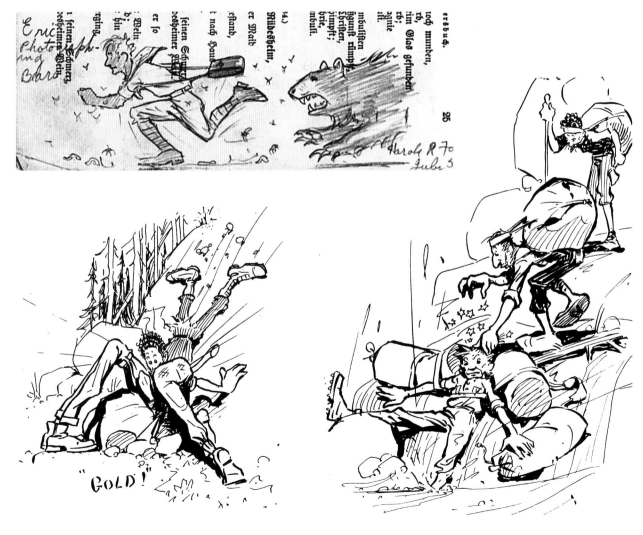

"GOLD!"

"I got ready to catch fish for supper and actually managed to catch one. It was the first one I had caught by myself. My friend, who looked on from the canoe, was sketching. Since I wanted to surprise him I did not say that I had got a bite. I pulled my catch ashore it was a pickerel. I was afraid that it would escape since it tugged tremendously at the line. One jerk and I landed it. Since I was now afraid it would bite me I started to hammer away at it with a log. He managed to work himself free of the hook and sprang into the water. I grabbed it and flung it far into the brush. I set about finishing it by stepping on its tail. I then hacked away at it until it was finished off. I held him up triumphantly and called to my friend, 'See Harold, I caught one.' He had seen the whole thing and was killing himself laughing."

H. Eric Bergman had wanted to be a ballet dancer but was discouraged by his parents. He apprenticed as a wood engraver and, after completing his training at eighteen, answered an ad in a Toronto paper and moved to Canada.

His art was shown in some of the most important exhibitions of his time including The Canadian National Gallery; International Print Makers in Los Angeles; International Exhibition of Woodcuts in Warsaw, Poland from which he won a Diploma; The Art Institute of Chicago; The Royal Scottish Watercolor Society, Edinburgh; The Royal Canadian Academy; The Philadelphia Traveling Exhibition of Canadian Printers; The Canadian National Exhibition, Rio de Janeiro, and several One-Man shows including the De Young Museum in San Francisco, the Winnipeg Art Gallery, and the Toronto Art Gallery. He also served as the president of the Manitoba Society of Artists and was an Honorary Life Member of the Canadian Handcrafters Guild.

The Trail 20/75 H. E. Bergman

"And that same day there passed into the hall, a damsel of high lineage, and a brow of may-blossom, and a cheek of apple-blossom—and lightly was her slender nose tip-tilted like a flower."

—Hal Foster
Prince Valiant in the
Days of King Arthur

T • H • R • E • E

HELEN *the* FAIR

Helen's father, Harry James Wells

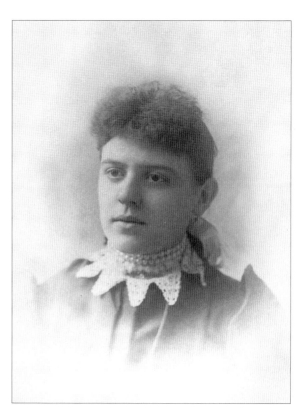

Helen's mother, Mabel Polly (nee Webb) Wells

Helen's grandfather, Leland Justin Webb

Helen's grandmother and the woman who raised her,
Helen Mar (nee Herman) Webb

Helen Lucille Wells

elen Lucille Wells was born in Topeka, Kansas on December 7th, 1894, to Mabel Polly (nee Webb) and Harry James Wells. Helen's mother died eighteen months later at the age of 24 and her maternal grandmother, Helen Mar Herman Webb Golden raised her for the next six years. Helen was named after her maternal grandmother who was a descendent of Elizabeth Penn, sister of the founder of Pennsylvania, Sir William Penn.

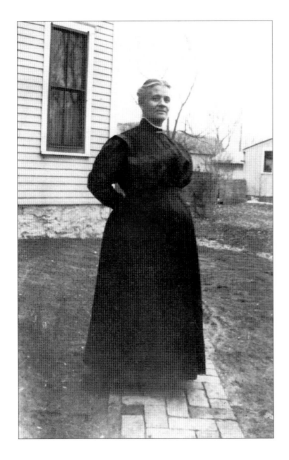

"I had a good childhood. My mother's mother was my 'Mother' during the years my father was unmarried. She had lost a son in infancy and her husband's death was closely followed by my Mother's. So I was all that was left to her and she felt there was nothing too good for me and spoiled me accordingly. Grandma took me in a horse and buggy to the cemetery every day. On the way home I would say it was time for 'poince,' which meant ice cream, so we'd always stop at Wagner's Drug Store. They had big tall glasses in metal holders with a handle on it and we'd sit on spiral wire chairs.

Helen's grandmother, Laura Jane Wells.

"When I went to my paternal grandparents things were different. My grandfather worked for the Santa Fe Railroad as a train inspector and when he had enough years to retire he wasn't old enough and trying to put in that extra year killed him. His name was Louis Kossuth Wells but everyone called him 'Bob.' He worked six days a week from 7 am to 7 pm for a 50 dollar gold piece. Red-letter days were the 1st and 15th of every month when Grandpa got paid. We'd ride the streetcar to town and take the money to the Savings and Loan Company. Then we'd have a soda and ride it back again. My grandmother, Laura Jane Wells had dropsy but she was a heavenly cook. The Wells family were all gifted with hearty appetites and Friday was baking day; home-made bread, 4 and 5-layered coconut cake, huge pans of ginger bread and all kinds of cookies."

When Helen was seven her father married Katherine Wilson. The Wells lived in Topeka and Wichita, Kansas and then moved to Kansas City, Missouri where Helen attended Westport School. After 8th grade, Harry Wells sent Helen to finishing school at St. Mary's Academy, a Catholic convent and school in Leavenworth, Kansas. It was there she was taught sewing, cooking, deportment and table manners as well as English, French, German, algebra and chemistry.

While attending St. Mary's, Helen's father and step-mother moved to Winnipeg looking for employment in the real estate business. After three years Harry could no longer afford to send Helen to St. Mary's, so she joined them in Winnipeg and began going to college part time.

The woman Hal would always refer to as a "neat blond."

After Harry and Katherine had Helen's half-sister, Gereen, on December 20, 1912 they decided to move back to the United States. Since Helen had a job she stayed in Winnipeg. On August 4, 1914, England declared war on Germany, so Canada was at war too. Many of the younger men went off to Europe, leaving few would-be suitors on the home front. Through a girlfriend that lived next door, Helen met some young men, and in the spring of 1915 one of them took her to a dance at the Winnipeg Canoe Club. It was there that she met and fell in love with Harold Foster. Joseph Cox had passed away

sometime before 1915 and left Hal as the only means of financial support for his mother and two half-brothers. Because of this he had not been conscripted into the war effort. At first glance all Foster saw, as he looked across the dance floor, was a pair of brown eyes, staring back at him. Helen's blond hair, white dress and pale complexion blended into the white wall she was standing against. For the artist, Helen embodied a passion that would last the next sixty-seven years. "Neither of us understood [the other's] Canadian and American talk," Helen once wrote, "so we just laughed and fell in love."

One evening, after a "ripening friendship", Hal took Helen to dinner at the Grange Hotel. With $5.00 in his pocket they managed to have cocktails (Manhattans), steak dinners, tip the waiter and still have three dollars left over. That evening, Hal proposed

The Winnipeg Canoe Club where Hall and Helen met at a dance.

and Helen accepted, and on August 28, 1915 they were married. Their honeymoon consisted of a 3-day canoe trip on unmapped lakes that no white woman had ever seen before.

"I had lived a sheltered existence, but marriage to a man like Hal Foster was like stepping into a kaleidoscope of constantly changing colors events and places—each more exciting than the one before. When we were first married all our vacations were canoe camping trips. Harold would load me up with the lighter equipment. Around my forehead would go an Indian "Trump Line" much like today's backpacks. It extended back over my shoulders.

"Hal carried the 16-foot canoe on a special yoke when we had to portage on Indian trails between lakes. Usually he went first, but on one occasion when we were on a well-marked Indian trail, Hal let me walk ahead. He hung a huge postcard sized camera around my neck and instructed me to take pictures of wild animals.

"With both hands full and the pack on my back I wondered how I was supposed to snap pictures. Just as I got to the end of the trail I came face-to-face with an enormous bull moose. He was eating and had great strings of weeds hanging from his mouth. I froze. So did the moose. Finally, he wandered off into the water.

The words on this page are taken from Helen Foster's memoirs, July 1982. Hal did all of the cartoons while the two of them were on their honeymoon.

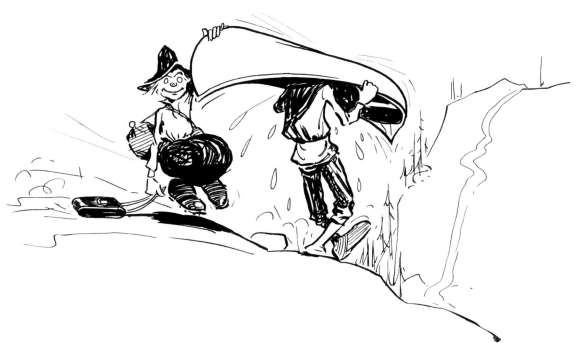

"I could scarcely wait to tell Hal about my adventure. 'Well, did you get a picture?' he asked. 'No,' I told him. 'How many hands do you think I have?' To this day Hal hasn't forgiven me for not getting the picture of that Bull Moose."

They lived at 277 Balmoral Street (later renamed Baltimore Road) and on April 29, 1916 Edward Lusher Foster II was born. Within three months, the Foster's were back in the wilds with "Teddy"* in an orange crate covered with mosquito netting sitting on the bottom of the canoe. "That was one time we did not take the rapids but used all the portages," Foster assured. "It was fun, though we both knew that I should have been working and studying, but we had gotten used to the 'Foster luck' and it never let us get hungry once."

In the off months from Brigdens, the couple found work as hunting guides in Ontario and Manitoba and in 1917 they found a "million dollar claim" in the Lake Rice region and began prospecting the vein with Eric and another friend. "We got what they call a 'showing'," explained Foster. "You break off a piece of that white stone quartz, wet it, and look very, very care-

Helen with "Teddy".

* Edward was nicknamed "Teddy" by Zoe Collins who was dating Eric Bergman at the time. Coincidentally Zoe is the great-aunt of Katherine Collins (Arn Saba) who would later conduct Hal Foster's last interview in 1979.

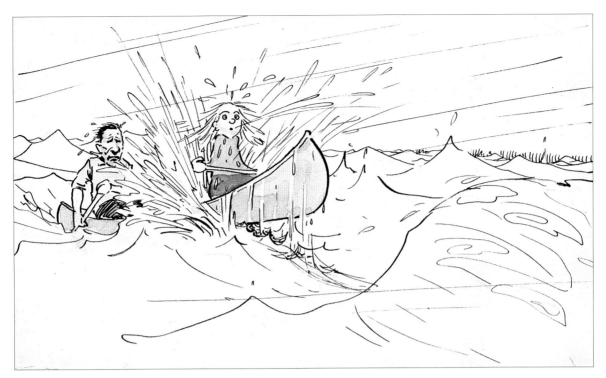

fully and sometimes you see a bit of gold there. Gold! Damn it! Lots of it! But it takes dynamite to get it out. I don't like explosives—I learned to fear them soon after I married."

After World War I ended in 1918, all of Canada found itself in recession-tough times. Once more work became scarce for Hal and his family. In May of 1919, every Manitoban's life changed. The Winnipeg General Strike of 1919 began May 15th and ran until June 26th. It would be the largest General Strike in the country's history. While opponents at the time accused the leaders of the strike of Bolshevism, it was actually a legitimate action taken over the issues of labor and collective bargaining. In essence it was really a class struggle between the union leaders and those they represented and the elected federal Tory-Unionist government. Everything from mail to milk delivery stopped. Streetcars and trains no longer ran, telephone and telegraph service ended, and

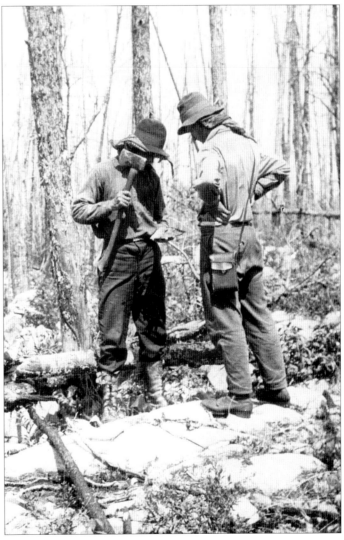

Hal and Eric Bergman prospect for gold.

Hal and "Teddy".

even the police walked off their jobs. A "Citizens Committee of One Thousand," consisted of upper-middle and middle-class volunteers, began to patrol the town. The Citizen's Committee set up headquarters in The Board of Trade Building—the same building where The Winnipeg School of Art resided.

On June 17, the strike leaders were arrested and charged with seditious conspiracy and libel. Then came "Bloody Saturday". On Saturday, June 21, thousands of strikers gathered in downtown Winnipeg at Market Square to protest the arrests. Mayor Charles Frederick Gray called on fifty-four North West Mounted Police (the precursor to the Royal Canadian Mounted Police) to disperse the crowds. Several hundred "special police" deputized by the city during the strike and armed with baseball bats and wagon spokes, supplied by local retailers, beat the protesters. The ensuing melee resulted in two strikers being killed and at least 30 injured. By the end of the day federal troops from Fort Osborne were patrolling the streets with machine-guns mounted on their vehicles. The unrest officially ended Thursday, June 26th, when the labor leaders declared an end to the strike.

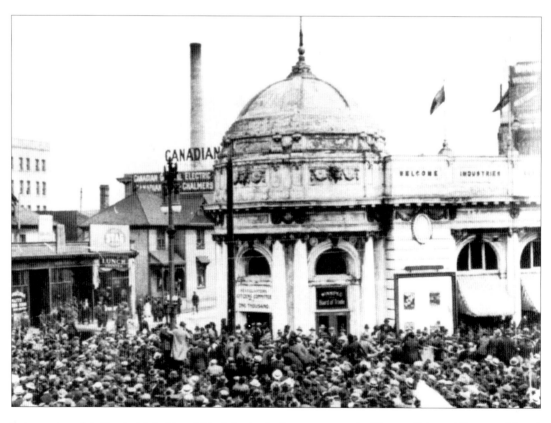

The photo, courtesy of the Provincial Archives of Manitoba, is of a demonstration at the Winnipeg Industrial Bureau and Board of Trade Building on June 4, 1919. The rally occurred only two days before Hal and Helen's second son Arthur was born.

In the midst of the turmoil Hal and Helen's second son, Arthur James Foster was born on the 6th of June. Within days of Arthur's birth, all of Helen's beautiful straight blond hair fell out, probably due to hormones. It took a while but soon it grew back—dark and curly. In later years, Helen would joke that no matter how old she was her hair was always 25 years younger than her. Even though her hair remained dark until it grayed, Hal always referred to Helen as his "neat blond".

The Winnipeg General Strike may have given rise to the modern Canadian Labor movement but it did little to bring peace to Canada. Now the Fosters had to consider the safety of their two young boys in addition to a shrinking job market. At Brigdens Hal had worked his way up to "Men's Fashions," illustrating models in the very difficult to render herringbone and tweed jackets. He had reached the top of his trade and done all that he could as an artist in Winnipeg; he was ready for a bigger job.

ABOVE: *Hal working on a deadline.*

LEFT: *Helen with Arthur—at the campsite.*

• *47*

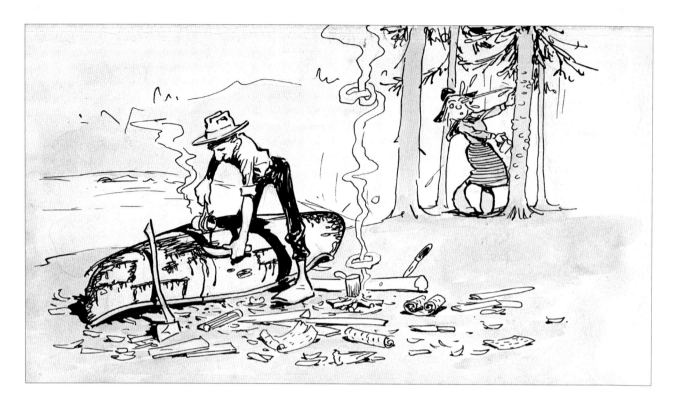

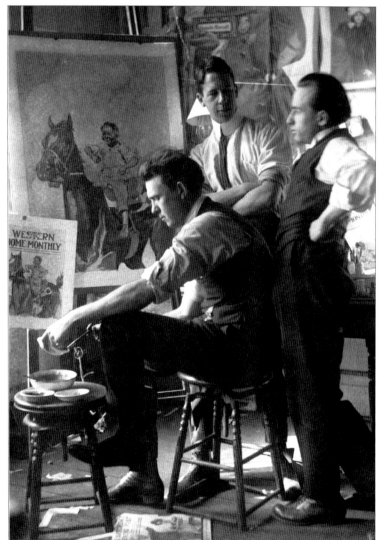

Hal worked for companies in Winnipeg other than Hudson Bay and Brigdens because of the seasonal work. Among his other places of employment were the Commercial Art Company and the Buckley Studio. Unfortunately no further information on these two businesses is available.

The photo at the left (Hal in center) shows a painting and a paste-up for a copy of Western Home Monthly. This particular issue appeared in September 1912; however, the paste-up is for May. Stoveo Press, also in Winnipeg, published the periodical. It is uncertain if Hal had worked for Stoveo because the records have been lost or destroyed. Another interesting aspect of this photograph is the issue of The Saturday Evening Post lying on the floor in the foreground. It is the September 18, 1909, issue and the cover is by J. C. Leyendecker who was one of Foster's greatest influences during his early years.

"Foster's own life has been one of rugged adventure, too. With his own background as a foundation, and a nimble imagination, Foster created a new concept in illustrated adventure pages, which he painstakingly produces with accurate detail."

—Foster Scrapbook clipping

F • O • U • R

KNIGHT ERRANT

NOVELTY

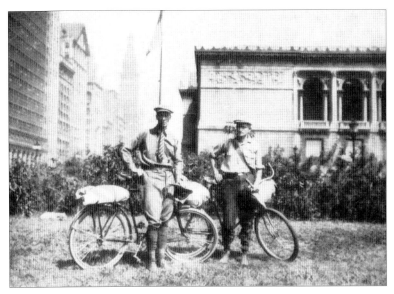

ABOVE: *Hal and Syd Metcalfe outside the Chicago Museum of Art in 1919.*

RIGHT: *A photo of the streets of Chicago from Hal's first trip in 1919.*

The post war economy of Winnipeg in 1919 left little work for freelance artists. At twenty-eight, with a family to support and no future prospects, Foster decided to take his artwork seriously and learn the craft. Whenever Hudson Bay or Brigdens needed artists with specialized skills, they would bring them in from either Toronto or Chicago. These artists would get paid extremely well; so, it made sense to leave Winnipeg. The decision was a mutual one and Helen, knowing it would leave her alone with the boys for weeks told him: "Harold, you have the skill but you've got to go where you can get more training and opportunity."

After Helen organized the finances they realized that there wasn't enough money for even one round trip train ticket. Since Chicago was the closest large city, Foster made that his destination. Hal pulled out his bicycle and talked friend and fellow artist, Sidney Metcalfe, into joining him on the 1,000-mile trek. On the morning of August 16, 1919, they set out with a few necessary utensils wrapped in blankets and tied to their handlebars.

"There wasn't a single mile of paved road between towns," Metcalf would later recount. "It was such rough going, Hal broke the rim of his wheel on one occasion and on another the pedal shaft." Each day, they'd do a "century" (100 miles) then sleep in barns or on haystacks. "The worst thing on the trip [were] the vicious dogs," commented Foster. "We got so we could kick the teeth out of a farm dog in one stroke."

They followed the Red River Valley to Grand Forks, Minnesota where a big storm hit and they saved a couple of days by hitching a ride on a milk train. When they rode through Waukegan, Illinois a gang of tough punks mistook them for Boy Scouts and "nearly made Waukegan the end of the line" for them. It took the two men fourteen days across dirt and gravel roads but on August 28th, (the Foster's sixth wedding anniversary)

Chicago, circa 1921.

they reached Chicago. That afternoon, Helen received a telegram, which read, "Help—send emergency fund." They had been robbed.

The two men had checked into a YMCA "and within a half-hour we were robbed of everything we had," remembered Foster. "We had put on our raincoats and gone for a shower. We didn't notice the guy leaving the shower as we entered. He took our keys, stole all our money then threw our keys into the room through the transom. So there we were in Chicago, broke, nothing but our bicycles and the suits we stood in. It gives you a great desire to achieve something— like a square meal." Luckily, Helen had kept some money in reserve and wired it to Hal.

They went to the Chicago Museum of Art and "visited Chicago studios to see what work was needed." Work was available, but affording to live in Chicago was another matter. "We got the feeling of the vast opportunity in the U.S.," Metcalf recalled, "and we determined to make our future there in Chicago." After a few days the traveling companions headed back to Winnipeg to prepare for their moves.

Unfortunately, Hal had never filed assessment papers for ownership of the gold mine so in 1920, after nearly three years of labor, claim jumpers stole it. Hal dedicated himself to making enough money to move to Chicago, and turned once more to work as a guide. That year, he traveled an estimated 750 miles by canoe and 500 miles on horseback. "I nearly broke my back," Foster wrote, "taking a canoe load of illicit whiskey down the Dalles Rapids on the Winnipeg River." The extra effort paid off.

In 1921 Foster moved to Chicago and got a job at the Jahn & Ollier* Engraving Company. Determined to get better work he quickly enrolled at the Chicago Art Institute for evening classes. Helen took the boys and moved back to Topeka to live with her grandparents until Hal had earned enough money to support the entire family. Helen was furious at the move—not because of Hal, but because citizenship laws had

From left to right, Helen's grandmother, Helen Mar Webb, Arthur, Helen's grandfather, Louis Kossuth Wells, Edward ("Teddy"), and Helen.

52 •

* Usually misspelled Oliver.

··STRATEGY··

STRATEGY is that force which combines wisdom with action. It is not the attack, but the generalship with which it is planned and executed, that wins the battle.

In the modern advertising campaign, where dollars are the soldiers, sheer numbers are far less important than the wisdom with which they are spent for illustrations and engravings.

The Jahn & Ollier Engraving Co. has for years contributed notably to the effectiveness of the Nation's advertising, by creating better illustrations for America's advertising tacticians, and by translating these drawings and photographs into printing plates of outstanding quality.

JAHN & OLLIER ENGRAVING CO.
556 West Adams Street, Chicago, Illinois.

Advertising Ideas and Illustrations ∞ Commercial Photographs ∞ Printing Plates in Black and Color

An early Foster illustration for Jahn & Ollier Engraving Company.

Some of the many ads Hal did for Palenske-Young in the late 1920's.

changed since she'd moved to Canada and the United States government no longer considered her to be an American citizen. Both Hal and Helen had to pay $9.00 each in order to become U.S. citizens. Hal waited until 1927.

Hal supplemented his education at the Institute with classes at the National Academy of Design and the Chicago Academy of Fine Arts. "I would compare other peoples work with my own. Then I'd go to school to learn what I didn't know." Over the next few years, Hal, Helen and the boys moved to the Chicago suburb of Evanston, Illinois where Hal became "an artist and illustrator, a father and congenial loafer." Eventually he went to work for the prestigious Palenske-Young Studio, located above the Chicago Motor Club. He put his talents to work illustrating ads and magazine covers alongside Paul Proehl, William Juhre, and Charles F. Armstrong. Charles quickly became a "fishing pal" and introduced Hal to the fantasy writings of

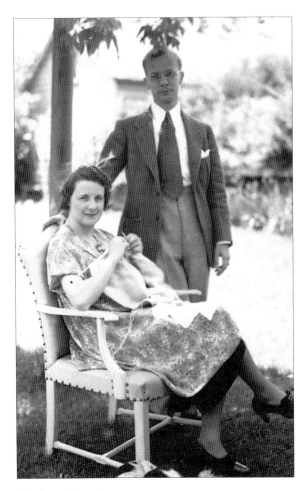

Charles and Bea Armstrong.

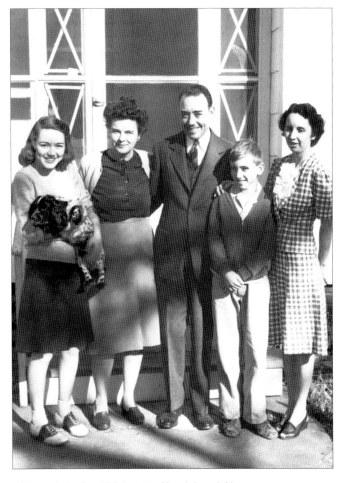

Helen with Paul and Thelma Proehl and their children.

The Palenske-Young symbol.

Outside of Tarzan, it is easy to determine what other artwork was done by Hal while he was working for Palenske-Young.
Both Hal's and Paul Proehl's signatures bear the "PY" brand after them instead of a date.

Hal on a visit to Topeka.

Hal's teacher, Charles Schroeder.

* Foster also learned composition and color theory from Schroeder. Among the other noted teachers at the Art institute while Hal was attending were Edgar Rice Burroughs artist J. Allen St. John and "The Shadow" cover painter George M. Rosen.

James Branch Cabell and Lord Dunsany.

Everyone at Palenske-Young was an extremely capable artist. Juhre would go on to illustrate the *Tarzan* daily strip after Rex Maxon's departure. Proehl and Hal both handled the major illustration jobs for the studio, and in 1932, Paul, not Hal, would be chosen to paint the *Chicago* poster for the Illinois Central Railroad. Charles F. Armstrong was a highly respected calligrapher and probably did all of the lettering on the *Tarzan* Sunday pages. Later, Hal would hire him to do the lettering on *Prince Valiant* and, after the Depression, Armstrong would move to New York where he founded Armstrong Process Lettering on Madison Avenue.

*"An example of his real humility as a true artist occurred when Harold first arrived in Chicago from his native Canada. He was by now far along in his field to rank as one of the best of illustrators, and ready to crack the American field of commercial art. His economic future was secure and rewards for years of apprenticeship and hard work were his. Now had come the time for relaxing and enjoying the fruits of success, but no. An innate integrity made him realize that he was covering with 'natural' ability a fundamental lack in the knowledge of anatomy. So what to do but start over again in the middle years and study. It meant his giving up vacations, nights, Saturdays and holidays to the drawing and observation of bones, muscles and nerves. And believe me, this is work that is tedious, boring and time consuming. I know—having studied under the same anatomy fanatic, a [Charles] Schroeder.**

Hal produced work for Northwest Paper, *This example of art integrity has had my admiration for the many years I've known Harold."*

—*Charles F. Armstrong*

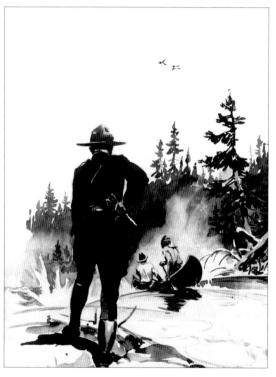

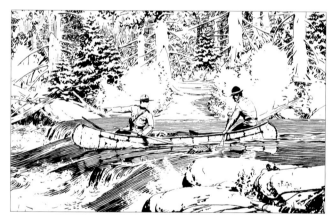

Hal produced several Mountie paintings for Northwest Paper Company's calendars in the 1930's. Among his other clients were Jekle Margarine, Southern Pacific Railroad, Illinois Pacific Railroad, and Popular Mechanics. It was this work that would lead to his association with the Campbell-Ewald Advertising Agency in Detroit and dramatically changed his life.

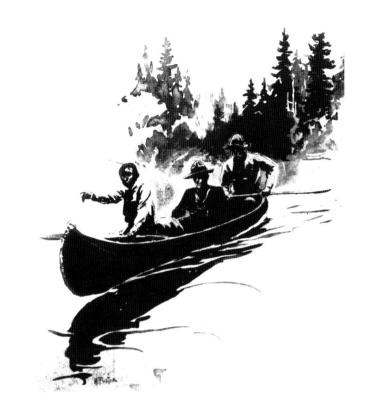

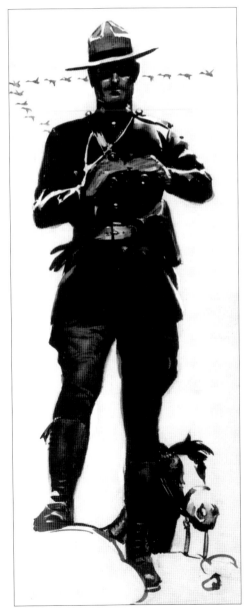

The three large pieces on this page and the one opposite in the lower left were found in a Wisconsin antique store in 1963, by Ralph F. Kocher. These rare images are reproduced here from photostats Kocher sent Foster.

F • I • V • E

"WE
ATE
APE"

LEFT AND BELOW: Hal's parents,
Edward Lusher Foster, and
Jeannette Grace (nee Rudolf) Foster
were used as models for Lord and
Lady Greystoke.

In 1927, Joseph H. Neebe, who was also associated with the Campbell-Ewald Advertising Agency, went to Tarzana, California to meet with Edgar Rice Burroughs. Neebe, founder of *Famous Books and Plays, Inc.* had originated the idea of adapting popular material into comic strips. Neebe wanted to adapt <u>Tarzan of the Apes</u>, which was first published in 1912, into a cartoon strip and Burroughs agreed. Neebe's idea was innovative since realistic adventure comics didn't exist at the time. While Windsor McKay's *Little Nemo in Slumberland*, possibly the greatest fantasy comic strip ever printed, had elements of adventure it was not realistic nor did it have a sense of drama. C.W. Kahles' *Hairbreadth Harry* also had adventure elements but the overall theme was obviously comedy. The closest thing to an action strip being printed was Roy Crane's *Wash Tubbs (Washington Tubbs II)* that began April 21, 1924. The feature had gone from a gag-a-day format to rollicking escapades of light-hearted daring-do. It wouldn't be until May 1929 when Crane introduced Captain Easy into the strip that it would take on a more adventurous tone. To insure *Tarzan's* success Neebe approached Burroughs' cover artist J. Allen St. John to do the adaptation but St. John, though interested, declined once he was informed about the deadlines. Neebe needed an illustrator with the sensibilities of a fine artist; so, in 1928, he went to his second choice, Hal Foster.

With the text adaptation by R.W. Palmer, Foster broke the story down into a 10-week series. At five panels a day, six days a week the total amount came to 300 panels. "I had no instructions at all, just the book." Foster claimed, "I did the adaptation myself." The artist researched the strip thoroughly from the period-specific clothing to the three-masted Barkentine—everything was authenticated. Foster even used his parents as models for Lord and Lady Greystoke. The family

resemblance is quite evident in the very first panel of the strip when compared with a photo of Edward Lusher Foster, and his mother, Jeannette Grace Foster, is best revealed when compared with Lady Greystoke from day 3, panel 2. As for Tarzan, there are many who believe Foster modeled his features after veteran film actor Henry Wilcoxon.

J. Allen St. John illustrated many of the Tarzan novels and was a highly respected artist.

> The drawings were rendered in brush. Shadow areas were painted in as solid blacks, glorifying the impact of light upon solid objects, with contour lines kept to a minimum. The effect of the violent light and shadow held together by a few lost-and-found drybrush lines was so new to the comics page that *Tarzan* was calculated to stand strikingly apart from its neighbors. Editors were afraid of the "radical" feature.[1]

Even though it was a successful ad agency Campbell-Ewald had never tried to sell a syndicated strip before. An expensive nation-wide campaign ensued, to which Palenske-Young Studio contributed $6,000.00, but not a single American newspaper subscribed to the strip. Neebe began looking for a distributor with experience in comic strip sales and submitted a sixty-four-page portfolio of the proposed series to King Features Syndicate. Newspaper tycoon William Randolph Hearst had final approval on all strips and the revolutionary-looking feature was not something he wanted to run in his papers.

It was advertising artwork like these two pieces that drew the attention of Joe Neebe and secured Foster as the illustrator on the Tarzan strip.

1 Art and Literacy Quality Keep Cartoon Level High, George Turner, Amarillo Sunday News-Globe, February 16, 1969, p. 1-D

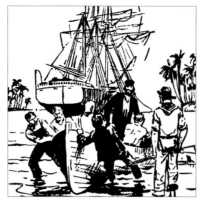

LEFT: Here is a comparison of one of Foster's reference photos and how he used it in a Tarzan panel depicting the three-masted Barkentine.

BELOW: A selection of panels from Foster's historic adaptation of Edgar Rice Burroughs' Tarzan of the Apes, which appeared as a daily strip in 1928.

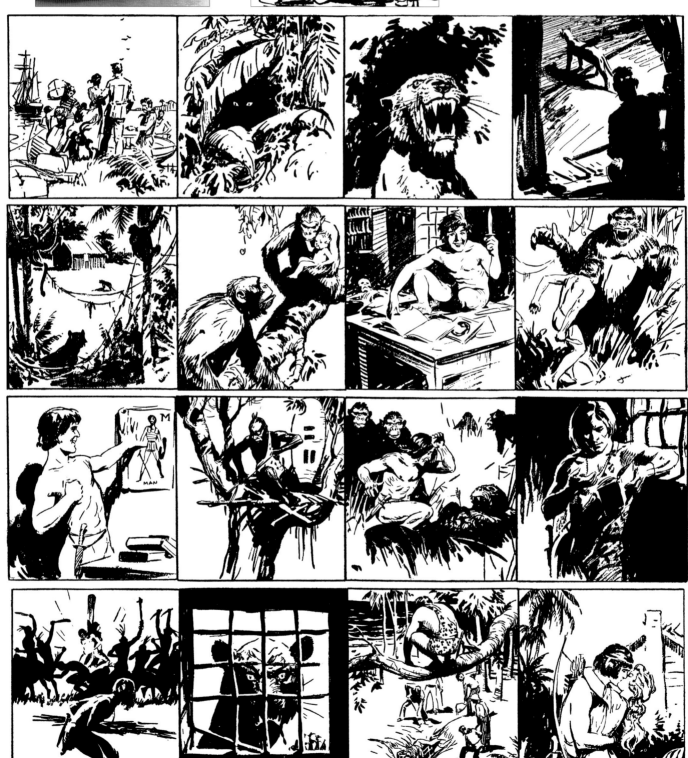

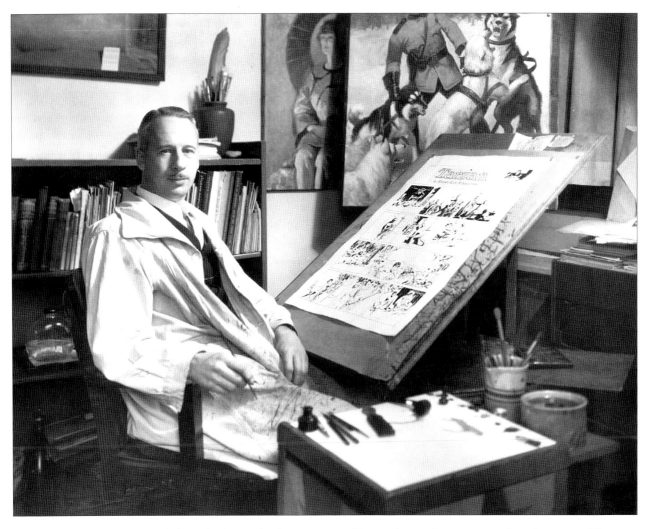

This is the only known promotional photo of Hal Foster for the Tarzan *strip. The page he is working on is #143, December 3, 1933. The paintings in the background are of special interest. One is of a known Mountie print, but the other one behind it has not been catalogued.*

Undaunted, Neebe contacted *The Metropolitan Newspaper Service's** general manager, Maximilian Elser in New York. Elser and his associate, Earl J. Hadley agreed to distribute *Tarzan* and devised a unique soft-sell approach to lure editors. In the sales agreement the newspaper editors only had to purchase the 10-week adaptation and could wait until they had a chance to judge reader's response before committing to an ongoing *Tarzan* syndicated strip. The editors need not have worried.

The *Tarzan* comic strip, illustrated by 36-year-old Harold R. Foster premiered in the British weekly publication *Tit-Bits*, in November 1928. The English run of the "Lord of the Jungle" predated the strip's American début by almost two months. On January 7, 1929, *Tarzan* appeared in 13 American and 2 Canadian newspapers. That same day, Dick Calkin's *Buck Rogers* appeared for the first time. Even if it were not for the earlier British publication date, Foster's realistic rendering, fluid anatomy, draftsmanship, and sense of composition would have forever marked him as "The Father of the Adventure Strip." In addition to these two great features 1929 would herald the first appearances of *Popeye* in Segar's "Thimble Theatre", Clifford McBride's *Napoleon*, and in Belgium, Herge's (Georges

• *65*

* Metropolitan would later become *United Feature Syndicate.*

Tarzan
by EDGAR RICE BURROUGHS

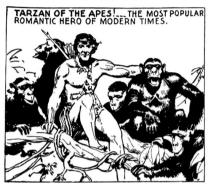

TARZAN OF THE APES!.... THE MOST POPULAR ROMANTIC HERO OF MODERN TIMES.

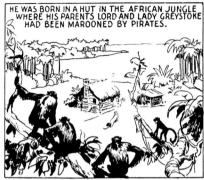

HE WAS BORN IN A HUT IN THE AFRICAN JUNGLE WHERE HIS PARENTS LORD AND LADY GREYSTOKE HAD BEEN MAROONED BY PIRATES.

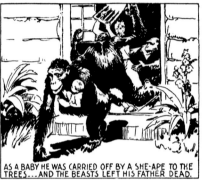

AS A BABY HE WAS CARRIED OFF BY A SHE-APE TO THE TREES.... AND THE BEASTS LEFT HIS FATHER DEAD.

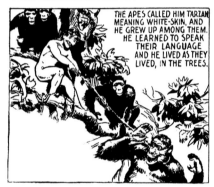

THE APES CALLED HIM TARZAN MEANING WHITE-SKIN, AND HE GREW UP AMONG THEM. HE LEARNED TO SPEAK THEIR LANGUAGE AND HE LIVED AS THEY LIVED, IN THE TREES.

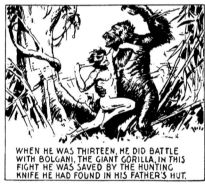

WHEN HE WAS THIRTEEN, HE DID BATTLE WITH BOLGANI, THE GIANT GORILLA, IN THIS FIGHT HE WAS SAVED BY THE HUNTING KNIFE HE HAD FOUND IN HIS FATHER'S HUT.

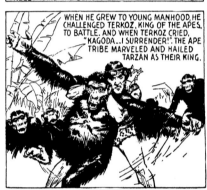

WHEN HE GREW TO YOUNG MANHOOD, HE CHALLENGED TERKOZ, KING OF THE APES, TO BATTLE. AND WHEN TERKOZ CRIED, "KAGODA...I SURRENDER!", THE APE TRIBE MARVELED AND HAILED TARZAN AS THEIR KING.

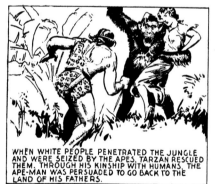

WHEN WHITE PEOPLE PENETRATED THE JUNGLE AND WERE SEIZED BY THE APES, TARZAN RESCUED THEM. THROUGH HIS KINSHIP WITH HUMANS, THE APE-MAN WAS PERSUADED TO GO BACK TO THE LAND OF HIS FATHERS.

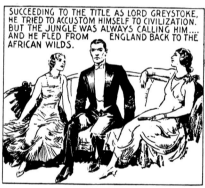

SUCCEEDING TO THE TITLE AS LORD GREYSTOKE, HE TRIED TO ACCUSTOM HIMSELF TO CIVILIZATION. BUT THE JUNGLE WAS ALWAYS CALLING HIM.... AND HE FLED FROM ENGLAND BACK TO THE AFRICAN WILDS.

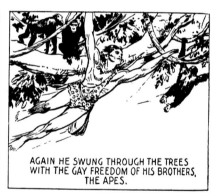

AGAIN HE SWUNG THROUGH THE TREES WITH THE GAY FREEDOM OF HIS BROTHERS, THE APES.

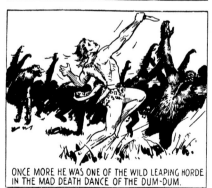

ONCE MORE HE WAS ONE OF THE WILD LEAPING HORDE IN THE MAD DEATH DANCE OF THE DUM-DUM.

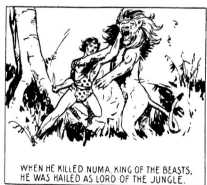

WHEN HE KILLED NUMA, KING OF THE BEASTS, HE WAS HAILED AS LORD OF THE JUNGLE.

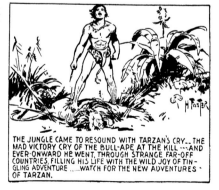

THE JUNGLE CAME TO RESOUND WITH TARZAN'S CRY... THE MAD VICTORY CRY OF THE BULL-APE AT THE KILL ---AND EVER-ONWARD HE WENT, THROUGH STRANGE FAR-OFF COUNTRIES, FILLING HIS LIFE WITH THE WILD JOY OF TINGLING ADVENTUREWATCH FOR THE NEW ADVENTURES OF TARZAN.

Foster produced this Tarzan origin page for papers which had not initially subscribed to the feature to introduce readers to Burroughs' hero.

Remi's internationally famous strip, *Tintin*.

Foster created the definitive Tarzan. He established a look of nobility and aristocracy that would be emulated by Burne Hogarth, Rubimor (Amilcar Ruben Moreira), Bob Lubbers, Russ Manning, Gil Kane, Mike Grell, Gray Morrow, Joe Kubert, and every other artist to illustrate the Ape-Man. Another Foster trademark that appeared for the first time in comics was the use of captions instead of word balloons. This technique, called a story-strip, allowed Foster to create compositions containing amazingly detailed backgrounds unhindered by text. It was a deliberate tactic and done to give the strip the appearance of being created in the same tradition as Pyle, Wyeth, and all of the other great book illustrators Hal admired. The tactic worked. The demand for the strip was so great that in August of 1929, Grosset & Dunlap collected and reprinted the entire series as The Illustrated Tarzan Book No. 1.

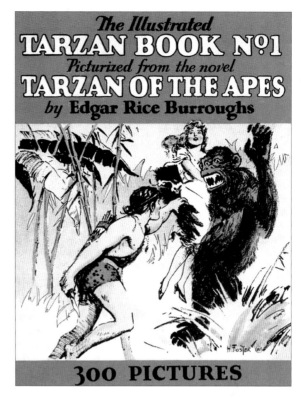

The Grosset & Dunlap collection.

After the initial run, Foster went back to advertising and Famous Books and Plays turned to The Metropolitan Newspaper Service bullpen artist Rex Hayden Maxon of Lincoln, Nebraska to draw the *Tarzan* daily strip. Hal had done Neebe a favor, but he considered himself an artist first and cartooning was, for him, an inferior medium. He did, however, produce a *Tarzan* origin page for papers which had not initially subscribed to the feature to introduce readers to Burroughs' hero. For papers who subscribed to the strip after the initial run, Foster made up a synopsis to run in the Sunday edition prior to the start of *The Return of Tarzan*. The origin story only appeared in black and white (see facing page), but was later reprinted in full color in *Tip Top Comics*, #41, September 1939. "I was an advertising illustrator, a very good second-rate one with hopes of becoming a first-rate one in time." Foster recalled. Later that year, those hopes were shattered along with the hopes of many other Americans.

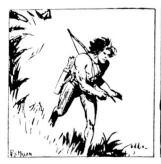 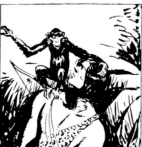 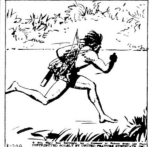

Rex Maxon's Tarzan strip.

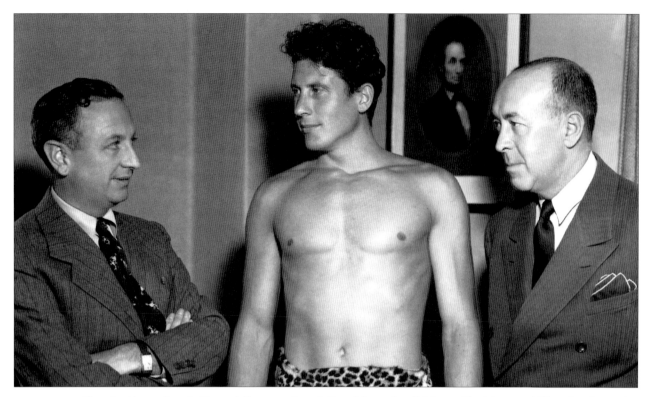

Unused publicity photo for Tarzan's Revenge *(1938). From left to right - Sol Lesser, Glen Morris, and Edgar Rice Burroughs.*

The Great Depression saw an end to most of the advertising dollar. Foster personally witnessed three suicides in downtown Chicago, including one man who fell nine stories to the pavement just outside of the restaurant where he was having lunch. "During the 1920's, everything had looked grand. I'd invested in stock like everybody else and was wiped out too." Palenske-Young found a unique way of attracting customers. "We had a 5-gallon can of alcohol. We had a source—this was in prohibition days. Every afternoon I'd mix a gallon of synthetic gin." At first the customers came in after work for a relaxing time and to drink, socialize, throw darts, play Ping-Pong and fly kites out the window. "Finally we put our foot down. Anybody who wanted to come in had to bring in a bit of work." The scheme brought in small assignments and kept the agency running on a shoe-string for the next year, "then *Tarzan* came along."

Edgar Rice Burroughs hated the artwork in the strip and felt Maxon was making a public fool of his hero. Starting at the advent of Maxon's run, and lasting over many years, Burroughs sent a series of letters to United Feature Syndicate complaining about the artist's inadequacies.

March 27, 1934

Dear Monte:

Of course, I have nothing to say about the artist, but it is a very serious matter to me when my character is made ridiculous.

I believe that Maxon can do very much better work. I recently saw a Whitman illustrated child's book, which I was told was done by Maxon and if such is true, then he is not giving his best to *Tarzan*. In fact, it

looks to me as though he is deliberately trying to make Tarzan appear ridiculous, for his other characters are much better drawn and better looking than Tarzan.

I wish something could be done about it.

Yours,

Edgar Rice Burroughs

Neebe once more sought out Foster. Hal was not interested because he felt he would be prostituting his talent, but with no work coming in and a family to support, he begrudgingly accepted Neebe's offer. "I was a bit offended to be asked to sell my birthright for a mess of pottage. But I thought, 'Wouldn't it be nice if I had a little bit of pottage right now?'" On September 27, 1931, Foster took over the color *Tarzan* Sunday series with page twenty-nine. Rex Maxon, who Foster never met, continued on the dailies. Starvation and Tarzan brought Foster back into cartooning.

Under the agreement, the earnings were divided accordingly: United Feature Syndicate took 50%, Burroughs took 20% and Famous Books and Plays paid Foster $75.00 a week out of their 30%. Foster and the remaining four artists in his agency enjoyed the steady income and "ate ape" for the next year and a half. Ever gracious with his good fortune, Hal parceled out lettering, background penciling, inking assignments, and research to his fellow artists and then paid them from his earnings. The $75.00 was divided equally with each man taking home $15.00, which was sometimes the only money they'd earn that week. This kept the page on time and provided enough income for Foster to feed his friends and their families.

The Foster's weren't strangers to "lean times." "Each family managed," said Helen. "We ate more spaghetti and hamburgers in those days than I have ever eaten before or since! Fifteen cents paid for enough meatballs for the whole family—two children and two adults." Hal also had other means of providing food. "Every once in a while I'd decide to go fishing, so I'd hand [Helen] a grub list and when she'd packed it with my gear off I'd go. We ate quite a lot of fish in those days too."

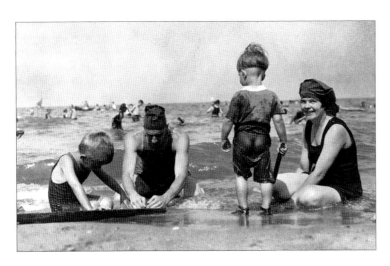

The 1930's ushered in many important comic strips and set new artistic standards for creators. Chic Young's *Blondie* appeared in 1930. Chester Gould's *Dick Tracy* began in 1931. Alex Raymond would create *Flash Gordon,*

The Foster's take time out to go to the beach at Wilmetta, Illinois.

Jungle Jim and (with Dashiell Hammett) *Secret Agent X-9* in 1934, while Al Capp's *Lil Abner*, Lee Falk & Phil Davis' *Mandrake the Magician*, and Milton Caniff's *Terry & The Pirates* also made their first appearances. "Mickey Mouse Magazine" and Zane Grey's *King of the Royal Mounted* were published in 1935 and in 1936, Lee Falk & Ray Moore's *The Phantom* began haunting the jungles.

"The coloring of the *Tarzan* Sunday page and the color separations were originally handled at the syndicate's headquarters by a staff of specialists who worked with half-tone screens of varying density. It was only after the page was printed that Foster saw the color version for the first time. He was horrified at the garish hues in the first few Sunday pages. It was Foster's feeling that color should intensify mood and atmosphere. To achieve that he began coloring a Photostat of each page and sending it along with the black and white page as a guide for the color separators. Muted grays and soft earth tones were added to the newspaper artist's palette for the first time. Another innovation by Foster was to plan his pages like a mural, with the line and color flowing throughout the panels in such a way as to create an overall design."[2]

Initially, Foster was content to simply scratch out the pages but then the letters started coming. Fan mail was a new experience for Hal. His art had been shown in galleries and he was published in magazines with minimal reaction from colleagues and editors; but now, he was reaching masses of people and they loved his work. The strip slowly became

a source of pride and he brought to it all of his talents. "I suddenly realized the comics page gave pleasure to millions and changed my attitude about just scratching out the artwork. Helen helped me control my inflated ego." The enthusiasm for the strip really didn't "hit home" for the Fosters until one avid fan broke his arm in a fall while playing ape-man in some high trees. It was their son, Arthur.

Foster was the first illustrator to bring a fine arts, sometimes impressionistic approach to comics, and he was the first to experiment with a style of painting called chiaroscuro.* He adapted a technique that was prevalent in the late Renaissance, Mannerist, and Baroque periods,

2 Turner.

* From Italian meaning "Clear-Dark" or "Light-Dark."

LEFT: *One of the paintings for the railroads.*

POWER OUT OF CONTROL ALWAYS MEANS *Waste*

Unfortunately

and used by such painters as Caravaggio, Rembrandt, and LaTour. Employing a single-source light with a strong, deep, concomitant shadow, Foster created dynamic illustrations, such as the one at the top of this page, simply through the development of intense black areas. He knew that these areas of extreme contrasts attracted the human eye, and he deliberately limited the amount of light in certain illustrations so that the highlights would become concentrated, thus producing the illusion of depth and resulting in subjects or objects that appeared solid. Without realizing it he paved the way for cartoonists like Noel Sickles, Milton Caniff, and Alex Raymond. In Foster's hands the *Tarzan* strip became as epic as any movie. His two-year "Egyptian" sequence is considered one of the chief watershed events in the medium and its quality and consistency has never been matched.

> Foster, with his illustrator's passion for historical detail, designed for these civilizations not just dress, weaponry, architecture and statuary, but even minutiae of ornaments, furniture, household utensils and agricultural tools. His Egyptians and his Vikings sit at different kinds of tables and eat off different kinds of plates. Kinds of ships, kinds of swords, kinds of shoes, even kinds of hairstyles change with each adventure. Always there is a concern that every artifact be consistent in style with every other artifact in the imaginary culture.[3]

Hal's philosophy towards illustration was simple: "No matter how pretty the picture is,

3 Thomas A. Pendleton, Journal of Popular Culture, XII:4, Spring 1979, p. 694.

SOON THE CORTEGE EMERGED ONTO A PLAIN, IN WHICH LAY THE MYSTERY CITY OF BALAKAN, CAPITAL OF THE GOLDEN REALM.

GORREY'S GREEDY HEART EXULTED WHEN HE BEHELD THE GLITTERING DOMES AND SPIRES OF GOLD.

if there is no story or meaning in it, there will be no interest." Eventually, the adventures of Tarzan could not hold the interest of its artist. Foster was constantly frustrated over what he considered to be poor scripts and the creative constraints imposed on him by laboring on someone else's property, yet he never let the artwork suffer.

Another frustration for Foster was the money. Even though the popularity of the strip was growing tremendously his bank account wasn't. He'd received a $25.00 per page increase in December of 1933, which was his only pay raise in almost two years. In February of 1934 Monte F. Bourjaily, General Manager of United Feature Syndicate sent a letter to Hal requesting a "special drawing in which Tarzan gives his kudos" to commemorate the fiftieth anniversary of the Huston Post. The request for a "freebie" met with a scathing reply by Foster.

> Dear Mr. Bourjaily:
>
> I have today received from you a copy of your letter to Mr. Burroughs re the Huston Post's 50th anniversary edition, and notice that you have hopes of my offering a contribution to their celebration. That hope will die unnourished by any great enthusiasm on my part—for with me Tarzan is a pet, and though I take a keen delight in his wanderings over the page, the wanderings of the page itself profits me but little.
>
> If I were working on a percentage basis it would be different; then any promotional work would eventually benefit me, and I could be persuaded to drop my regular work for it. I might also remind you that I did all the pioneer promotional work on that first Tarzan book some years ago, work which Palenske-Young went into the red $6,000.00, by no means a small contribution and one which, due to their generosity to me, has yielded them no profit. I am, therefore, unwilling to take time off from work profitable to them to do something that yields them nothing.

"I AM GRATEFUL FOR YOUR ATTEMPT TO SAVE ME," THE JUNGLE LORD SAID TO SYBIL.

"I DID NOT DO IT FOR YOU," SHE REPLIED, "BUT TO SOOTHE MY PRIDE. I WANTED TO PROVE MYSELF EQUAL TO THE EMERGENCY."

I take great pleasure in doing "Tarzan", and, to sing my own praise, have done a good job of it—a job that has, I think, shown my enthusiasm; but you must know by the tone of this letter, Mr. Bourjaily, that the financial arrangements are a big fly in a small amount of ointment.

If, or when, there is a reapportioning of Tarzan's income, consider how much Palenske-Young has gambled and how "worthy the workman is for his hire."*

I trust this will be soon, and remain,

Yours sincerely,

Harold R. Foster

It wasn't the response Bourjaily expected. United Feature immediately contacted Neebe but he was unwilling to take any more out of his 30% to pay Foster. In a letter dated March 23, 1934, to Edgar Rice Burroughs, Foster voiced his frustrations.

There seems to be some slight fear that I regard the *Tarzan* page as a glittering gold mine. If that were so, my yells would have been heard long since clear out to Tarzana. My position is, I think, stated plainly enough in the letter sent to United Feature Syndicate. You may be the father of Tarzan and Joe Neebe may have got him his present job, but it is I who keeps him working at it hard enough to please his boss, the public.

He has so far been successful in encounters with every sort of wild animal save only the wolf at my door.

Sincerely yours,

Harold R. Foster

* Although he did not participate in organized religion, Hal certainly knew this quote. It is from the Bible, The Gospel of Matthew, Chapter 10 Verse 10.

WHEN THE SHIPS HAD BEEN LASHED TOGETHER, TARZAN LED HIS VIKING FIGHTING MEN ABOARD THE ENEMY VESSEL

WITH THE APE-MAN IN THE VANGUARD GROWLING LIKE A BEAST, THE BATTLE WAS JOINED WITH SAVAGE FURY.

It was Don Garden, not Hal Foster who wrote the Viking sequence for Tarzan; *however, the success of the story-line may have encouraged Foster to pursue* Prince Valiant. *Another interesting feature of this strip is how closely the symbol on Tarzan's shield matches the crest of Val's mentor, Gawain.*

The letter concerned Burroughs and he quickly sent a response on March 27, 1934, to Bourjaily at United Feature Syndicate.

> Dear Monte:
>
> I am just in receipt of information that leads me to fear that you may loose Foster. To my mind this would be a calamity, and if another hundred a week would save him for you I believe it would be a good investment.
>
> As a matter of fact, the name Tarzan and Foster's splendid artwork are what make the Sunday *Tarzan* Page the outstanding feature of its kind, and both Foster and myself are receiving a darned small percentage of the profits.
>
> I am not inclined to take any less, and I doubt Joe Neebe will, and frankly I think it is up to United Feature to do something for Foster that will hold him. If you loose him your page will flop. I am convinced of this because of the innumerable comments that I hear on the artwork on the *Tarzan* Sunday Page.
>
> Yours,
>
> Edgar Rice Burroughs

United Feature relented and eventually gave Foster an extra $25.00, raising his rate to $125.00 a page, but the damage had already been done—he'd begun work on a character of his own.

"All in all Prince Valiant *is a tour-de-force. Day after day, week after week, Harold Foster has created living characters who reflect their epoch faithfully. He has drawn those characters and their world with great fidelity."*

—Stephen Becker, Author

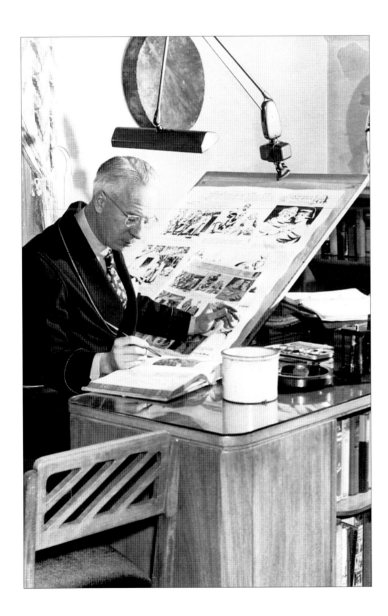

S • I • X

In the Days of

KING ARTHUR

oster saw how *Buck Rogers* and *Flash Gordon* were capturing the imaginations of their readers and went with a hunch that, "The public is always wrong." Instead of going into the future he would chart a path into the past. "I wanted to create the kind of hero I wanted to be myself, controlling his actions myself," Foster once said. "That's how the idea of *Prince Valiant* got started." Foster drew his first *Prince Valiant* page in 1934, but tore it up because he wasn't sufficiently grounded in the history of the period to make it look believable. "It took almost two years of research and groundwork for my hero to become properly dressed and armed, in order to claim his place in the world." Thrilled by tales of chivalry Foster turned to the rich literary English and French legends and myths for inspiration. During that year he haunted the Field Museum in Chicago and read dozens of novels and texts on the Middle Ages.

Hal decided early on that his hero would be a Knight of the Round Table and made tens of thousands of notes and sketches. By the time he was done he'd laid out the history of "The Prince of Thule" from his earliest days to his old age. Hal also dressed his knights in Norman armor—from a period several centuries after the time of Camelot and from when they were first written. "If I drew [King Arthur] as my research has shown, nobody'd believe it. I cannot draw King Arthur with a black beard, dressed in bearskins and a few odds and ends of armor that the Romans left when they went out of Britain, because that is not the image people have."

In 1936, the Fosters moved to 1407, Western Ave., Topeka, Kansas where it was quiet—they were moving into the Dust Bowl. Just one year before, the "Black Cloud" blanketed Kansas choking people and livestock and destroying crops. Temperatures across much of eastern Kansas in 1936 soared above 110 degrees and there were 59 days where the temperature was above 100 degrees. The Fosters arrived in Topeka during the worst year ever recorded—even up to the present day.

ABOVE: Helen with Helen Mar. The Fosters moved to Topeka to take care of Helen's grandmother.

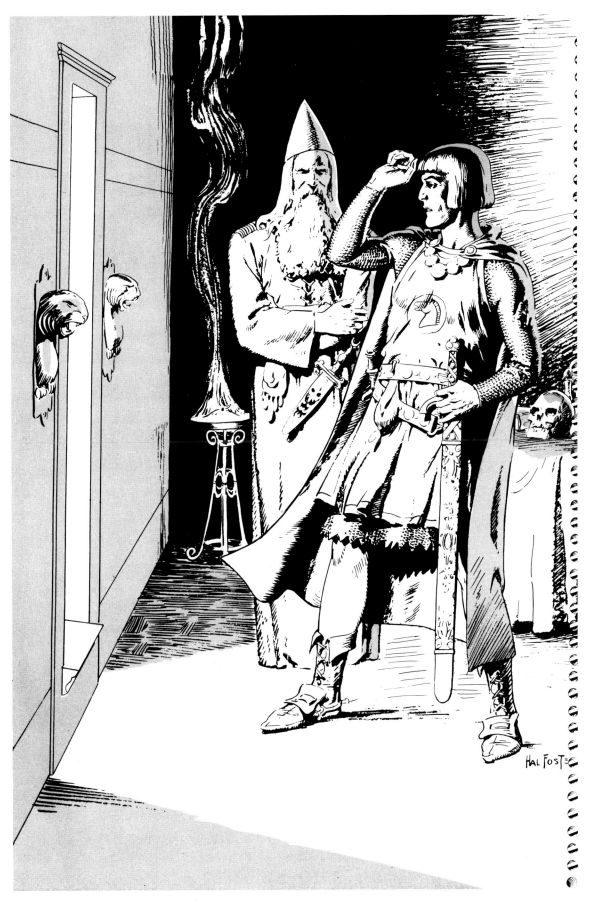

Prince Valiant and Merlin from the 1946 edition of Famous Artists and Writers of King Features Syndicate.
Provided courtesy of the Ohio State University's Cartoon Research Library.

"I came [to Topeka] in August 1936, when the dust storms and drought vied with the terrific heat to make things unendurable. All the heat records fell and I worked for two months [in an upstairs room] with the thermometer over 100 degrees; 115 was not uncommon. The sweat rolled down my torso and soaked all my clothes (consisting of only a pair of shorts) and the sheets of blotter I had to place under my arm.

"I came here for two very good reasons. My Helen had a grandmother, [Helen Mar Herman Webb Golden] whom she loved very much. The old lady was too advanced in years to live anywhere else and too independent to live with anyone else. We came here to be with her for the remaining years and last August [1938] was her last month. The other reason was that I had to get rid of the big palooka 'Tarzan' and get *Prince Valiant* started. I couldn't get any work done in Chicago, there were too many pleasant sociable friends, too many places to play—and I love to play.

"But I got *Tarzan* finished four and a half months in advance, wrote Prince Val and finished twelve pages together with colored Photostats."[1]

Foster's dedication was intense, kinetic and so thoroughly zealous that at one point he was illustrating three pages a week. Once he completed his proposal he approached United Feature Syndicate with his idea. In what is considered by most to be the greatest business failure in the history of comic strips, Bourjaily turned him down. Foster's offer to United Feature was simply a courtesy. William Randolph Hearst wanted Foster and "what Hearst wanted Hearst got." The newspaper tycoon was so impressed with Foster's work on *Tarzan* that he promised Hal complete ownership of any comic strip he developed—a very rare offer in those days. Hearst had unknowingly let Foster go in 1928, when he turned down Joseph Neebe's original *Tarzan* proposal, and he wasn't about to make the same mistake again.

During the previous eighteen months Hal had been corresponding with Joseph V. Connolly, the president of Hearst's King Features Syndicate. When Foster was ready King Features sent comics editor Bradley Kelly to Topeka

William Randolph Hearst.
Photo by the Hearst Corporation.

1 Letter to Milton Caniff, September 19, 1938.

78 ·

to look at the proposed new strip. "On my arrival in Topeka," reported Kelly, "Hal put before me six full months of the drawings and story of *Prince Valiant*." Kelly was a likeable person and liked everybody in return. As the two settled down to discuss the pages Hal "brought over a bottle of Scotch. I don't know whether it was my work or the bottle of Scotch that sold him," said Foster, "but we finished the bottle and I put him in his rented car and sent him back to Kansa City, where he could get a plane." A very enthusiastic Kelly returned to New York.

Hal's next visitor was Joe Connolly. As president of the syndicate his endorsement was necessary before Hearst could see the pages for his approval. "Connolly came out and saw the pages and the color Photostats. He seemed to be pleased but he couldn't show any pleasure at all because he was a big shot. He had no emotion, so he took my finished originals and the written story, and these beautifully colored Photostats. And what did he do? He lost the colored Photostats! So he wrote me a letter, saying that he had an idea: 'Why didn't I have these pages Photostatted and color them?' I never liked Connolly after that. Pompous big shot."

On November 5th Hal received a telegram from Brad Kelly which read: "Good news for you / will mail exclusive service contract / fifty fifty of gross collections with one hundred fifty dollars weekly guaranty." After receiving the telegram Hal "retired to a quiet creek bank with rod in hand and a squirrel rifle across his knees" to relax and compose a letter to United Feature Syndicate. Now Burroughs had to be told.

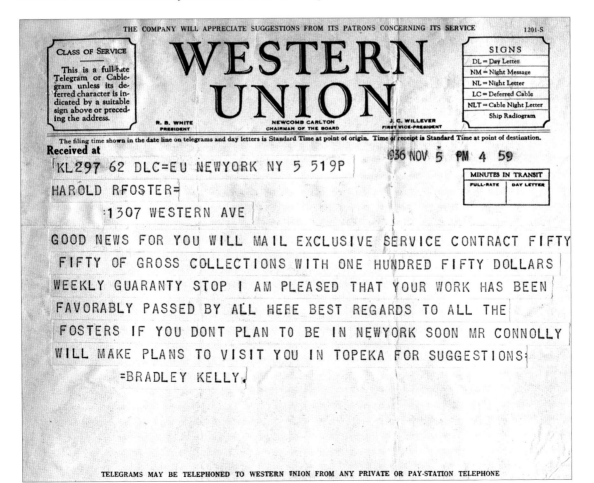

November 24, 1936

Dear Mr. Burroughs:

In connection with our *Tarzan* artist, I have been considerably alarmed by a report from Harold Foster that he is planning to give up *Tarzan* sometime during the winter and to produce a new feature of his own. He wrote me that, while he has enjoyed every minute of the time he put on *Tarzan*, he preferred to be the owner and producer of his own feature. While Foster is technically employed by Famous Books and Plays, I have written to Foster to see if he was interested in a new financial arrangement on *Tarzan*. I have telephoned Joe Neebe who says that Famous Books and Plays cannot afford any further contribution to Foster's pay. Neebe is to be here today and we are to consider the possible successor to Foster, in case he cannot be persuaded to continue on the page.

I think Foster has done a whale of a job and I believe that if it is all possible to keep him, we want to keep him on.

Sincerely,

George Carlin

Foster quit *Tarzan* in mid-December 1936 and turned his attention to his own strip. Originally Hal intended his strip to be called *Derek, Son of Thane*, but Connolly immediately turned that down. His second choice, *Prince Arn*, met more favor, but it was Connolly, not Foster, who would finally christen the now-famous character. The first episode of *Prince Valiant in the Days of King Arthur* appeared in 8 American newspapers on February 13, 1937, Hal was 44 years old. It would be another year before one of the most important events in comic book history, Jerry Siegel and Joe Shuster's *Superman*, would make his first appearance in Action Comics #1. Bob Kane's *Batman*, written by Bill Finger, wouldn't see print in Detective Comics #27 until 1939, and Will Eisner's *The Spirit* wouldn't be published until 1940.

At first Foster thought the name "Prince Valiant", was too blatant, too obvious, but he slowly grew into it. Incredibly, he had gotten so far ahead on *Tarzan* that for twelve weeks two full pages of his incredible craftsmanship competed for the readers' attention. Foster deliberately made his last pages some of the best of his run so United Feature would have trouble replacing him; however, he'd also given them a three-month buffer in which to find someone. Edgar Rice Burroughs' secretary, C.R. Rothmund, relayed to United Feature his only directive and that was "whoever draws the strip that he have a copy of Foster's first strip, *Tarzan of the Apes*, before him at all times." The syndicate turned to Burne Hogarth (born December 25, 1911, in Chicago) to carry

the feature and his first *Tarzan* Sunday page appeared on May 9, 1937.

Hogarth's characters looked like stiff Foster swipes initially. As a storyteller Foster's critique of his successors' work was brusque: "I saw a few faults. His figures didn't seem to balance; they were all stretched out in violent motion. I didn't like that. I like to draw a squatty, relaxed figure before and after a violent action. <u>All</u> violent action looks like a salad with nothing on it but vinegar—you have to have different ingredients." But once Hogarth settled into the feature the pages seemed to generate their own energy.

While the Tarzan novels were "nothing [he] could get [his] teeth into" Foster was a voracious reader and now he had a 300-year span of history to glean stories from. For inspiration he borrowed from the best. James Branch Cabell, Haldane McFall, and Edward Plunkett (Lord) Dunsany were three of his favorite authors.

Foster takes a short break in Topeka.

"I unblushingly steal my story only changing their beautiful phrases with a glossing of my poor diction and hope, if detected, that they will regard my pilfering as light-heartedly. I read any historical novel I can get hold of—those by Cecilia Holland are especially good. I like historical novels over just history of dates and places because it may not always be correct but it'll give you a better understanding. All I read [goes] into *Prince Valiant;* all the things that one picks up while reading are part of it. So I think most of my misfortunes have turned out to be profit. The more I learn about King Arthur's days the less I think of our modern civilization. True, life was often cruel in those days—but it was an honest brutality. At least they didn't justify it with a lot of virtuous platitudes as we often do.

"As for getting data for my Val page it is difficult but not impossible here [in Topeka]. Within fifty miles there are two colleges and a university where one can get something extra in the way of information if one takes along a bucket of patience and a quart of Scotch.

"In Chicago I had the Field Museum to go to but I invariably got so interested in other things that it was a days work to get one fact. But oh, what a raft of interesting and unrelated information I'd stored up. That's the beauty of being thrown out on the cold world at 13 and denied an education…getting one becomes an interesting game that gets better as

AND THESE TWO WHO WANTED A ROYAL WEDDING PER-FORMED BY THE POPE, NO LESS, ARE QUITE CONTENT. THE WIND IN THE TREE-TOPS THEIR ORGAN MUSIC, BIRD-SONG THEIR CHORUS; AS AN EX-CARDINAL JOINS FOR-EVER THE EX-EMPEROR OF SARAMAND AND THE EX-QUEEN OF THE MISTY ISLES. AN EX-EMPRESS OF ROME IS WITNESS.

HAL FOSTER

NOW HERE, ACCORDING TO APPROVED WRITERS OF ROMANCE, THE SAGA OF PRINCE VALIANT SHOULD END. BUT THE WINNING OF ALETA IS ONE THING, COSTING VAL NO MORE THAN HIS HEART, BUT LIVING WITH HER IS ANOTHER STORY...... AND WE THINK THE STORY WORTH TELLING.

NEXT WEEK — A Small Mutiny.

time goes on even if one collects a junk-pile of odds and ends they all come together at times and make something."[2]

The mythology Foster created was captivating. King Aguar of Thule (now Norway) was driven from his throne by the usurper Sligon. The deposed monarch fled with his queen and young son, Prince Valiant to the wild fens of Britain.* Val looses his mother at a young age then decides to venture off to become a knight. Along the way he acquires "Flamberge—The Singing Sword," a blade forged by the same mage who created Arthur's legendary Excalibur. He is knighted by King Arthur on the field of battle, helps his father reclaim the throne of Thule, and later wins the heart of Aleta, Queen of the Misty Isles whom he marries. The tales were so epic, so grand that the former King of England Edward, The Duke of Windsor called *Prince Valiant* the "greatest contribution to English literature in the past hundred years."

Soon the characters became so real to Hal that the magical fantasy elements of the earlier strips vanished and were replaced entirely by human dramas. "Prince Valiant became more and more of a character, someone that I knew personally; I knew just what he could do. [He] stands at my shoulder when I'm writing and if I get him out of character, though I can't see him, I know he's shaking his head. It's awfully hard to handle a hero like Prince Valiant, because in order to be a hero you've got to be a big prig, you know—he's got to be good and honest, and all these qualities that are not endearing. I wanted to create a

TOO LONG HAVE YOU MADE ME A HERO, FOSTER, NOW WRITE SOME PLEASANT SIN INTO MY SAGA

One of Foster's rarely seen cartoons for the National Cartoonist Society.

* Foster placed Val's place of birth at Trondheim Fjord. Years later, on a trip to Norway, Hal visited the site but instead of finding a castle he only found a sawmill.

2 Letter to Milton Caniff.

believable hero, one that would be essentially good but not a sissy. I've let Prince Valiant get knocked down. He's often made human mistakes and gotten himself into trouble; he's the kind of hero people can identify with." People did identify with Valiant, and Foster continued to break new ground. He showed one of the first marriages in comics. "When [Val] got married at nineteen King editors told me it was a mistake because the hero should never marry, else he'd lose all romance. Now that he's got a ball and chain I get more mail than I did when I started this thing." He also showed the first birth in adventure comics because, for him, it was the next logical step. "In my strip when people fall in love they get married and have children." By this time (1947) Foster had made his characters so believable the event was covered in the birth columns of the newspapers. *Prince Valiant* was quickly reaching celebrity status—and so was his creator.

Jerry and Brad Kelly greet Hal and Helen for the Prince Arn Natal Day party.
Hal wore the baby bonnet through much of the party.

Vital statistics broke into the comics in almost unprecedented fashion this week. Sunday Prince Valiant and his beautiful Aleta will become parents—and right at present this column and King Features cannot recall another instance of leading characters giving birth in a straight adventure "comic." [Foster] introduced the child to provide a new person through whose eyes the story events could be seen.

One of the many Prince Arn birth announcements which appeared in newspapers around the country.

Invitation to Prince Arn Natal Day party.

On August 31, 1947, Prince Arn was born. To celebrate, Val went out and, in true Viking fashion, got drunk. The incident caused a deluge of mail from mothers complaining that their children's hero had disgraced himself.

HELEN AND HAL FOSTER

Hal loved his adopted country and put his skills to use by producing political cartoons. Here are three published pieces that were kept in the family scrapbooks. "Helen and I used to laugh that we always knew where Hitler was in Europe. The minute the German troops arrived, the newspaper dropped Prince Valiant."

The cartoon above left is from Hal Foster's 1944 Christmas card. Due to the extreme polarity of the population of the United States during World War II cartoons of this kind were common. It is reproduced here, unedited, solely as a historic document.

Hal and Buck Rogers creator, Dick Calkin at a World War II Bond Drive in Chicago.

HIGH COMPLIMENTS ON THE TUNISIAN FRONT

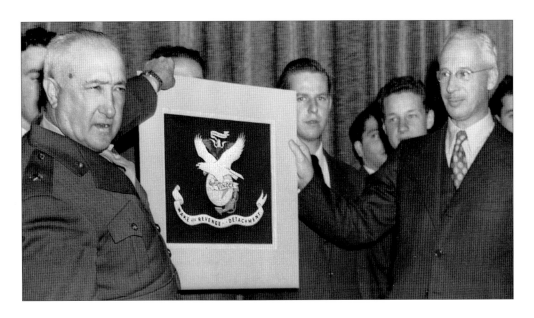

FAR ABOVE: *This use of pointers is the first time Foster ever came close to using word balloons.*

ABOVE: *On Armistice Day, November 11, 1942, Hal Foster presented Brig. General Robert L. Denig, U.S.M.C. with a flag that he designed. The slogan "Wake Revenge Detatchment" refers to the Marines' recapture of Wake Island.*

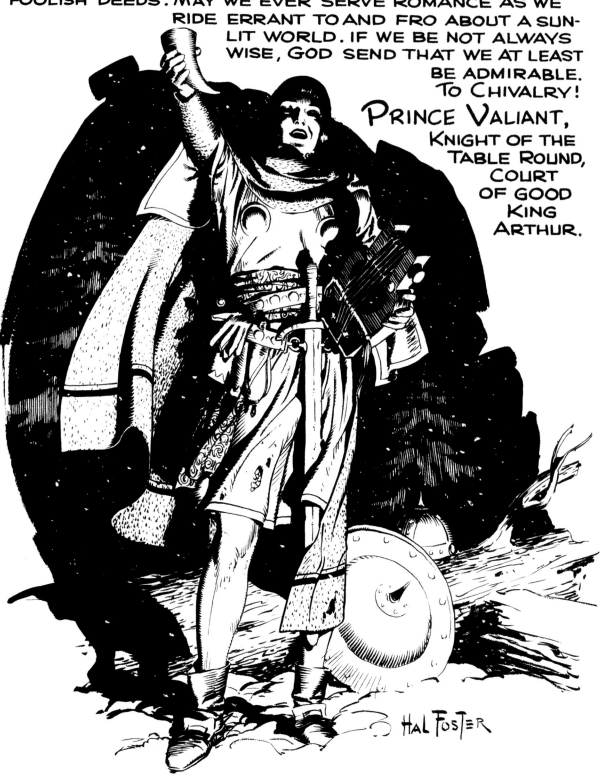

GENTLEMEN:

A TOAST! TO CHIVALRY! MAY COMMON SENSE NE'ER QUELL OUR LOVE FOR HIGH-HEARTED ADVENTURINGS, NOR DULL EXPEDIENCY PREVENT OUR DOING BRAVE, SPLENDID, FOOLISH DEEDS. MAY WE EVER SERVE ROMANCE AS WE RIDE ERRANT TO AND FRO ABOUT A SUN-LIT WORLD. IF WE BE NOT ALWAYS WISE, GOD SEND THAT WE AT LEAST BE ADMIRABLE. TO CHIVALRY!

PRINCE VALIANT, KNIGHT OF THE TABLE ROUND, COURT OF GOOD KING ARTHUR.

HAL FOSTER

"Style is the most valuable asset of the modern artist. That's why so many styles are reported lost or stolen each year."

—Brad Holland, Illustrator

S • E • V • E • N

Father of the

ADVENTURE STRIP

"'J. C. Leyendecker was my deity,' Foster once said, and his early works for Palenske-Young, like the piece on the left shows just how influenced he was when it's compared with the Leyendecker on the right. Foster's ten years of catalogue work gave his characters a sense of ease, of casualness, and of believability.

"When I was working for Jerry Siegel he told me that Hal Foster's Tarzan *had a great influence on Joe Shuster's visualization of* Superman. *Foster had a huge impact on the industry. It wasn't that people were swiping him; really, I think they were honestly trying to raise the quality of the industry by copying Foster's work. Years later when I was talking to Shelly [Moldoff] he recounted how, when he met Foster, he told him that he swiped whole panels from* Prince Valiant. *I think he was the only one who ever did."*

—Murphy Anderson

Even the great Jack Kirby borrowed from Hal Foster. In 1937, Prince Valiant dons a demonic mask made out of the skin of a duck and even uses quills for fangs. In 1972, Kirby's "Demon" comic book for DC Comics made its debut. Kirby openly admitted to the homage and acknowledged Hal Foster's inspiration.

SOON NOW, AND I SHALL KNOW.

Hal Foster's 1929 Tarzan *and Bob Kane's Batman. The panel is from* Detective Comics #31, *September 1939.*

There is no denying the impact Foster's work had on newspaper strips. Some homages were subtle while others, like *Kevin the Bold* by Kreigh Collins were extremely blatant; however, Hal's artistic influence was felt beyond the strips. While the Golden Age of Comics would have existed without Hal Foster, many artists recognized his extraordinary ability to interpret the world into simple line. Jerry Seigel, Bob Kane, Sheldon Moldoff and many others found inspiration – and panel swipes – from the Sunday pages of *Tarzan* and *Prince Valiant*. Even the great Disney artist, Carl Barks once said that he kept Foster's water scenes as reference because "he was the only one who could get it right." Whole panels were light-boxed or traced into new stories; poses, compositions, expressions, backgrounds – everything was pilfered. Swiping was a common practice within the immerging comic book industry's sweatshops in order for artists to meet the grueling production deadlines. Young artists, many of them unschooled, used swipes as on the job training and borrowed prodigiously. When the next generation of adventure illustrators began making their presence felt in the 1950's and 1960's, Frank Frazetta was at the forefront, leading the way with his Foster-influenced art.

In the late 1960's, Walt Disney Productions approached Hal Foster asking to borrow copies of all of his *Tarzan* Sunday pages. Disney Studios was producing the animated film *The Jungle Book* and they needed jungle reference for their background painters. Unfortunately, neither Foster nor United Feature had kept any of the *Tarzan* artwork so a representative of Disney went to Vern Coriell. Coriell was the editor of both *The Burroughs Bulletin* and *The Gridley Wave* and at the time was trying to put together a Tarzan portfolio. Luckily for Disney, Coriell had just borrowed a complete collection of all of the Foster color *Tarzan* Sunday pages from fellow Burroughs collector, Robert R. Barrett. Coriell loaned the pages to Disney and got them back before he told his friend about the transaction. "I sort of 'hit the ceiling!'" Barrett recalled, "On the one hand egotistically glad that it was my pages they were using, but mad as hell that [Vern] hadn't asked me if he could send the pages to Disney. Of course they handled the pages very carefully and they were returned with no damage. [Vern and I] were close friends and the episode didn't rankle me for long."

FRANK FRAZETTA

Many would argue that Frank Frazetta has proven to be the greatest fantasy artist of all time. The impact of Hal Foster's influence on Frank Frazetta's work shouldn't go unnoticed; just look at the design of Frazetta's signature. Frank utilized panels from Hal's 1929 Tarzan strip (below left) and from Prince Valiant (below right). The Frazetta painting below was done as the cover for Tarzan and the Lost Empire, while the panel bottom right is from Frazetta's classic Thun'da comic book.

RIGHT: Hal and Frank at one of the National Cartoonists Society picnics held at Fred Waring's home.

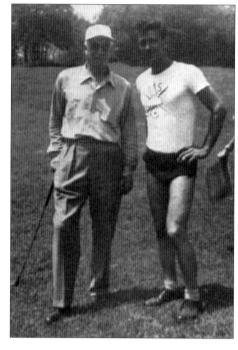

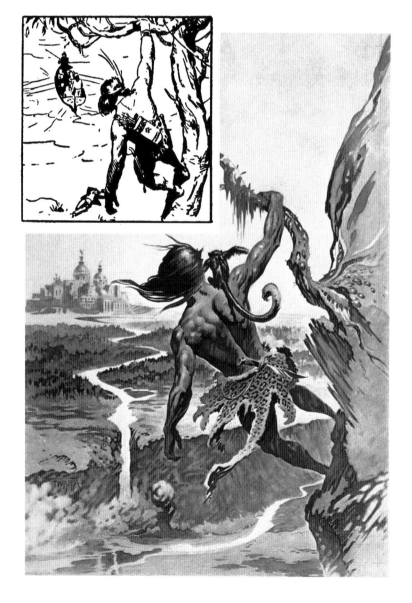

THE MONSTER GLIDING OVER THE OOZE

AND BY THAT TIME, I'LL LOSE MYSELF DEEP IN THESE MISTY JUNGLES!

Gil Kane on Hal Foster
Introduction to the 1969 Comic Art Convention interview

What Hal Foster brought into comics was more than superior skills as a draftsman, as a designer. What he brought into comics was an intelligence and a spirit that created the tradition of the romantic hero as we know it; he is absolutely the father of the whole romantic adventure hero saga that adventure comics is all about.

And one of the great things about his work is that in the area of romance he brought restraint, which is almost impossible—it's always a self-indulgent subject. You'll always find in romance, work which is so elaborate and so full of supped-up accentuated quality that you never find elements of restraint, of harmony, of a considered line, a considered design, or of naturalism. Naturalism is one thing you hardly ever find with romance, and yet Mr. Foster's work has the quality of naturalism within the framework of romanticism that gives it enormous range and appeal. He can tell a story and make it raw and savage, and make it lyrical, and make it very, very human where any kind of violence or death or tragedy that occurs in the script has meaning simply because the characters exist as people and not just athletic postures jumping all over the page.

And even in terms of athletic postures, it was Hal Foster who created the basic standards just for the way heroes stand in comics. The whole concept of nobility and aristocracy that is part and parcel of *Prince Valiant* (but of course was seen all the way through *Tarzan*) is what Mr. Foster brought into the field. While a lot of artists have a kind of magnificence in their work, just through vitality, hardly any have reserve, understatement and nobility because there is a quality of mind and spirit, a sense of control, discipline and restraint required.

Mr. Foster is just the most superb craftsman tied to a romantic spirit. In my mind it is unlikely that the "Egyptian" sequence in *Tarzan* will ever be duplicated. It's probably the finest sustained sequence ever done. Whatever comics have in terms of a visual medium, whatever potential they have to be considered as a basis for art, it has come out of an examination of Mr. Foster's work.

TO ANY SIMPLE TRICK AND WILL HOWL TO ME FOR MERCY —

WITH THE AID OF HIS WINGS, THE HAWKMAN SPINS IN THE AIR, AND WITH A MIGHTY HEAVE, TOSSES THE STATUE-MAN OVER HIM!

A panel from Prince Valiant *page #73, July 3, 1938, compared to a Sheldon "Shelly" Moldoff,* Hawkman *panel from* Flash Comics *#7, 1940. Note the pant-line on Hawkman's left thigh, which was accidentally transferred over from the* Prince Valiant *panel and left in when the book went to print.*

BELOW: *The top panel is from* Tarzan *page #158, March 18, 1934, illustrated by Hal Foster. The bottom panel is from* Flash Gordon, *June 10, 1934, illustrated by Alex Raymond. When examining the two it's amazing to see the amount of depth in the Foster panel when compared with Raymond's. Even though the panels are almost the same dimensions and layout, Foster's command of perspective and proportions gives his work a greater sense of scale and grandeur.*

Knowing his artistic influences and choice of subject matter the following books were probably on Foster's reading list.

Howard Pyle's four Arthurian novels:

<u>The Story of King Arthur and his Knights</u> (1903)

<u>The Story of the Champions of the Round Table</u> (1905)

<u>The Story of Launcelot and his Companions</u> (1907)

<u>The Story of the Grail and the Passing of Arthur</u> (1910)

One other book that Howard Pyle wrote and illustrated, and from which the picture above is taken, is Otto of the Silver Hand, *which was first published in 1888. It is a tale of the Middle Ages which resonates in the pages of* Prince Valiant *both in story and art. The panel at the right is from* Prince Valiant, *page #73, July 3, 1938.*

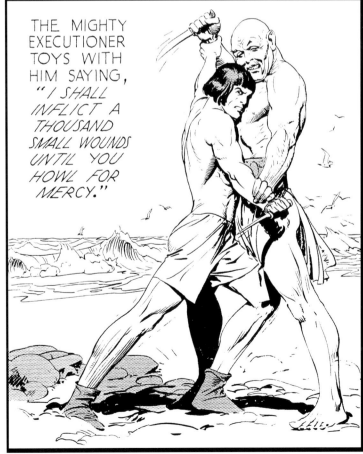

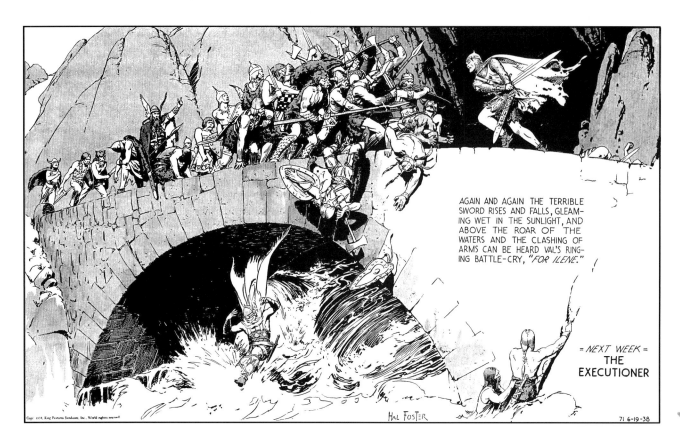

AGAIN AND AGAIN THE TERRIBLE
SWORD RISES AND FALLS, GLEAM-
ING WET IN THE SUNLIGHT, AND
ABOVE THE ROAR OF THE
WATERS AND THE CLASHING OF
ARMS CAN BE HEARD VAL'S RING-
ING BATTLE-CRY, *"FOR ILENE."*

= *NEXT WEEK* =
THE
EXECUTIONER

HAL FOSTER

71 6-19-38

Probably the most recognized scene from Prince Valiant is the epic Bridge at Dundorn Glen. It is a masterpiece of composition and design, and a superb example of what an adventure strip should be.

However, the story has its roots in Pyle's novel, Otto of the Silver Hand. *The image at the left and the passage below are both from that novel.*

Down the steep path from the hill above swept the pursuing horsemen. Down the steep path to the bridgehead, and there drew rein; for in the middle of the narrow way sat the motionless, steel-clad figure upon the great war-horse, with wide, red, panting nostrils, and body streaked with sweat and flecked with patches of foam.

One side of the roadway of the bridge was guarded by a low stone wall; the other side was naked and open and bare to the deep, slow-moving water beneath. It was a dangerous place to attack a desperate man clad in armor and proof.

It is only fitting that "The Father of the Adventure Strip" be the stepson to "The Father of American Illustration."

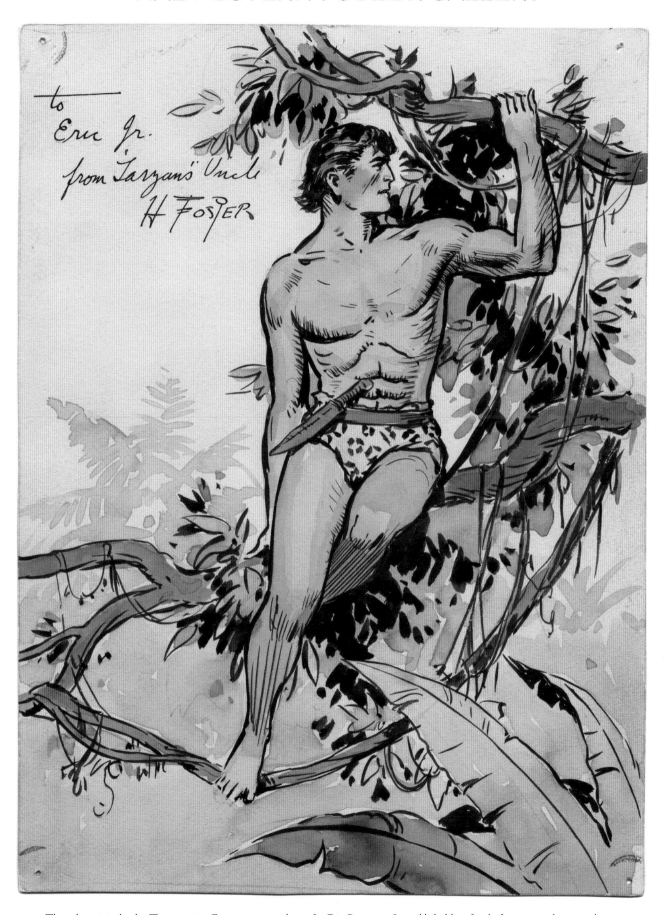

to
Eric Jr.
from Tarzan's Uncle
H Foster

The only original color Tarzan piece Foster ever created was for Eric Bergman, Jr., published here for the first time and at actual size.

LEFT: *From King Features' promotional booklet, Kingpin Release No. 9.*

UPPER RIGHT: *A personal work in watercolor entitled Manitou River.*

LOWER RIGHT: Quiet *was one of Hal's First Place winning oil landscapes from the 1936 Kansas Free Fair.*

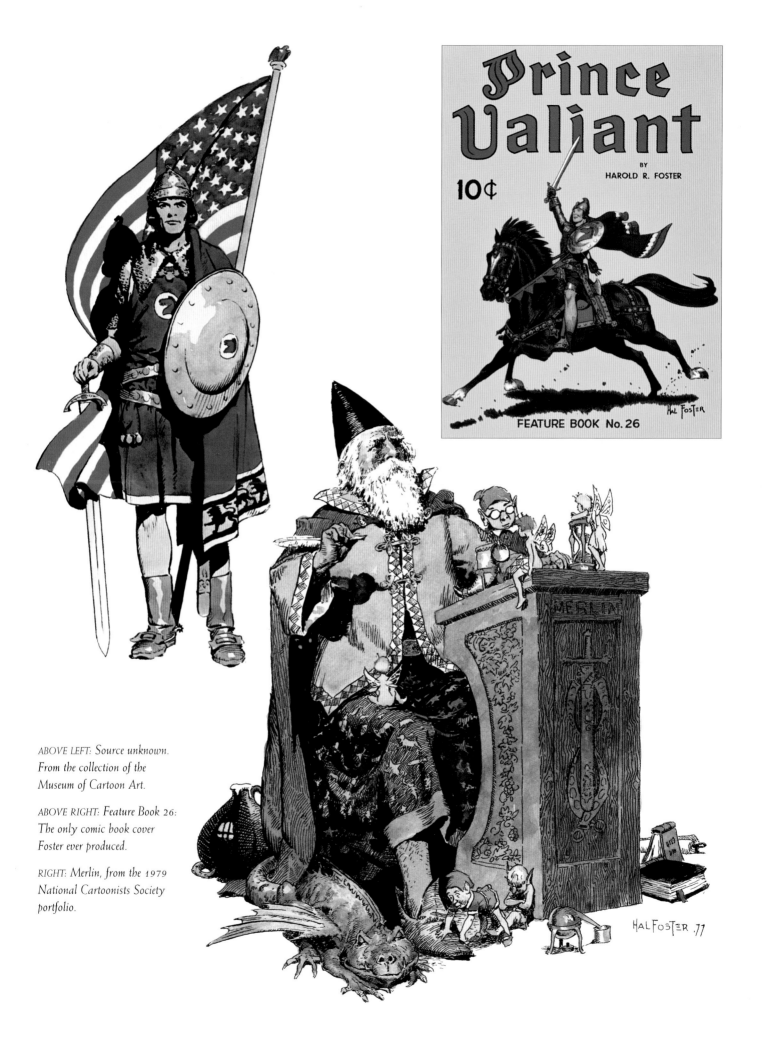

Prince Valiant
BY
HAROLD R. FOSTER

10¢

FEATURE BOOK No. 26

ABOVE LEFT: Source unknown. From the collection of the Museum of Cartoon Art.

ABOVE RIGHT: Feature Book 26: The only comic book cover Foster ever produced.

RIGHT: Merlin, from the 1979 National Cartoonists Society portfolio.

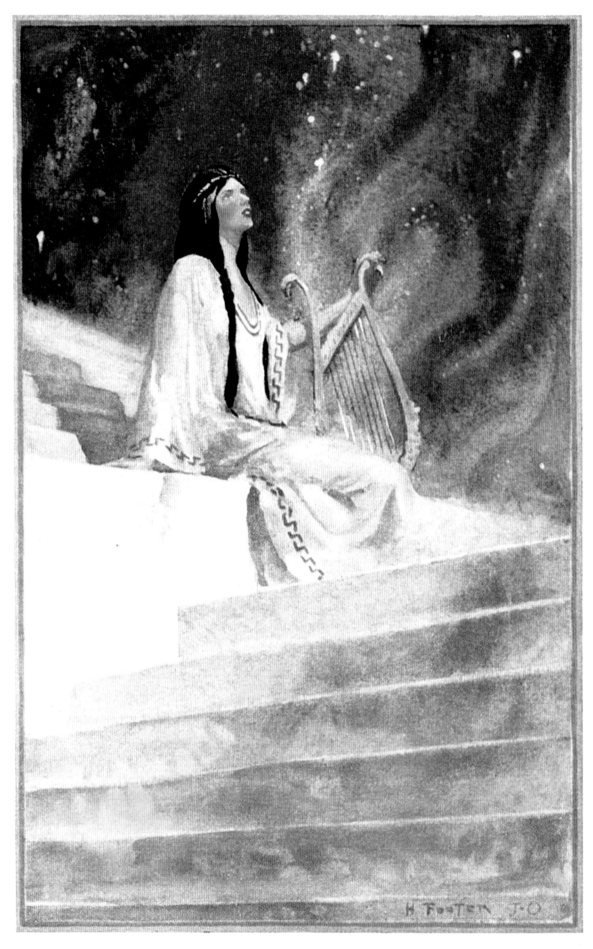

Foster painted the cover to the Ravinia Festival's 1930 production of the opera Aida. The piece, a marked departure from Foster's other paintings, might have been inspired by the works of Edmund Dulac (1882-1953). The 'J+O' after Foster's name indicates that he did this for his former employer, Jahn & Ollier

See Zion National Park
Bryce Canyon—Cedar Breaks
Kaibab Forest—Grand Canyon

The most enchanting vacation region
on earth! Canyons of tremendous depth
... mountains of majestic height ...
mammoth amphitheatres of fanciful
architecture and sculpture—castles,
cathedrals, pagodas, giants, gnomes,
all gleaming with ever-changing colors!
Painted deserts, vast virgin forests,
cliff dwellings, wild life!

Easy to reach. Low summer fares. Through
Pullmans to Cedar City, Utah, thence 3, 4 or 5-
day all-expense motor-bus tours; also escorted
tours. Comfortable lodges. A wonderful vaca-
tion itself or a side trip en route to Yellowstone
or the Pacific Coast. Season June 1 to October 1.

The Zion Red Book tells all. Ask for it.

Address nearest representative or General Passen-
ger Agent, Dept. 102, at Omaha, Neb. : Salt Lake
City, Utah : Portland, Ore. : Los Angeles, Calif.

UNION PACIFIC

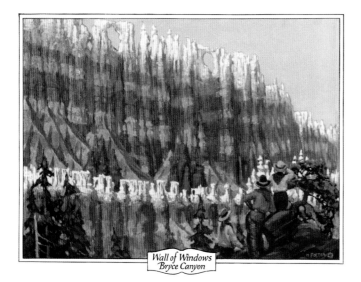

GRAND CANYON

"Most Sublime of All Earthly Scenes"

Grand Canyon National Park

So world travelers say of this colossal
chasm, more than a mile deep, more than
two hundred miles long, and twelve miles
wide, filled with magnificent rock temples
aflame with changing colors. See it this
summer from the loftier North Rim, reached
through the enchanting Kaibab National
Forest with its thousands of deer, by a 5-
day, all-expense Union Pacific motor bus
tour that also includes

*Zion National Park
Bryce Canyon Cedar Breaks
Kaibab Forest Prismatic Plains*

Easy to reach. Low summer fares. Through Pullmans
to Cedar City, Utah, the gateway. Escorted tours.
Comfortable lodges. A wonderful vacation itself or
a memorable side trip en route to Yellowstone or the
Pacific Coast. Season June 1 to October 1.

The Zion-Grand Canyon Red Book tells all. Ask for it.

Address nearest representative or General Passenger
Agent, Dept. 124, at Omaha, Neb. : Salt Lake City,
Utah : Portland, Ore. : Los Angeles, Calif.

UNION PACIFIC
THE OVERLAND ROUTE

*Wall of Windows
Bryce Canyon*

Union Pacific Railroad advertisements featuring Hal Foster illustrations.

Aladdin

Jack the Giant Killer

Foster painted Aladdin and Jack the Giant Killer for his sons Edward and Arthur.

OPPOSITE PAGE:

UPPER LEFT: A personal work entitled God of Destiny

UPPER RIGHT: Foster did several glamour portraits including this one of Dolores Costello who would later marry the great actor, John Barrymore.

LOWER RIGHT: A specially commissioned watercolor portrait done by Foster in 1928.

LOWER LEFT: At his good friend, Robert Ripley's request, Foster painted this spectral image of an Indian on a drum head. Ripley had the drum because the head was purported to be one of only two in existence made of human skin.

*These two pages feature a number of Popular Mechanics
magazine covers painted by Foster in the mid 1930's*

DIVING AMONG SEA KILLERS

★ POPULAR MECHANICS MAGAZINE
WRITTEN SO YOU CAN UNDERSTAND IT

SEE PAGE 506

KING OF THE MONEY DRIVERS

APRIL
25 CENTS

The ALLOY of a THOUSAND USES

POPULAR MECHANICS MAGAZINE

JULY
25 CENTS

SEE PAGE 92

NEW POWER FROM THE SUN

POPULAR MECHANICS MAGAZINE
WRITTEN SO YOU CAN UNDERSTAND IT

OCT.
25 CENTS

SEE PAGE 558

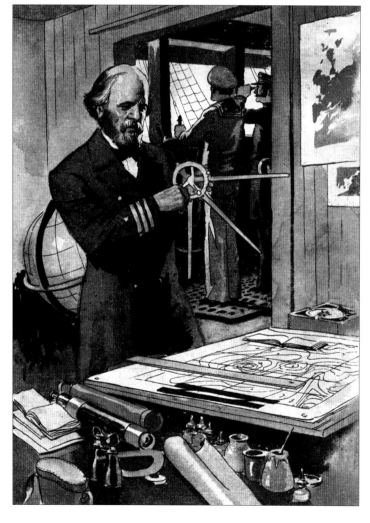

Jahn & Ollier produced a portfolio called 'The Lucky Bag of 1930'. Here are some of the illustrations Foster painted for the booklet.

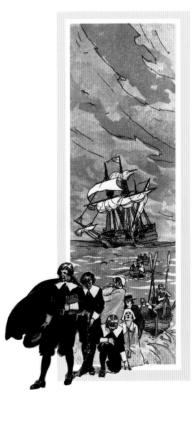

THE MERRIEST OF CHRISTMASES TO YOU

Many of the Foster's own Christmas cards.

BELOW: In 1946 King Features produced a special giveaway item, Charles Dickens' A Christmas Carol, *for which Foster did this wrap-around cover.*

SAY! YOU FOLKS GET CARDS FROM ALL
OVER DON'T YOU? HERE'S ONE FROM
THE CONNECTICUT HILLS WISHING YOU
GOOD HEALTH AND HAPPINESS FOR *1948*

Helen & HAL FOSTER

TRUST THE BRIGHT STAR THAT NEVER FAILS

PIP POP MERRY CHRISTMAS

BANG

VROOM!

Christmas 1955

THANKS FOR THE PLEASANT
MEMORIES YOU HAVE LEFT
WITH US... Helen AND Hal Foster

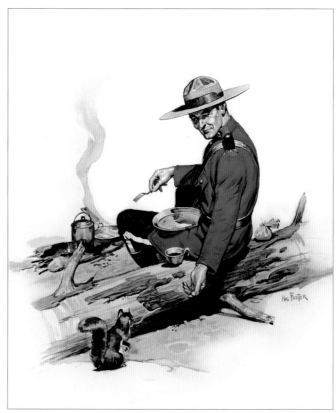

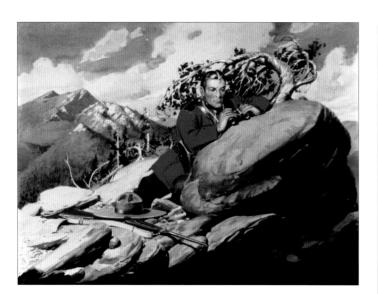

Foster's Mountie paintings appeared in Northwest Paper's calendars in the 1930's and it was probably some of these images that inspired the famous Western and Religious artist, Arnold Friberg, to accept his first assignment with Northwest Paper. Friberg would go on to produce more than 300 Mountie paintings.

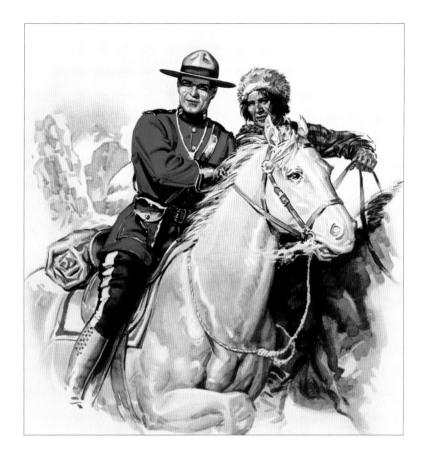

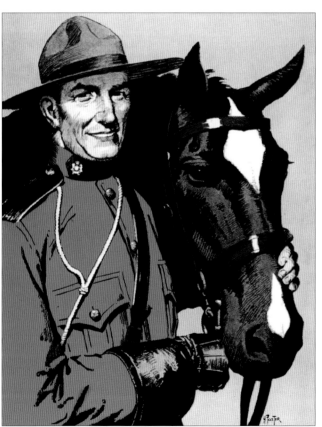

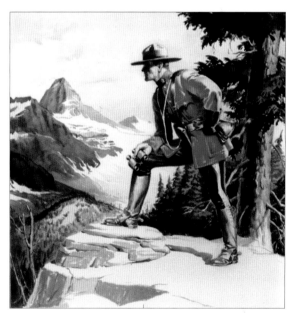

The 2 far left, and above, lower right were provided by the collection of the Tweed Museum of Art, University of Minnesota, Duluth, gift of the Potlatch Corporation.

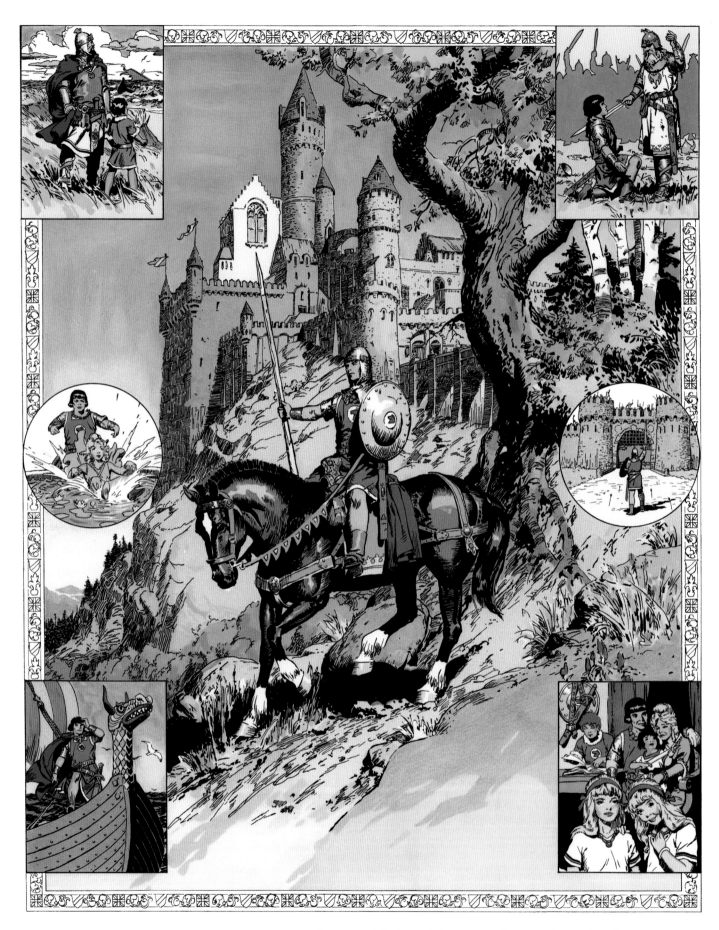

Foster created this Prince Valiant montage for a print that was limited to only 100 copies.
Provided courtesy of the Ohio State University's Cartoon Research Library.

"So accurate has Hal been on historical detail he is often praised by historians, and teachers use the drawings in their classrooms. Prince Valiant entertains as it teaches, and I think that is the highest compliment one can pay to any artist."

—Bradley Kelly
Comics Editor,
King Features Syndicate

E • I • G • H • T

The

BARD *of* AVALON

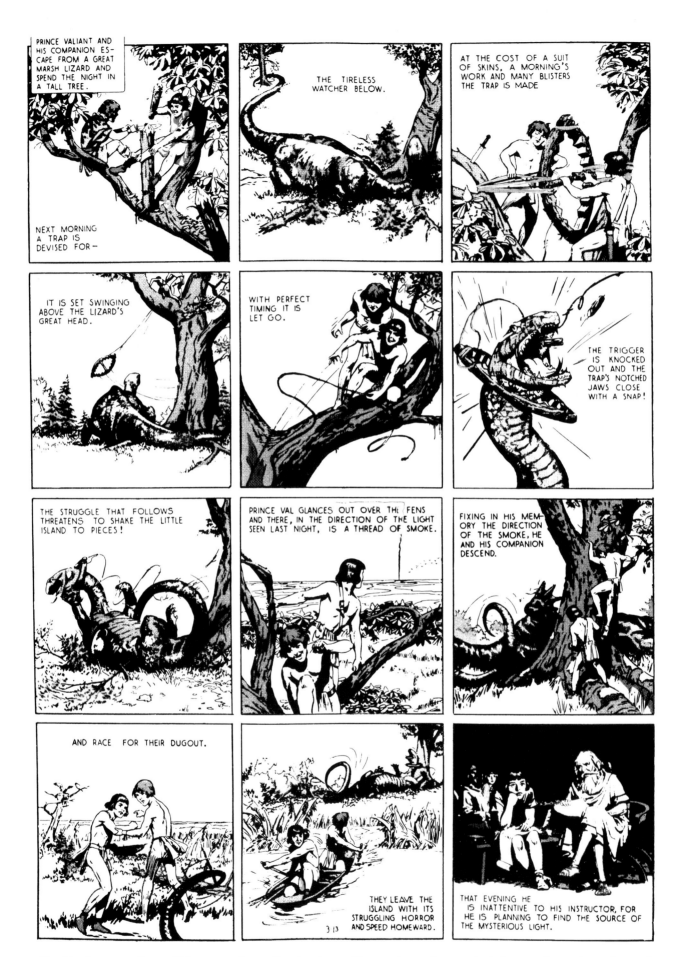

This March 13, 1937 Prince Valiant *page, features Foster's early use of fantasy elements. Later work relied more on human drama than myth.*

A book on Hal Foster would not be complete without examining his views on writing and art. For Hal, the written word was just as important as the visual image. Because of the limitations of space, the text and pictures needed to advance together but separately. To just explain a picture was a wasted effort; so, Foster intentionally decided to narrate the space between the panels. He became the voice between the heartbeats and imbued his characters with life and emotion in simple, lyrical prose. Characters shared personal secrets with the readers and no one else—not even other characters on the page. Hidden thoughts, hopes, dreams of adventure and dreams of love became known only to the privileged few who followed what Hal referred to as his "illustrated romance." Where did he get his ideas from and how did he bring them to the printed page? How did he create 'art' and how did he balance story and illustration? These are questions that will be debated for years; however, the answers are best found in Foster's own words: "The drawing of comics is not all important but the story idea is. A good story could succeed with poor drawing but good drawing cannot support a poor story."[1]

HAL FOSTER THE WRITER—STORYTELLING 101

Dear Dr. Georgen,

In reply to your letter of July 20th I have often been asked where I got the idea for the *Prince Valiant* saga and only now have I traced it back to the year 1910. In that year the family fortunes ran out and we were destitute. I had to quit school and go to work.

We were in Winnipeg, Canada at the time, the winter nights were long and I could not afford even a ten-cent movie. Books became my entertainment, especially historical novels.

"The Tales of King Arthur caught my interest and I began to sketch the characters. That required books on art and drawing and much practice, but

1 Letter to Victor Kally, February 24, 1969

Photo on page 113 is of Hal and Cindy Lou Hermann.

it paid off and I became a fashion illustrator for a mail order catalogue. As the company I was working for was not too affluent it laid off all employees for two months in midsummer. I found the cheapest way to spend a summer was to throw my outfit into a canoe and travel the rivers of Manitoba and Ontario. I made sketches and those sketches have appeared in the illustrations of Prince Valiant's voyage to Canada.[2]

"The Medieval period gave me scope. That's why I picked it. At first I thought of the Crusades but the theme was too limited. With *Prince Valiant* I had a leeway of almost three centuries due to the lack of written records. With the decline of the Roman civilization in the fifth century written records ceased being kept. I also wanted a strip that would permit me to do fantasy. I wanted to show magicians, ogres and dragons besides knights. They were real bastards back in those days and if I could write the story as it really was it would be a bestseller—even better than Peyton Place. They were forever knocking each other off and even Arthur is supposed to have sired an illegitimate son (Modred) by his sister Morgawse. There are still some juicy scandals going around about the days of King Arthur."[3]

"When reading fantasy and about the medieval period, sometimes just a phrase or word will give me the idea for a plot. Then I enlarge it into an adventure. I use real people in my strip too. A person's personality will write a story. You know by looking at them that they're no hero, and they might be a little silly or something, and that forms a story. For example a waiter in a restaurant in Europe was transformed into a comical squire for Sir Gawain. I've traveled everywhere Prince Valiant has adventured except the Middle East and Africa."

In fact, during the forty-three years Hal worked on the strip he and Helen visited over 44 different countries. Wherever they went, one thing was certain, one of the first stops was to a museum.

While Foster borrowed ideas from published writers such as Pyle, Cabell, and Dunsany there was one source closer to home, which he used as a source for ideas. Between the seafaring tales he learned in Halifax as a boy and the Journal of his great great great grandfather, Leonard Chrostofer Rudolf, Hal had stories to last for years.

2 Letter to Dr. Helga Georgen, Germany, dated July 29, 1977

3 Interview with Bill Crouch, Jr., Cartoonist Profiles #22, June 1974, pp. 44, 45.

After some months spending of my acquaintance I had a proposition of a Secretary's position by a Prince of Valachi residing in Vienna, which I accepted. This Prince was the son of a Hospodar, who had been strangled at Constantinople for his siding with the German Emperor. He and another brother were shut in the seraglio, but by the English Ambassador secretly carried off to England from whence they wandered to all the courts of Europe. Everywhere they received great presents and kept till the Emperor settled this by a yearly pension of 4,000 florins, and a regiment of horses. The other brother was received by the Prussian Army. This Prince's name was Cantacuzeno Prince of Valachy with at least 24 other Christian names. He was of the Greek religion and had a little court of Greek priests and other poor rogues, especially concubines; he was married and had two little sons. He said he was descended in a right line from the Emperor Constantine Magno.

1740

In the spring next the Colonel got leave to return home. I took this opportunity to return with him quitting the Regiment. At Buda or Offen Prince William Eugene Von Baden Durlach coming out of Transilvany joined company with us, and in a place called Moor we were obliged to keep quarantine because we came from a country infected with the plague.

For a historic drama, Hal let the strip reflect the spirit of its audience. It was during the era of the post-war baby boom that Val and Aleta had their son, Arn. The domestic background was used as an effective counter-point to Val's dynamic, sometimes violent adventures. The human drama and court intrigues played a huge role in establishing all of the characters in *Prince Valiant* as fully realized individuals. "The hardest thing in writing the *Prince Valiant* saga has been to keep Val human. He has to be good and virtuous, but I try and keep him human also. He has faults and frailties like everybody else. Now that I've developed Val's character completely, I have to be careful to keep him in his character. It's as if he were standing behind me while I draw."

For Hal, names were important in helping to establish a character's personality. Part of the reason he may not have originally liked the name "Prince Valiant" for his lead character was because it predetermined a large part of Val's personality. "It's important to have names that fit your characters. Many years ago a friend sent me a long list of the medieval version of Norse names and it's been a big help." After Val and Aleta's twin girls

Prince Valiant
IN THE DAYS OF KING ARTHUR
BY HAROLD R. FOSTER

Our Story TURNS TO A CURIOUS INCIDENT AS TOLD BY PRINCE ARN: *"I HAVE OFTEN HEARD MY SIRE CALL MOMMIE A LITTLE WITCH, BUT I KNOW SHE IS A GREAT SORCERESS AND CAN CAST A SPELL THAT MAKES A WARRIOR PRINCE ACT AS SILLY AS A PUPPY. THEN ONE DAY I DISCOVERED A MAGIC WORD THAT COULD BREAK HER SPELL!"*

"MY SIRE CALLED HER A 'PLUMP LITTLE PIGEON' AND SHE SCREAMED 'PLUMP!' AND PUSHED HIM AWAY."

"I COULD SEE THAT ALL WAS OVER BETWEEN THEM, BUT I WAS GLAD MY SIRE DID NOT DRAW HIS SWORD AND SLAY HER, FOR SHE CALLED HIM THINGS NO ONE ELSE WOULD DARE!"

"I THOUGHT IT MY DUTY TO STAY AS HER PROTECTOR NOW THAT MY SIRE WAS LEAVING, BUT WHEN I TRIED TO USE THE MAGIC WORD AND STOOD BEFORE HER AND SAID 'PLUMP' SHE STOOPED TO VIOLENCE, SO I THREW IN WITH MY SIRE."

"WE STRODE OUT OF THE PALACE--HE DID; I HAD TO RUN......I OFFERED TO RETURN FOR THE SWORDS BUT HE DIDN'T ANSWER. THEN AS WE PASSED BENEATH A WINDOW MY SIRE RECEIVED A FELL BLOW UPON THE CROWN AND A VOICE HISSED: 'PLUMP, AM I?'"

"'I WILL BE YOUR TRUE COMPANION AND WE WILL GO ADVENTURING TO AVALON, CARCASONNE AND FAR CATHAY!' I CRIED. BUT HE ONLY SAID: 'GO JUMP IN THE SEA!' HE WAS NO FUN AT ALL!"

"THEN MOMMIE CAME AND LAUGHED THAT LITTLE LAUGH THAT SORT OF TICKLES INSIDE. I LEFT, FOR I KNEW WHAT WAS COMING BY THE SILLY LOOK ON HIS FACE. HOW SUCH PEOPLE CAN RULE A KINGDOM, I DON'T KNOW!"

"IF EVER A WOMAN TRIES TO GET ME UNDER HER SPELLS I SHALL LOOK HER IN THE EYE AND SAY: 'PLUMP'"

NEXT WEEK:-The Pilgrimage.

While noted for his action sequences, Hal balanced them with family scenes. Val's domestic squabbles both humanized and popularized the character.

were born, King Features held a contest to name them, but Foster reserved the right to select the winning entry. A young girl, Cindy Lou Hermann, sent in the winning names "Karen" and "Valeta" and visited Hal in Connecticut. For Val and Aleta's fourth child, a boy who would become the king of the Misty Isles, John Hall won the competition with "Galen" after the Greek physician, Claudius Galen.

The primary goal for Foster was to make the characters so interesting that people would continue to read the strip every week. As in real life ensemble performances, the interactions and reactions of the characters, made *Prince Valiant* entertaining and worthy of people's time. "People are bombarded with printed matter of all kinds. We have developed a sales resistance to all printed material and it is a good relief to look at a picture. Resistance to reading has become so great that instead of reading the book or article to get its full beauty and meaning, we are content to read monthly digested articles and reviews." Because of this Foster would edit out two-thirds of his "novel" into simple, but elegant, prose. "When I have one or two months sketched I call loudly for Helen and she tries to type the pages, poking fun at my spelling (which is refreshingly original if unorthodox) and catching any mistakes. After a big fight, during which I tell her that she doesn't deserve a talented husband and she points out some of the more glaring of my faults, but still accords me none of the appreciation I deserve, the pages are filed and I go to work again."

Helen finds another uniquely spelled word.

Foster refused to editorialize in his strip. "I try to avoid carrying any message whatsoever. I don't like to point out the excellence of virtue. I don't like to see too much violence; I don't like to see blood splattered around because when you're doing that [it] means you're trying to dramatize a fight. For instance, when two men fight, the reason for that fighting and the reason that the fight ends the way it does should be taken care of in the writing. But when you spill a lot of blood and show a head falling off or something like that, that means you failed some place and you've got to use some dramatic gimmick in order to put it over." When it came to killing a character Hal would simply say, "I always kill the right people."

One of the "right people" Hal killed off early in the strip caused a furor. Foster had to dispose of Val's love, Ilene, because she wouldn't have allowed him to continue his daring deeds. Ilene was beautiful, but she had drawbacks as a perspective wife. "I had to kill her off," said Foster. "As I saw her, she would have made a good wife. She'd have his slippers waiting when he came home but she wouldn't like it if he went out slitting throats." So Foster wrote her out of the script in what he termed, "the logical conclusion." King Features was flooded with mail—he had angered his readers.

Foster heard from his readers a lot. "One time I had [Val] get drunk when his first child [Prince Arn] was born and you should have seen the mail I got! One woman wrote, saying her son's hero had fallen off his pedestal. Basically heroes can be very dull and a pedestal is a good place for them." Another time Foster showed Val fighting Arabs and "I mentioned Allah but they all said I was criticizing Mohammedans. I didn't." Hal wrote back to each of his detractors, apologized for disturbing them and politely reminded them that King Arthur lived in the middle of the 5th century and that Mohammed had not been born yet.

People would also take great delight in pointing out the strips errors. "The one I was surprised wasn't caught by more people was when I did a segment on the sacking of Rome. I wrote in the story that they landed on the banks of the Tigris and marched to Rome. It really should have been the Tiber. Only one fan caught it and wrote: 'Wasn't that a helluva long march?' The Tigris is in Iraq and the [Tiber's] in Italy." However, one error that no one caught was when Foster thought he had drawn the Arch of Trajan in a panel and later discovered it for himself was the Arch of Constantine.

With exacting and meticulous detail Foster researched his strip. So thorough were his investigations that in the December 13, 1959 strip (drawn 3 months prior) Foster announced to the world that the Druids did not build Stonehenge. One day later the British Ministry of Works announced that they'd come to the same conclusion.

When Foster wanted his hero to travel to North America in 1947, he studied medieval maps, currents, and early ship design before charting the course. The ships sailed by way of the Shetland Island, the Faroes, Iceland, the tip of Greenland, and through the Straits of Belle Isle, which separates Labrador from Newfoundland until they finally arrived at the mouth of the Niagara River. "I couldn't just say he sailed across the ocean," said Foster. "I had to study the winds and the currents, the Westerlies, the Gulf Stream; all those things had to be taken into consideration. I wanted to explain it in detail; the direction I took him in was plausible. I suppose you can say, 'It's only the funny paper and you

can do anything.' But I don't feel that way. When you do it correctly people get an entirely new concept." Hal once wrote to Milton Caniff:

"The public does not know, and would not appreciate or give a damn if it did, the amount of fact and data I get into *Prince Valiant*. And I don't care either for I do it for my own pleasure, figuring that if I got a lot of pleasure doing something my own way all my working hours it would be clear profit. If the public liked it and would pay for the pleasure of looking at it, why, that is an extra dividend. This is indeed a great game you and I are in; something to do that is interesting and pleasant, to do it the way you want to with sufficient rewards to remove financial worry, and, in my case, enough leisure to make life worthwhile. I cannot work ambitiously to achieve fame or a lot of money, to do that would cut down on my leisure for enjoyment that I'd have nothing but either fame or the money, neither one of which is of any earthly value except to win the approbation of a lot of people for whose opinion I don't give a damn."[4]

Bringing *Prince Valiant* to fruition was not all labor and research. The Fosters also made time to explore the country as a family; however, adventure and exploration were just as much a part of Hal's life as it was for Valiant. Even while on vacations the strip was constantly on Hal's mind; whether it be a stunning vista or an interesting face in the crowd, his little black sketchbook was never long out of hand. Foster also craved for the one thing Topeka denied him—the company of creative-minded peers.

"When Helen and I get a bit restless we hop into the car, point it in some direction and step on it and see where it brings us out. This year so far we managed to get stuck in the snow on a Colorado mountain, lost in a Utah desert without food or water, robbed at the Kentucky Derby after betting on most of the wrong horses, in and out of the Grand Canyon, slightly potted for a week in New York, washed out of the Great Smokies and present at the Indian Ceremonials at Gallup, New Mexico, besides a few visits to Chicago to see if civilization still exists and if people still write good plays and good music.

Cowgirl Helen at Gallup, New Mexico.

"The Topeka people are generous, kindly and dull. I know only three in all Kansas who can hold a

4 Letter to Milton Caniff, September, 19, 1938.

conversation without boring one to death within a half hour [though] there is yet an undercurrent of friendliness that is warming."[5]

The Fosters only spent three years in Topeka, but Hal would always remember them as the best three years of his life. There was a feeling of freedom there, of creativity—of creation. While Val may have been conceived in Winnipeg in 1910, he was born in Topeka in 1936. It was a time of innocence for the Foster's, where they could play and work and shoot the ornaments off their Christmas trees and not have to worry about strangers from "the outside world" intruding on their privacy. Soon *Prince Valiant* would become an international sensation and its creator would have to deal with the fame he neither sought nor desired.

"I have enjoyed the hunting and fishing one dreams about in Canada, Wisconsin and Michigan but it always took a special trip once or twice a year—now I can leave my studio at 4 o'clock, grab a gun and have a few hours fine shooting within ten miles of the house. My golf club is within a 10 minute ride, we go to Kansas City, 70 miles away for good liquor of which we are passionately fond, and, when the circus comes to town, get up before daylight to watch them unload and stay with them until they load again at midnight. Enjoyment is contagious and our Topeka friends get such a wholesome wallop out of simple things that we sort of wonder…?"[6]

ABOVE: Pictures from the Foster family photo albums attest to how much they enjoyed traveling the country, camping and fishing. If you look closely you can find Edward and Arthur standing on the logs.

RIGHT: One of many cartoons Hal would do for the National Cartoonist Society, and the only time Val speaks with a word balloon.

122 •

5 Caniff.
6 Caniff.

Hal Foster: Readers accuse me of bias because Nubian slaves, a Jewish Merchant, and an Irishman appeared in some of the sequences. The only people you can draw are white, rich Protestants.

Milton Canniff: I've received complaints from white, rich Protestants about the way I depict them.

N • I • N • E

VOICE *from* VAL-HAL-EN

The wall of the Palm restaurant.

The Foster's moved to 1202 Main Street, Evanston, Illinois in 1940 partly because Hal had hay fever and because they also wanted to be near family and friends. That August Hal and Helen took a trip to King Features Syndicate's New York office. While in the city the Foster's ate dinner with Milton and Bunny Caniff at a former speakeasy, the Palm restaurant. After their meal the two artists entertained restaurateur John Ganzi and the diners by drawing portraits on one of the walls. Caniff drew *Terry and the Pirates'* hero Pat Ryan and Foster did Val. It was a productive trip for Hal but he was unprepared for the reception he received. A few weeks after returning to Evanston, he wrote to Caniff.

> A strange change has come over me since I was in New York. I fear I have lived too long in the seclusion of the Kansas desert and in the primitive outskirts of this pioneer town, I have become naïve and my coy innocence could not stand up against the flattery I received in New York. I know, of course, that no human mind can withstand the corroding inroads of flattery. But mine was even more unprepared than the normal and I now find myself giving vent to serious banalities and unctuous bromides in the most serious manner. I am inclined to posture and frown and fly into uncontrollable rage if addressed as Hal without the prefix "The Great." This new found consciousness of my own importance has its inconvenient side; I haven't seen my shoes for two weeks and "she who has given me the best years of her life" has to reach up with both hands and grasp my sky-touching nose and drag it down so I can feed.[1]

In 1944, Hal and Helen moved to Redding, Connecticut where they had purchased a

124 •

1 Letter to Milton Caniff, September 20, 1940.

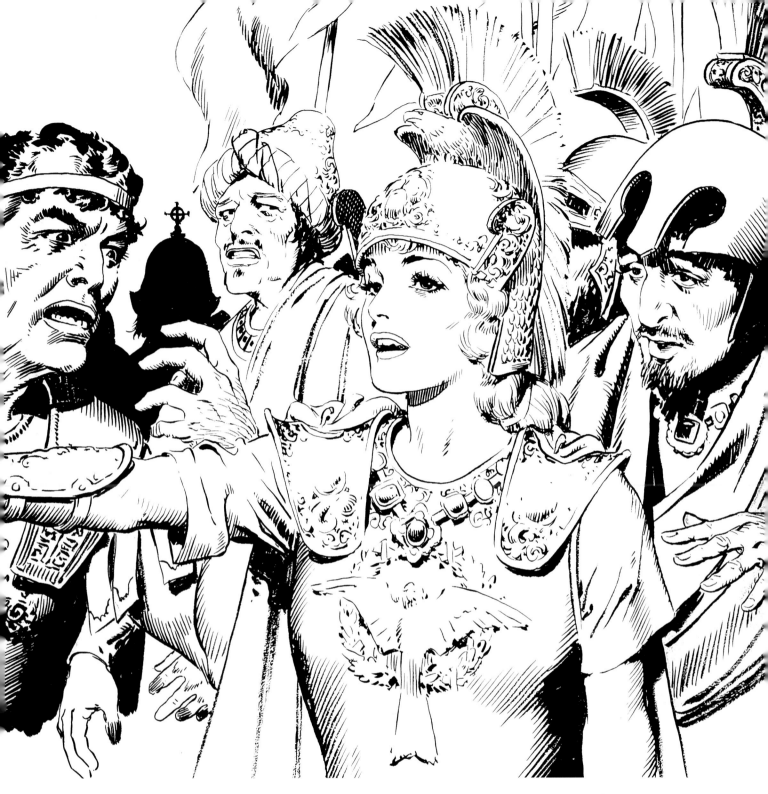

house that sat on six beautifully wooded acres. The Fosters dubbed the property "Val-Hal-En" after Val, Hal and Hel_en_. It was Hal's friend and King Features' comics editor, Bradley Kelly, who lived in the area, who prompted the move. Hal could now hunt, fish and relax just a few steps away from his house. The woods helped him focus and get back to his roots, and it may have inspired Val's trip to "The New World" (1947). Val-Hal-En also gave the Fosters easier access to New York City where they could participate in Hearst papers' events, and live closer to Hal's peers in the industry. Hal's studio was a

• *125*

room over the garage and he used to keep a rifle near his drawing table. Whenever he saw a snapping turtle sunning itself on a rock by the trout stream that ran through his front yard he'd pull out the gun, and without getting up from his chair, shoot at the creature from his window.

It took Foster fifty to sixty hours a week to produce each Sunday episode (there was only one daily comic strip), but King Features never had to worry about deadline problems because he was always 9-12 weeks ahead of schedule. "I go to my studio about 9 a.m. and work through until 5:30 with a break for lunch. My schedule is seven days a week including most holidays." After Don Maley of *Editor & Publisher* told Hal in 1969 that he'd spent nearly ninety-two thousand hours at his drawing table just on *Prince Valiant* Foster quipped, "No wonder my behind's beginning to flatten out!" Hal would lay out the story on Sunday, pencil the entire two foot by three foot page on Monday, ink it Tuesday through Thursday, and color it Friday. Saturdays were spent on research for the next page and answering his mail.

HAL FOSTER THE ARTISTE — ILLUSTRATION 101

"In drawing the human figure, I started with the outline of the body for proportion and then dressed the figure. The result of all my years of studying art in Chicago is that I can visualize the human body and don't need a model to work from. Back then I studied the body from the skeleton out. I thought I was going to medical school.[2]

"I used myself in an idealized version as the model for Prince Valiant. I deleted what I disliked and he's sort of my body with muscles. He's all the things I would have loved to have been. The haircut was simply designed in a traditional cut. It was padding for the helmet. However, it's been the single most famous thing from the strip. I made him have black hair because it would show up more prominently when reproduced. After all his mother was a Roman woman that had married King Aguar. Prince Valiant has sort of a Roman nose. Besides, you always think of a blond in terms of beautiful women. I idealized my wife Helen into Aleta."[3]

"An artist is so used to drawing faces that he finally comes down to a standard face, the same nose, the same eyes, the same expressions, until sometimes you draw a mob scene and they all look like a large family.[4] I've [also] noticed over the years that hands

2 Interview with Bill Crouch, Jr., Cartoonist Profiles #22, June 1974, p. 46.
3 Crouch, p. 48.
4 Gil Kane Interview, The 1969 Comic Art Convention.

are more expressive than faces. Hands can take so many positions that can express emotion."[5]

"I make a rough sketch with the main figure or action just a little off center, other figures should be grouped, touching. It is more pleasing if something in the background links them all together, a table or fence...maybe a cast shadow. The blacks are important to give balance and composition.[6] In order to get your blacks and your spot of interest on the page you have to make a rough sketch and then fit architecture into the doorway, or the turrets, or something like that." [7]

"I have appreciation and any education that doesn't give you appreciation is mere memory work. When I went prospecting for gold in Manitoba, I became interested in geology. Today, as I travel through the country, I can 'read' a story that is written to grand music and I am not merely going from one filling station to another.[8] "When I sit down to draw, I can recall the lovely shape of a tree, the ripple of a stream, the contours of a mountain—all because I have lived it. It's a part of me." [9]

"The most difficult action to depict involves sports techniques because there are so many experts who know more about them than the artist does. I wanted to show an archery sequence so I took up archery so that I would get it right. I never knew there were so many archers in the United States until the mail began to arrive."[10]

"I find that there's too much action, you've got to build up to the action. If you've done one battle scene then the next battle scene to have to put in several more knights and a few more corpses, and so on until you pile them up. So that a bit of action is followed by a little bit of home, the children, Prince Arn and some of the others...a little childish adventure. Then I can come back to some of the big [adventures]. Just as you design a page you have to design your story the same way. Action, then a downgrading of the action so that you can come back up again, and you don't have to come up higher—you can come up to the same level of violence. In the page itself, you design it so that you'll have probably a

5 Crouch, p. 48.
6 Letter to Al Rainovic, January 25, 1969.
7 Gil Kane.
8 A Two-Fisted Artist Draws 'Prince Valiant', Stephen J. Monchak, Editor & Publisher, April 6, 1940, p. 32.
9 Cartoonist's Life Full but Rewarding, Miscellaneous newspaper clipping.
10 Prince Valiant Roams Conn. Woods But Fumes At Snorting Bulldozer, New Haven Register, November 17, 1957.

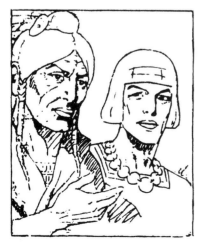

big head with a dramatic expression that will show the character of whoever it is. Then you can have a bit of action with probably half figures, so that you get a variety and keep it from getting monotonous."[11]

"I never did roughs on separate pieces of paper. I'd just sketch it out using a Venus HB pencil. Before the comics shrunk I used to work on a 27 x 34 piece of 3-ply Strathmore with a kid finish. Now the originals are down to 16 x 24 inches. It was a pleasure to work in that larger size."[12]

"I use Higgins ink and for the delicate work a Windsor Newton #2 brush. Then for fine detail I like a #170 Gillott pen."[13]

The lettering used in Prince Valiant resembles the script used on college diplomas and Foster considered lettering to be an art in itself. "The letters should all appear gray when you look at them squinty-eyed. If a dark area jumps out at you it's all wrong.[14] For coloring Windsor Newton watercolors are my favorite. I use the color to either bring the figures out or place them in the distance.[15]

"When I exhibited my paintings I got a few grudging nods from fellow artists. But in the syndicated strip field the average guy gives you a pat on the back.[16] It's true that I brought traditional art and illustration technique to the funnies but it wasn't done consciously. This has always been my style. Some people dissect their art in formal terms but I've never done that with my work.[17] Talent in my opinion is merely enthusiasm. Practice makes one good."[18]

Foster's artistic heroes were Jose Maria Sert, Frank Brangwyn, John Singer Sargent and Norman

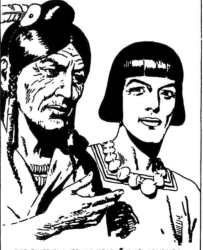

THE CHIEF SHAKES HIS HEAD. "YOUR JOURNEY DOWN TO THE SEA MIGHT BE PERILOUS, FOR THE TRIBES ACROSS THE GREAT RIVER ARE RESTLESS, OUT OF CONTROL OF THEIR LEADERS."

11 Gil Kane.
12 Crouch, p. 46.
13 Crouch, p. 46
14 Hal Foster both lives and loves the days of Camelot, Don Maley, Editor & Publisher, January 25, 1969
15 Crouch, p. 46.
16 Art and Literacy Quality Keep Cartoon Level High, George Turner, Amarillo Sunday News-Globe, February 16,1969, p. 1-D.
17 Monchak, p. 32.
18 Monchak, p. 32.

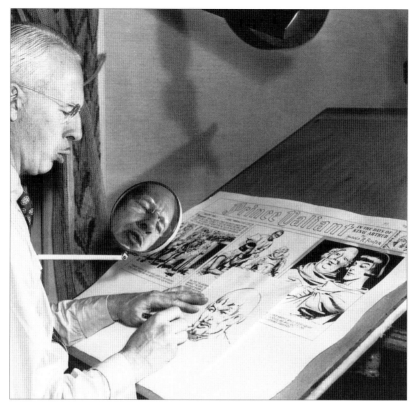

There is one question that comes quite often: "Do you use models?" No. I haven't time. To go down to the Model Bureau, pick out the subject and have the model called, photographed or brought out to the studio and the drawing made would consume far too much time…and the deadline will not back up. If an out-of-the ordinary expression stumps me, I draw the face of the character I want, then I hang a special sort of Rube Goldberg mirror around my neck, twist my pretty face into the expression I want…and there is my model.

Rockwell. These artists strived for a sense of realism in their art; a sense that each and every person they portrayed was a unique individual, and Foster assimilated this philosophy into his own work. If a man on a *Prince Valiant* page looked fifty his hands and body and hair looked fifty; if it was a girl of fifteen her hands and body and hair looked fifteen. This is especially noticeable in large group shots where no two characters look alike nor do any two characters have the same pose. Even when multiple characters are doing the same thing, like pulling a rope, they all move independent of one another. Foster's people stretch, lean, slump, slouch, scratch, belch, and do all the average, everyday things ordinary people do. Foster portrays them as beings of flesh and blood and bone and because he does it so convincingly the viewer suspends belief and accepts that they are real.

> The brushwork used to compose [his] figures indicates an attempt at realism. There are no broad, sweeping lines in Foster's work, no delight in ink for ink's sake. Instead there is a restrained, almost puritanical use of tiny brushstrokes—an effort to render light and shadow without constantly reminding the reader he is looking at artwork; that what he is looking at is not real.
>
> Artists and writers influenced by visual media tend towards the erotic in their figures. Foster's storytelling techniques arise from a literary tradition rather than a visual one. His men and women are not mere sex objects. They have beauty but a beauty without eroticism, a beauty of stature and deeds—a beauty both without and within.[19]

19 Greg Potter, The Comics Journal No. 63, spring 1981.

Foster experimented with vertical and horizontal panel formats. Elaborate wide-angle establishing shots were a major storytelling devise that he spent hours designing. Today, unfortunately, the shrinkage of the comics has all but removed the panorama as a useful storytelling tool. "It would take about three panels to do any sort of panorama effect," Foster explained, "[and I would] use the background to show time and place. Place is shown by the trees, pine forests or palms, mountains or deserts, architecture or costumes according to where the story is located. Time is bare limbs, snow, autumn colors, etc." Every country or area has its own type of geography, trees, and buildings and Hal never included a locale that he had not personally visited for thematic accuracy. "A tree is an individual. You have to draw _a_ tree. When I draw an oak tree it's an oak tree; if I'm drawing a spruce tree, it's a spruce tree. For instance, if you see the flattop pines, the tall cedars you know you're in Rome, or Italy. Very few people stop to think about that, but every picture they've seen of Rome has those trees, so that immediately they know it's around Rome."

Whether it was the frustrated fine artist in him or just his illustrator's artistic standard Foster always wanted more. "You're never satisfied with your work. Anyone who's pleased with their work will stop right there, because if you're satisfied then you don't have to improve. You've satisfied yourself. But, no, I'm not satisfied. I can pick out my own faults. The only drawback is not having enough time to make the art as good as I'd like to." When asked what he felt would raise his art to his own personal satisfaction Foster replied: "I don't know—a touch of genius I guess."

The "touch of genius" Hal strived for came to him once during his four decades on _Prince Valiant_, but an arbitrary editorial decision deprived readers of seeing what he believed to be his greatest achievement. In 1944, the head of King Features, Joseph V. Connolly rejected a page that Foster had labored on for days. "The best page I ever did was Prince Valiant on the Aegean Sea, and he'd been cast away in a small boat, and through the mist he saw this island with a palace on it." Foster described. "And this building, this palace went up, oh, I'd spent days on this, all the little towers and bridges, and Connolly sent it back and scribbled in blue pencil on the corner was, 'Not enough action.' That's the best page I ever did." Brad Kelly later told Foster that the decision had nothing to do with the art but was simply Connolly's desire to "take [Foster] down a peg." The page never appeared in the Sunday strip and was later lost when Hal's son Edward's house caught fire in February 1967. No one was hurt but one room was gutted destroying several paintings and the page, which Hal had personally watercolored.

Prince Valiant set a high standard of excellence in the industry that has seldom been matched and it was Foster's drive for perfection that set the pace. "I've torn up two or three pages, written pages, and I've torn up half finished original pages. But it takes quite something to tear up a page you're working on and start over again. All that work. You stop and think, why should I do all this work? Who notices? But they do. Every little thing I do, fans write me; tell me about it. Yes, the fan mail is very, very good. In fact it's too flattering."

The more popular _Prince Valiant_ became the more fan mail Hal received. At first the

Val-Hal-En. Foster's studio window is directly below his head in the reflection.

admiration was intoxicating, but soon the demands on his time became exasperating. Foster personally answered every single letter he received; a task that drained him.

> I have just finished getting off the answers to all the fan mail that had accumulated since August first. This world has so many funny people in it that, though it may become aggravating it will never be a bore. This group of fans seems to have cropped out from some queer strata of human society that is very inquisitive. Some phase of the moon probably brought them out and they want to know everything from how I wrap my pages for mailing to how much I make. After answering the more sane of the letters I feel all let out, as if I emptied all my insides into the envelopes and mailed them…leaving me the impression that I sit here naked.[20]

The vast majority of the fans would praise Foster and then ask for a free sketch. Every once in a while, if the letter was truly genuine, Hal would cut out a panel from a Sunday page and send it to a reader, but even that ultimately proved to be an impossible chore. Due to *Prince Valiant*'s ever-increasing popularity, Foster eventually became bombarded with dozens of requests a week from admirers who had little or no concept of the demands they were making on his time. Sometimes people would show up unannounced and request a visit with their hero, or to ask for his help or advice.

> Now I can get to my fan mail and tell my dear public: "No, I don't make drawings for every sap who thinks because he compliments the artist that [I am] under obligations to make him a free painting," and "No I can't send you all the back [pages] of *Prince Valiant* from the beginning," or "Sorry Madame, but girls do have breasts and I put them on accordingly. Haven't you got 'em too?" and to dozen others: "No, it is

• *131*

20 Caniff, September 20, 1940.

From the Hal Foster Collection at Syracuse University, printed at actual size.

not possible for me to get my syndicate to publish your very, very lousy strips."[21]

"People are constantly calling me and asking for art lessons, but I find it easy to lose them. This place is hard enough to find when you know where it is and I find if I give them the wrong directions they never

21 Caniff, December 1, 1939.

show up. Then there's the vacation crowd who say to themselves, 'let's drop in on old Hal Foster.' They think that because they like *Prince Valiant* I owe them a duty or something. I usually limit them to one half-hour visits but I become absorbed in my work and when I turn around they're still there watching me. One guy had the absurdity to ask that I let him watch me draw an entire strip. I told him that it would take a week and that there were no hotels in the neighborhood for him to stay at."[22]

For someone who enjoyed nature the way he did—enjoyed its quiet moments and its seclusion—Hal was unprepared for fame. While *Prince Valiant* gave him the freedom financially to hunt, fish, and travel the world, it inevitably took those things away from him. Though sometimes frustrated by his fans, Foster also appreciated them. On one occasion, a mother wrote to Hal and told him how her two boys enjoyed Val's adventures. She went on to say how her sons, encouraged by the strip, learned how to hunt with bow and arrow, and that after reading an article on Foster, they were saving up to buy hunting rifles. She didn't ask for a page or a panel or a drawing but simply wanted him to know Val's morals and sense of honor were appreciated. A week later, to her surprise and the boys' delight, a box arrived from their favorite illustrator containing two of his own hunting rifles.

Another instance, when *Prince Valiant* was dropped from a paper and fans forced the editors to reinstate the strip, Foster's feelings became quite evident. "I had heard from several protesting California fans," Foster immediately wrote to Milton Caniff, "so I am very happy that Val is going to ride again. Thank Heaven for loyal comics fans!"[23] *Prince Valiant* was indeed Foster's proverbial "two-edged-sword" yet the edge that gave always stayed sharp while the one that took, dulled with age. "I am so lucky to be able to draw about the things I know and love. Eventually they all find their way into the *Prince Valiant* strip. Yes, it's been a wonderful life."

22 Maley, Editor & Publisher, January 25, 1969.
23 Caniff, May 12, 1977.

FOLLOWING PAGES: *The Baptism of Prince Arn, shown at it's original size. Courtesy of The Ohio State University Cartoon Research Library.*

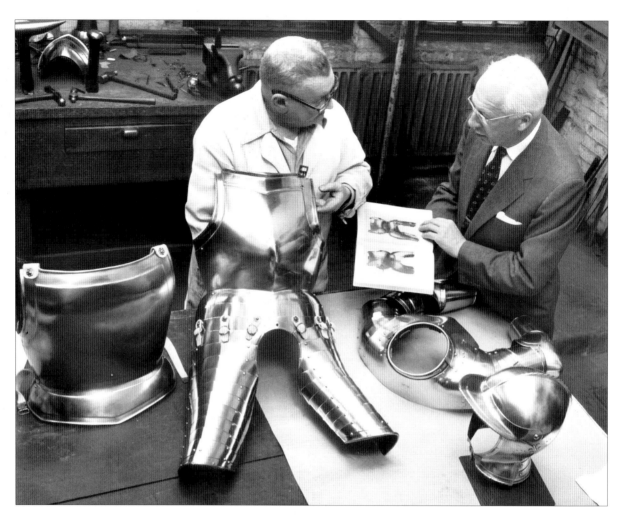

SHOP TALK—RESEARCH ON OUTFITTING A KNIGHT

"I hate to admit it but all of the things many fictional characters have done with a sword just couldn't happen, but the movies have conditioned people into thinking that this is the way things were, so I have to double-check on what is and is not possible. Until the 15th century the sword was of impractical design, so heavy and badly balanced that it was of little use for thrusting, even though it was pointed. That's why you find Prince Valiant using his sword as a cutting, not a dueling weapon. It was not nearly as effective as people believe.

"You'll notice not too many people use [chain-mail]. There are several reasons: One is that it's too heavy and the other is that it's too expensive. When worn with a padded undergarment a shirt of mail could weigh up to 40 pounds and that the whole weight of it was borne on the shoulders. To add to the difficulty, the action of the sword caused folds to collect in the bend of the arm, further hampering the freedom of movement. Additionally, you had to be a rich man to own one. A horse and saddle, sword, helmet, coat of mail and a shield cost as much as 20 oxen or 120 sheep."[24]

ABOVE: *At the time of this photo 60-year-old Scottish-born George Donald was one of only two armorers working full-time at his trade in the U.S. He had been one for over 30 years.*

24 King Features Press Release written by Harold R. Foster

The following three letters are a correspondence written in 1935 and 1936, by Hal Foster to Philip Steele who was only 18 years old at the time. Philip founded and was the president of The Rocky Mountain College of Art & Design in Denver, Colorado. The letters appear courtesy of Philip's son, Steven who has been president of the college since his father passed away in 1993.

Philip Steele by Glen Cuerden, provided by The Rocky Mountain College of Art & Design.

July 24, 1936

Dear Philip:

I have your sample of penmanship and the sheet whereon an artistic soul struggling for expression has gone through the birth-pains with startling results. The contents of your letter flattered me to a very gratifying extent and has added to a conceit whose proportions I can hardly stand under and my friends can't stand for.

As you will see from my letterhead, I am not in New York, where good old Auntie lives, but in Chicago—too great a distance for commuting, but we have some great relief stations, not comfort stations, in our town and it would pay an ambitious young artist to get used to these places if he seriously intends entering the diminishing and stony field of Art.

Much as I would like to have you in our studio, it is, at this time, impossible. Experienced artists have been sailing paper darts out of the window and into the busy crowds on Michigan Avenue, sailing kites from the fire-escape, much to the surprise of serious business men in the adjoining buildings and are now shooting pointed darts at the target for nickels—to add you to this general near unemployment would cause overcrowding (unless you were well supplied with nickels).

Before you embark on the heart-breaking task of getting into any studio take the advice of Thomas Kimball who never spoke a truer word than when he told you to master your medium and let good whiskey or the Posers-that-Be furnish the inspiration. Your sketches show a good feeling for drawing—as if you had a lot of it in you but suffered constipation of the faculties due to lack of knowledge. You can rectify that quick enough in figure drawing by studying the skeleton. Get a good book on anatomy—one that shows the bone-structure—

study it minutely and in boring detail until you know the proportion and range of action of every bone—the proportion of every bone in relation to the others—and don't, like most students, neglect the hands and feet so that in later years you will have to draw all your figures standing in long grass with their hands in their pockets.

If you will examine your own figure, you will see how important this bone-study is. At every place where a line changes, every important angle, you can place your finger on a bone just under the skin—the muscles just fill in the spaces between, so that if one has not a good knowledge of what is underneath, the outside cannot be drawn with any degree of accuracy, especially when action is desired. When you can draw skeletons in any desired position like this*— then it is time to learn the meat, after which you can pick out whichever Deity happens to be popular and propitiate him to send you talent and inspiration. You can easily tell when the gift of talent is granted because if it is you will no longer have any inclination to practice draughtsmanship on lavatory walls.

Never for an instant forget or underestimate the value of proportion—you may not know what the exact size of a man's head should be, but if you saw a man coming down the street with a head smaller, or larger, than the average it would differentiate that man immediately. Figure that a table is either big or small compared with the plates, knives or forks on the table.

I advise an exhaustive study of the human skeleton—not only for drawing humans alone but nearly

every warm-blooded animal has exactly the same construction—differing only in proportion. They even have the same number of muscles in general but differ in size according to their use. In fact the animal differs from man very little in body. The chief difference is that the animal is dignified—whereas man is pompous—is not mean nor ambitious, has a clean mind, good teeth, is honest and would I am sure, vote the straight Democratic ticket.

Go to New York if you can—there you are in a position to see and study other artists' work—there is more push and excitement —good art schools with pedantic, dogmatic instructors and the best equipment. The very atmosphere of the place makes you want to hustle ahead—only mob psychology perhaps, half-serious, half-insane, with a good mixture of ignorance and banality, but it works. But don't blame me if you starve.

I have handed out so much advice to young artist-to-be that I am beginning to feel like a kindly gray-bearded old philosopher—and me just in the first flush of young middle age. If, when I get home, I have a fatuous benevolent expression on my pan, I shall curse you heartily.

H. Foster

October 24, 1935

Dear Philip:

I was very glad to hear from you and that you have finally achieved the Big Town and all its advantages, excitement and hollowness. Don't let it deceive you though. It's big, pompous and seriously important on the outside, but pathetically provincial underneath.

What you say about your fellow students is very familiar to me so at the risk of being slightly pedantic, I'll give you some advice: There are three classes of students —the Arty, the genuine, and those who don't make any difference.

Avoid the 'Arty' as you would dope—more so—dope is amusing but the 'Arty' are more insidious. They talk art with a capital A—know more about art that you and I can ever learn—are familiar with the work of every known artist and worship Art as if it was sacred—a religion and they its High Priests. Some of this class are very clever students, and, in most cases are students all their lives. The Art Schools are full of them—it is their temple and outside they never produce anything real. Don't, as you value our sense of humor, get in with this class of artist; if you do, the language and appearance of art

will become more to you than the craftsmanship.

The real student is hard to find—very often he does not even do good work, but will be doing his best to get the real stuff and not bothering his head about the phony. You should have nothing to do with art at all for quite some time yet. Learning to draw is no more difficult, nor mysterious than learning to write—it is purely mechanical. The human figure is no different than a boxcar or a truck—to draw either you have to know all about them—and it doesn't take much art to draw a truck—only knowledge.

Composition is merely placing the things you draw in a manner pleasing to the eye—just being rational and showing good taste in arrangement with a bit of psychology—not much art.

Color is a mechanical knowledge of the effects of light, shade and distance on an object's natural color—the mechanical knowledge of how to mix pigments to attain those colors and the training of the eye to see colors.

When you have trained your eye, hand, and judgment, then you apply Art, or, I should say, art will creep into your work much to everyone's surprise. If art is sacred and mysterious to you at any time, just go out and get drunk and forget it because it is becoming phony. Art is just good honest craftsmanship.

The more enthusiasm you put into study and practice now, the harder you work at the seemingly uninteresting foundation, the more time you will have to play later on—BUT don't take anything in this world so seriously that you forget how to live—we work to live, not live to work. And New York is filled with interesting things, places, sights, smells and experiences. This is a changing world and anything you pass up may not present itself again.

Now, after handing out all that sage advice, I feel very fatherly and white-whiskered. Hope I haven't bored you with a lot of banalities you already know but it's done with the best of intentions and with the knowledge that many a promising student has got himself all bogged down to the axles in the mysteries of Art, while his mind floated away among rosy clouds and rainbows, when he should have been learning an honest and interesting craft.

Let's hear from you as you go along for I'll be interested in our progress and your bumps.

Yours truly, H. Foster

January 30, 1936

Dear Philip,

Thanks for remembering me at Xmas. Your greeting card certainly was individual and the thought pleased me very much. Sorry to get so far behind in my correspondence—I see an unanswered letter of yours from last November, which should have been answered long ago—no excuse except laziness.

I can see why you are not making as rapid progress as you could wish by glancing at your page of 'Boners'—the skeleton drawings. Proportion, my son, proportion! Don't ever draw anything without being conscious of its relative size to other things. An arm is just so long compared with a torso or leg or head—it's standardized. Never draw one of those skeleton figures haphazard! If the leg is so long, then the body must be in proportion—the arm in proportion to the body—the head-hand-cage all in proportion to another. Don't sketch, foozle or kid Philip Steele. The time to be hazy is when the music is soft and lights mellow or when the wind is whispering in the tall trees. But when it comes to something definite, take it in your teeth and shake it. [George] Bridgman, I am sure, will let you make love to his pet skeleton. Sit before it and make a careful drawing, using a ruler and dividers to measure it and make the best damn drawing you can of it, front and side. Put all the measurements down on the margin too for future reference. Did I say that all this preparatory work was monotonous? If you have forgotten about Art, it isn't. You are not in the position of a scientist carrying on definite research work—and not as a prizefighter training for a fight next week.

Glad to hear you have become quite discouraged. A snake gets that way too just before shedding his old skin—he gets rid of a lot of old stuff, too. When you have been properly discouraged for a few weeks, you no longer expect anything from yourself—then you can start—from scratch.

Have you done any loafing along the docks? Don't neglect it. I spent my boyhood in Halifax and the waterfront taught me more than school. I think my hair still smells of coffee, rum, tar, dried cod, rotting fruit, molasses and bilge water.

To some people a rusty freighter is just a machine for carrying stuff from here to there—but to me it is a battered soldier-of-fortune which has had the good fortune to look over the horizon that hems us all in. The shipping always reassured me that the world was round and far places really existed—Penang, Mandalay, Zanzibar and far Cathay. Maybe Sinbad spoke more truth than the Encyclopedia Britannica!

I am slowly recovering from a serious accident. A week ago Sunday a friend and I were out riding. We were cantering across a snow-covered field parallel to a road down which a bobsleigh full of sweet-young-things were hilariously gliding. My horse plunged into a snow-filled ditch and I was thrown. Physically I was unhurt but, Philip, I ask you to picture this: A horse standing head down and a gray-haired old sportsman with legs wrapped around the horses' neck, also head down and, nearby, a sleigh-full of young wenches screaming with laughter. Wounded? Well! The flesh will heal but the ego is scarred forever.

Had I broken my fool neck, I would have had sweet sympathy but I finally dropped on my back like a ripe fruit and lay there gazing up into my horse's stupid face while the ladies shrieked hysterically. So, if you break your leg, or have some other trivial mishap, don't ask me for sympathy—I have suffered!

Yours truly,

Harold R. Foster

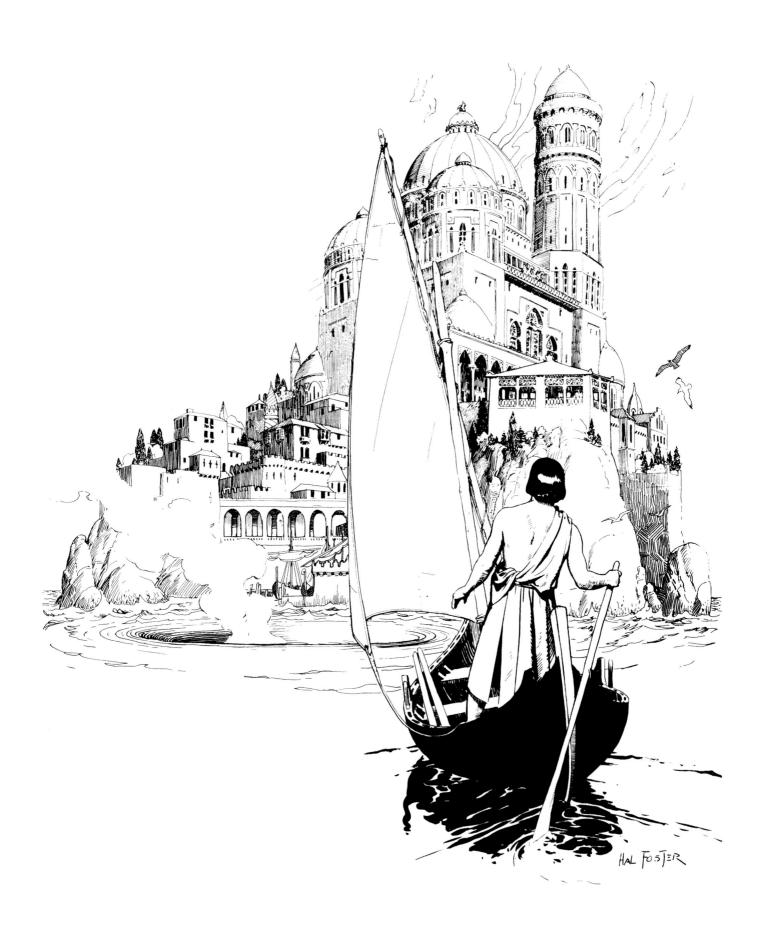

The Prince Valiant *page that was rejected.*

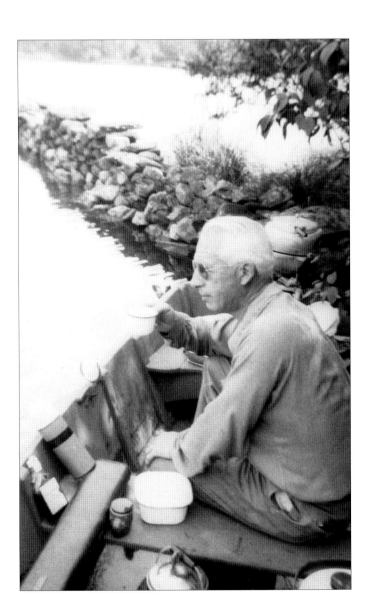

T • E • N

A

CANADIAN
YANKEE *in*
KING
ARTHUR'S
COURT

PRINCE VALIANT By Hal Foster

TOP: *The only daily* Prince Valiant *strip Hal Foster ever produced. It appeared on September 9, 1956.*

ABOVE: *From* The Christmas Story, *1948.*

From Medieval Castle

P*rince Valiant* left Foster little time to work on other major projects. In 1943, Hal again collaborated with Joe Neebe on a short strip adaptation of Franz Werfel's The Song of Bernadette. Hal illustrated 30 numbered black and white strips that ran from April 19-May 22, 1943. The entire adaptation hasn't been reprinted in over thirty years. Due to paper shortages caused by the Second World War, King Features Syndicate conceived the 1/3rd page *Medieval Castle* strip; a tale which allowed Foster to explore the time of the first Crusade. If a newspaper needed space because of the shortage they could remove the bottom tier containing *Medieval Castle* and still print *Prince Valiant* intact. *Medieval Castle* lasted from page 376 (April 23, 1944) through page 459 (November 25, 1945) and was adapted as a hardback by Hastings House in 1957, and as a children's version, *The Young Knight* in 1945. Finally, there was a limited-run daily panel called *The Christmas Story* that ran for six days prior to Christmas 1948, which retold the story of the birth of Jesus. While Foster's time was limited, he did manage to set aside time to do the family's annual Christmas card. For forty years Hal produced some of the most beautiful, humorous and poignant cards to ever celebrate the season, and many are collected for the first time on the following pages.

In the billowing light stood a young, white-clad lady.

Bernadette tried to cross herself . . .

From Song of Bernadette, 1943.

wishing you all a corny, old fashioned sentimental Christmas

HaL – HeLEN FOsTER

Good Cheer!

MR. and MRS. HAROLD R. FOSTER

Christmas Greetings
1967

GOD REST YOU MERRY GENTLEMEN...
YEAH! YEAH! YEAH!

MUSIC BY **HAL FOSTER**
LYRICS BY **HELEN FOSTER**

Now, Val, don't be so grumpy — the HAL FOSTERS just want you to go out and wish all their friends the BEST OF EVERYTHING in 1977.

HELEN AND HAL FOSTER
MAY ALL THE LITTLE HAPPENINGS OF
1947 BE HAPPY ONES

Enough Good Wishes
to last the
Seasons 'round

THE H. FOSTERS

WE HOPE ALL
YOURS COME
TRUE

MR. and MRS. HAL FOSTER

May Your Christmas be full~

of Pleasant Surprises

MAY EVERY INGREDIENT OF
A HAPPY XMAS BE YOURS
HAL / HELEN FOSTER

Season's Greetings 1966

HELEN AND HAL FOSTER

GREETINGS!
THE FOSTERS!

Good Will
to All

Ye Merrie Christmas Applesauce

What if our Christmas card is late,
you always have our best wishes.

HELEN and HAL FOSTER

To Helen and Hal Foster 1945

Season's Greetings

MAY YOUR HAPPY
MOMENTS MULTIPLY

BELOW: Foster did the six-panel life's story in 1959.
Even after 44 years of marriage Helen remained
Hal's "neat blond".

"Old Stuff"
OUR CHRISTMAS GREETINGS
The H. Fosters

WE GIVE THANKS THAT
YOU HAVE CROSSED OUR
PATH AND SO HAVE MADE
THE WAY BRIGHTER

HELEN AND HAL FOSTER

1954

"SANTA, YOU ARE UNDER INVESTIGATION"
"YEAH, WHERE'D YUH GET THE MONEY FOR TOYS?"
"I WANT TAPES, I NEED 'EM."

"COME, RIDE WITH ME THIS CHRISTMAS"

HELEN AND HAL FOSTER
WISH YOU

A BRAVE CHRISTMAS
AND A VICTORIOUS
NEW YEAR

CHEERIO!
THE HAL FOSTERS'

MERRY RATIONS
AND
HAPPY PRIORITIES
HELEN AND HAL FOSTER

Season's Greetings
1975

HELEN
HAROLD
FOSTER

"Hello Santa, hope you like the warm weather,
we'll be here in Florida from now on."

BEST WISHES TO ALL FOR 1970
Helen and Hal Foster

May all good things
Come your way
in 1979

Hal and Helen Foster

Christmas '64

A toast to the pleasant memories
of the past and hope of
more in the future.

Helen and Hal Foster

IT'S SANTA CALLING FOR BAIL MONEY, HE'S
SET OFF ANOTHER BURGLAR ALARM!

' WHY DIDN'T YOU TELL ME
YOU HAD MOVED TO FLORIDA ? '

THOSE DARNED ECOLOGISTS
HAVE GONE TOO FAR

ABOVE: An unused card done in 1972.

"As a fellow artist, I wish to tell you how greatly I admire your exquisite drawings for Prince Valiant. I find this series, with its interesting story and brilliant drawings, one of the most outstanding newspaper features of the present time. 'Hats off' to you and King Features for presenting to this troubled old world such a charming, refreshing and educational series of adventures."

—Willy Pogany, Illustrator
Designer of the Silver Lady Award

E • L • E • V • E • N

The

SPOILS *of* WAR

Prince Valiant

IN THE DAYS OF KING ARTHUR
BY HAROLD R FOSTER

SYNOPSIS

WHILE TAKING THEIR PRISONER, THE ROBBER KNIGHT, SIR NEGARTH, TO CAMELOT TO BE JUDGED BY KING ARTHUR, PRINCE VALIANT AND SIR GAWAIN BATTLE A STRANGE MONSTER AND ARE SAVED BY THE HEROIC CONDUCT OF SIR NEGARTH. VAL PLEADS IN VAIN FOR SIR NEGARTH'S FREEDOM.

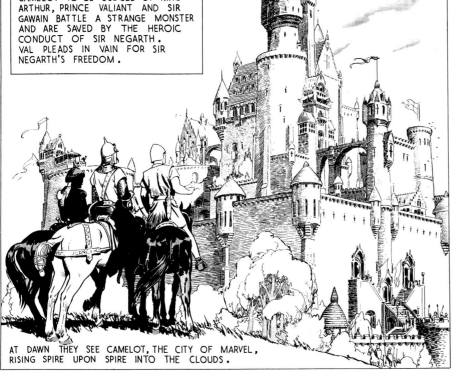

AT DAWN THEY SEE CAMELOT, THE CITY OF MARVEL, RISING SPIRE UPON SPIRE INTO THE CLOUDS.

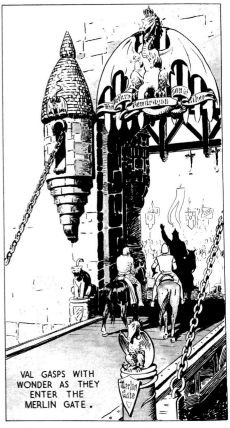

VAL GASPS WITH WONDER AS THEY ENTER THE MERLIN GATE.

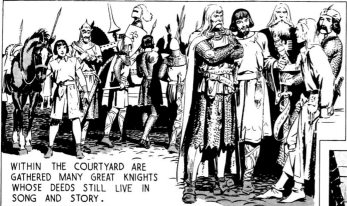

WITHIN THE COURTYARD ARE GATHERED MANY GREAT KNIGHTS WHOSE DEEDS STILL LIVE IN SONG AND STORY.

DESPITE VAL'S PLEA THE GALLANT SIR NEGARTH IS LODGED IN A CELL TO AWAIT HIS JUDGMENT.

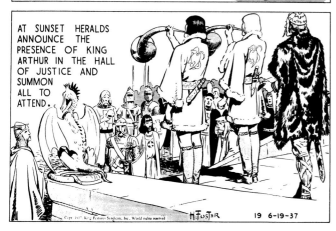

AT SUNSET HERALDS ANNOUNCE THE PRESENCE OF KING ARTHUR IN THE HALL OF JUSTICE AND SUMMON ALL TO ATTEND.

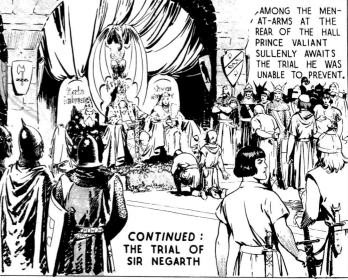

AMONG THE MEN-AT-ARMS AT THE REAR OF THE HALL PRINCE VALIANT SULLENLY AWAITS THE TRIAL HE WAS UNABLE TO PREVENT.

CONTINUED: THE TRIAL OF SIR NEGARTH

19 6-19-37

Arthur "Bugs" Baer and Jimmy "Ward" Greene congratulate Hal on his "Lady".

Prince Valiant became one of the most successful comic series of all time, winning many awards from both peers and parents' groups. In 1938, Hal won a First Place for Prince Valiant page #19 at the Kansas Free Fair—it was the first of many honors for the strip.

On November 6, 1952, he received the Banshees' The Silver Lady Award as the "Outstanding Cartoonist of the Year." It was the industries' equivalent to the Oscar. Foster was only the sixth person to receive the prestigious award at a luncheon held in his honor in the Grand Ballroom of the Hotel Waldorf-Astoria. Arthur "Bugs" Baer was the Master of Ceremonies and the entertainment included Milton Berle, music by Meyer Davis, Les Compagnons de La Chamson, and Alice Ghostley and the cast of Leonard Stillman's Musical hit New Faces, which performed scenes from the show.

In 1954, Parent's Magazine gave Hal their Gold Medal Award, and in 1958, he was given The Reuben Award by the National Cartoonists Society for "Outstanding Cartoonist for 1957." He was also awarded the National Cartoonists Society plaque for Best Story Strip in 1964, and the National Cartoonists Society plaque for Special Feature in 1966, and 1967. In 1969 he received the SAM Award from The Swedish Academy of Cartoons, and in 1975, the National Cartoonists Society Silver T-Square Award, which was presented to him by Bill Gallo at Fred Waring's annual outing. In 1977, after nearly 50 years of writing and illustrating Adventure Strips, Foster was given the Golden Key to the Hall of Fame of the National Cartoonists Society. Hal was the first living artist elected to The Museum of Cartoon Arts Hall of Fame, and Prince Valiant was chosen as the Best Comic of all German-speaking countries. Finally, in 1978, he received the Elzie Segar Award for "Outstanding Contributions to the Art of Cartooning."

OPPOSITE: The award-winning Prince Valiant, page #19.

When he was living in Topeka and working on Tarzan, Hal continued to paint and entered several pieces in the *1936, Kansas Free Fair*. In total he won 2 Firsts (Oils), 2 Seconds (Watercolors), and 1 Third (Oil—ribbon not shown). The titles on the ribbons are: "Quiet," which is in the Color Gallery, "Shylock," and "Merchants of Bagdad" for which no images have survived to date, and "Marine Phantasy," which appears in the photo below. The titles have been copied unedited and retain Hal's uniquely misspelled words.

Hal also made numerous radio and television appearances including: "The Original Amateur Hour" with Ted Mack, "The Frank Luther Show," "The Ray Dorey Show," Dave Garroway's "Wide Wide World", the "Today" show, and "To Tell the Truth" (from which he gave his winnings to the Mark Twain Public Library in Redding, Connecticut).

Foster was a member of The Banshees, the Newspaper Comics Council, the National Cartoonists Society, the Metropolitan Museum of Art, the Saugatuck Fish & Game Club, the Ridgewood Country Club, and was made a Fellow of the Royal Society of Arts of England.

Hal accepts his Reuben Award from Rube Goldberg.

REMINISCENCE

Hal Foster lived near me in Connecticut and we saw a lot of each other. We partied, had bull sessions and I learned a lot from him.

In 1950, when I first joined the National Cartoonists Society, Hal made a speech that devastated me. He said that comic strips were on their way out. Editors don't like them. They cost too much and take up editorial space. I had just sold *Beetle Bailey* to King Features and hoped to have a long and happy career. I called my editor the next morning and told him what Hal had said. "Forget it," he told me. "There are always prophets of doom. Comics are the most popular part of the newspaper and editors need them." My editor was right. Fifty years later *Prince Valiant* and *Beetle Bailey* still thrive. In 1957 Hal won the *Reuben* from The National Cartoonists Society as the Best Cartoonist of the Year and had previously won *The Silver Lady Award* from the Banshees Society, a group containing editors of the foremost newspapers in the country.

George Wunder (Terry and the Pirates) pays tribute to Hal.

JOHN CAMERON SWAYZE

October 29, 1952

Dear Mr. Foster,

 It is a privilege to add my con-
gratulations to the many you will receive
as a result of winning "The Lady" for 1952.

 "Prince Valiant" is simply wonderful.
I have always been interested in history
and your painstaking efforts in this re-
gard makes the feature particularly appeal-
ing to me. This, plus your spendid art
work, make it little wonder that your fans
are of all ages.

 Again, congratulations. You deserve
it.

 Sincerely,

[signature]

NBC NEWS **NEW YORK**

Hal told me once that he was starting to charge $5.00 to fans who wanted one of his originals, "to discourage them," he hoped. Today his originals sell for around $10,000.00 each. He is considered one of the greatest comic strip artists of all times.

—Mort Walker

In addition to The Silver Lady Award, Hal received a 4-inch thick book (below) containing hundreds of letters from peers, educators, congressmen, and almost every editor within the Hearst group. The book came complete with a drop-down drawbridge and a pop-up Val redesigned to hold the "Lady" in his hand.

156 •

WALT DISNEY

November 6, 1952

Dear Hal Foster -

I welcome the opportunity of joining the Banshees
and your legions of friends and admirers in ac-
claiming you as the outstanding newspaper artist
of the year. It is an honor that you richly de-
serve and which will find no dissenting vote.

With your PRINCE VALIANT you have brought new
prestige and dignity to the field of newspaper
cartooning. Your magnificent drawings and your
colorful continuities are providing a superior
brand of entertainment for Sunday newspaper
readers across the nation and abroad. And PRINCE
VALIANT is more than mere entertainment. The en-
dorsements by educators and parent-teacher groups
attest the beneficent influence on youngsters and
adults alike of your authentic re-creations of by-
gone historical characters and events.

I congratulate you on "The Lady" Award which so
fittingly symbolizes your splendid achievements.

Sincerely,

Mr. Hal Foster
King Feature Syndicates
235 East 45th Street
New York 17, N. Y.

WD:DV

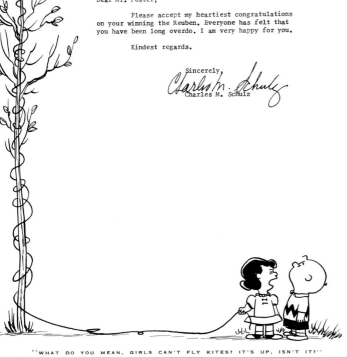

CHARLES M. SCHULZ
112 WEST MINNEHAHA PARKWAY
MINNEAPOLIS 19, MINNESOTA

April 28, 1958

Dear Mr. Foster,

Please accept my heartiest congratulations
on your winning the Reuben. Everyone has felt that
you have been long overdo. I am very happy for you.

Kindest regards.

Sincerely,

Charles M. Schulz

"WHAT DO YOU MEAN, GIRLS CAN'T FLY KITES? IT'S UP, ISN'T IT?"

WHEW! IT WAS A LONG ROAD
DOWN HERE TO FLORIDA.

"A NEW INVENTION!
WHAT WILL THEY
THINK OF NEXT?"

ELECTION YEAR IN THE 5TH CENTURY
"NOW CITIZENS, YOU ARE FREE TO VOTE FOR THE
TYRANT OF YOUR CHOICE. SO VOTE, VOTE AS IF
YOUR LIVES DEPENDED ON IT! AHEM."

AN EPICUREAN TREAT FOR THE
N.C.S. DINNER, COURTESY OF
PRINCE VALIANT.

"DONT USE SUCH LANGUAGE VAL! I ONLY
WANTED TO SEE HOW YOU MIGHT HAVE
LOOKED IN 'THE TWENTIES'"

𝕎HEN THE DAYS TOIL IS
ENDED IT IS NICE TO RELAX
WITH THE BOYS OF THE N.C.S.

Hal contributed many cartoons for use in various
National Cartoonist Society publications. The cartoons
allowed him to poke fun at Prince Valiant and to show
off his more humorous side.

IT IS NOT TRUE THAT PRINCE VALIANT
WINS THEM ALL!

Prince Valiant

IN THE DAYS OF
KING ARTHUR

HAL FOSTER

HAL FOSTER

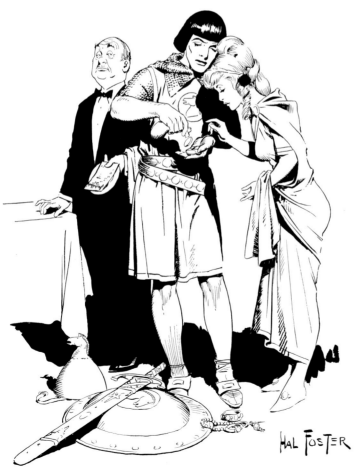

HAL FOSTER

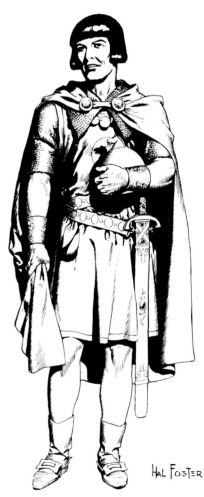

HAL FOSTER

PRINCE VALIANT
25TH YEAR

N.C.S. 16TH
BIRTHDAY

HAL FOSTER

"Come out Sir Philphot and fight like a man!"
"I can't buster, these iron pants are rusted on."

TOP: *Members of the National Cartoonists Society from left to right: Gene Basset (Political Cartoonist), Rube Goldberg (Classic Cartoonist), Karl Hubenthal (Sports Cartoonist), Milt Morris ("Neighborly Neighbors"), Al Smith (hidden, "Mutt & Jeff"), Art Wood (Writer), Walt Kelly ("Pogo"), John Stampone (Editorial Cartoonist), Roger Stevens (Comic Writer), Bill Sanders (Editorial Cartoonist), Milton Caniff ("Terry and the Pirates" and "Steve Canyon"), Mort Walker ("Beetle Bailey"), Ronald Madsen (Attorney), Dik Browne ("Haggar the Horrible"), Hal Foster ("Prince Valiant"), and Bob Dunn ("They'll do it Every Time").*

ABOVE: *Hal enjoyed producing cartoons for the NCS. Here are two of special importance. the one on the left was done in 1962 to celebrate the dual birthdays. The one on the right appeared in the NCS publication "The American Cartoonist", vol. 1, #5, May 1979, and was the last Prince Valiant cartoon he ever did for publication.*

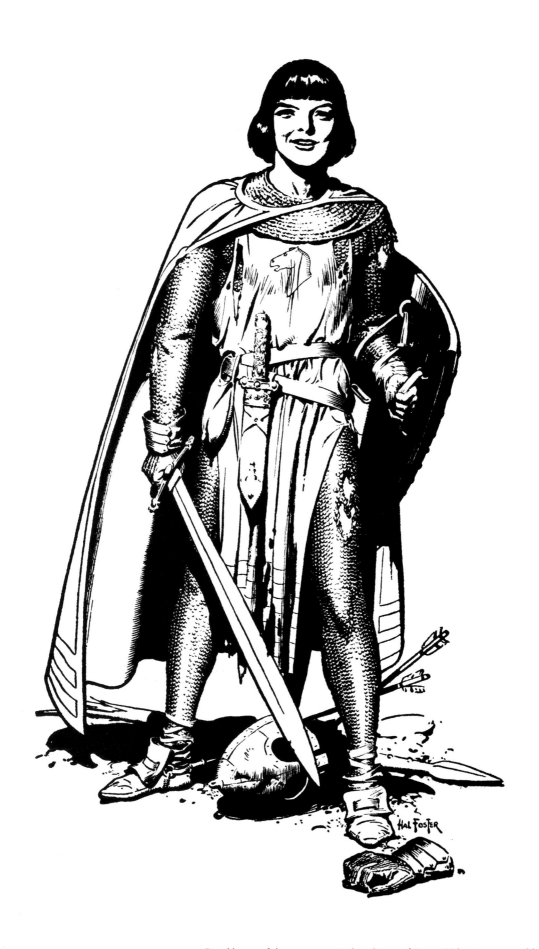

Possibly one of the most recognized renditions of Prince Valiant ever created by Hal Foster.

"I like your Prince Valiant very much. It offers romance and adventure in a weekday routine, and excellent recreation for the mind and nerves in the hustle of our times."

—Erik von Frenckell
Mayor of Helsinki and President
of the Organization Committee of
the 1952 Olympic Games

T • W • E • L • V • E

BEYOND CAMELOT

The magic of
CinemaScope
brings you the Viking world of

20th
Century-Fox
presents

Prince
Valiant

In The Wonder of Stereophonic Sound!
Color by Technicolor

...in full battle array...in full panoplied spectacle...in full-visioned splendor!

CinemaScope is your sword, your shield, your lightning charger...as you storm the castles of infidels with the Viking Christians...as you fight at the tournaments of Camelot with the noblest Viking of all...in the most beloved story in all adventuredom!

Starring

James MASON · Janet LEIGH · Robert WAGNER
Debra PAGET · Sterling HAYDEN

with VICTOR McLAGLEN · DONALD CRISP · BRIAN AHERNE · BARRY JONES
MARY PHILIPS · HOWARD WENDELL · TOM CONWAY · and a CAST OF THOUSANDS!

Produced by ROBERT L. JACKS · Directed by HENRY HATHAWAY · Screen Play by DUDLEY NICHOLS

Based on King Features Syndicate's "Prince Valiant" by Harold Foster

S I G N A T U R E

MAT—402

PREVIOUS PAGE: Janet Leigh and Hal at the ROXY Theater in New York City awaiting the premier of Prince Valiant.

Prince Valiant premier at Grauman's
Chinese Theater.

Hal didn't like what Hollywood did to Prince Valiant, and he always said that he was happy that he took a flat fee of fifty thousand dollars for the rights rather than a cut of the royalties. "The movie brought in the most money in one chunk I've seen at one time. Most of it went in income taxes, but I had enough left over for a new dining room and a trip to Europe."

While the quality of the story and acting in *Prince Valiant* may be lacking, the score for the film is one of the finest from this era. Composer Franz Waxman (1905-1967) is the only person to have won an Oscar for Best Score in two consecutive years. The first was for Billy Wilder's *Sunset Boulevard* in 1950 and the second for George Steven's *A Place in the Sun* in 1951. Waxman always considered his score to the 1954 film *Prince Valiant* to be one of his greatest achievements. It is dynamic and vibrant and is representative of the best in film music from the Golden Age of movies. The action piece for "Sir Brack" is thrilling and the love theme, "Val and Aleta" is a beautiful example of the genre.

One of the finest and most prolific composers in Hollywood, Waxman was also a con-summate conductor and impresario. He was brought to the United States by Erich Pommer to serve as Musical Director for the Jerome Kern-Oscar Hammerstein II film *Music in the Air* for FOX Films in 1934. Waxman's first Hollywood score was for James Whale's 1935 horror classic *The Bride of Frankenstein*. Parts of this score were later used in *Flash Gordon's Atomic Rocketship* (1935), *Flash Gordon's Trip to Mars* (1938), *Flash Gordon Conquers the Universe* (1940), and recently, *Small Soldiers* (1998) and *Gods and Monsters* (1998). Additional movie scores of particular interest to Adventure Strip readers includes *Secret Agent X-9* (1937), *Jungle Jim* (1936), and *Earth Girls are Easy* (1989) which contained music from *Prince Valiant*.

Trained in Europe, Waxman wrote lush orchestrations with big, symphonic sound. Some of the 144 films Waxman scored in his 32 years in Hollywood that showcased his versatility were: *Rebecca* (1940), *Peyton Place* (1957), *Spirit of St. Louis* (1957), *Mister Roberts* (1955), *Rear Window* (1954), *Dark Passage* (1947), *To Have and Have Not* (1944), *The Philadelphia Story* (1940), and one of the first Jazz scores, *Crime in the Streets* (1956).

The music for *Prince Valiant* is noticeable today in film scores by Jerry Goldsmith and John Williams. The second track contains Goldsmith's fanfare for *The Shadow* (1994), and the third track contains a motif Williams would later use in *Star Wars: The Phantom Menace* (1999). It was not the first time the body of work of this Golden Age genius was used in a George Lucas film. In 1970 Franz Waxman's music for *Buck Rogers* (1940) made it into the score of Lucas' *THX1138*.

Previous section edited by Franz Waxman's son, John W. Waxman.

A CARTOONIST'S OPENING NITE
by Hal Foster (with Bill Crouch, Jr.)

The movie of *Prince Valiant* was a beautiful thing. The people who made it wanted me to come out to Hollywood but I declined. I knew damn well it would be a waste of my time. The producers of the film had their minds set on making the script a bit childish which was all right.

When I was later on the "This is Your Life" television show I met most of the actors. Robert Wagner who played Val told me he was in fact a fan of the comic strip.

The film opened at the Roxy theater in New York City. It was a gala affair and as requested Helen and I sent out invitations to all our personal friends to come to the film's debut. A special section of the balcony was reserved for us, or so we were told.

The evening of the opening Helen and I stood in the foyer of the theater and greeted our guests and did the usual public relations stuff. We were among the last people to actually enter the theater and we found we had no tickets. The ushers were determined to throw us out as gate crashers. Only the timely intervention of somebody from King Features got us seats at all.

However, we were seated—not in the special reserve section but up front and on the side. That section of the audience seemed to be populated by a group of drunks who criticized the film throughout. They had no idea who we were.

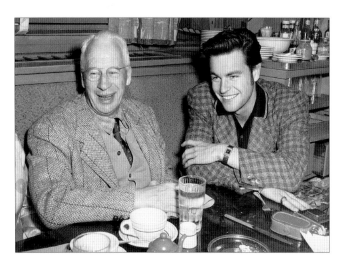

ABOVE: Hal was given a chance to visit the Prince Valiant movie set after he appeared on "This is Your Life."

LEFT: With Prince Valiant film star Robert Wagner.

As soon as the movie was over, Helen and I went to Grand Central Station and caught the train for Redding and home, feeling very bad about the film. At the gala party following the debut people kept asking, "Where's Foster?"

I was on my way home to lay my head under a pillow. However, the film did get good reviews and was considered a great success. This we didn't learn until the next day.

REAL ESCAPE IN REEL LIFE
(JULY 21, 1953)

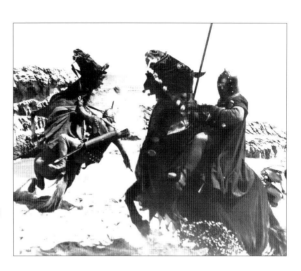

Calabasas, California. Hollywood actor James Mason narrowly escaped death today in the filming of a spectacular scene from his new motion picture, *Prince Valiant*. Mason was riding down a cliff when his horse (right), slipped in the soft dirt, catapulted the actor from his saddle, and rolled over him twice. Fortunately Mason rolled with the horse, escaping the brunt of the horse's weight. This exclusive photo shows the actor being thrown from his mount.

BELOW LEFT: The strip also generated merchandise outside of the Sunday comics. In addition to the sword, shield, and archery sets there were toy knights complete with castle, a board game, paper dolls, candy bars and even a painted briefcase.

BELOW RIGHT: Not only children were targeted by the merchandisers. The ad below, taken from one of the Foster scrapbooks, appears as it did in 1954— complete with Aleta in the panel insert.

From left-to-right: Mrs. & Mr. Sidney "Sid" Metcalfe, Lillian Cook, Bob Jacks, Terry Moore, Robert Wagner, Janet Leigh, Debra Paget, Brian Aherne, Ralph Edwards, Victor McLaglem, Hal Foster, Helen Foster, Joe Neebe, Bradley Kelly.

On April 14, 1954, Hal went to California believing that he would be receiving another award. Instead he was the subject of Ralph Edward's television show, "This Is Your Life." Eric Bergman, Syd Metcalf, Paul Proehl, Charles Armstrong, Joe Neebe, Bradley Kelly, Robert L. Jacks (producer of the *Prince Valiant* film) and many of the movie's cast were all in attendance to surprise Hal. It wasn't revealed until later that Eric, who left after his part, almost lost his job because his boss refused to give him the time off to attend the show.

A copy of the original film was found during the writing of this book and was restored by Syracuse University.

The man who started it all, Joe Neebe, laughs with Ralph Edwards and Hal.

Hal gets pointers from Victor Mature on the set of
Demetrius and the Gladiators *(1954)*

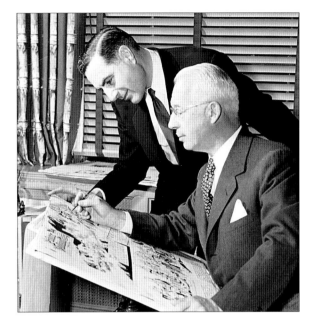

Ted Mack of NBC-TV's "Original Amateur Hour" and Hal.

*Helen and Hal Foster have dinner at The Stork Club with
Harry Foster Welch, better known as the voice of Popeye.*

*Babe Ruth, Jimmy Halto ("They'll do it Every Time"),
and Hal Foster.*

Hal with Milton Berle at the 1952, Banshee's Luncheon.

Hal is knighted in the name of Hermes and the Knights of his Empire.
Prince Valiant was the theme for both the 1955, and the 1967, Mardi Gras parades.

Hal shakes hands with the former King of
England, and one of Prince Valiant's biggest
fans, Edward, Duke of Windsor. King Features'
General manager, Jimmy "Ward" Greene looks
on as well as "some English bloke."

"The only testimonial to Dad that I could contribute that would sum up what I honestly know about him and which at the same time would have meaning to him is: 'He still paddles stern in my canoe.'

"I would like to say something nice about Prince Valiant too but as a romantic and an interesting character he pales in comparison with his creator, besides I don't know him as well."

—*Edward "Ted" Foster*

T·H·I·R·T·E·E·N

The

ROYAL
FAMILY

FOR 36 YEARS YOU HAVE DELUDED ME INTO
THINKING YOU THE LOVLIEST THING IN THE
WORLD. I STILL DO. LOVE YOU, I MEAN.

Harold.

The artwork in this section appears here for the first time and most of it has been reproduced at original size.
The lenses of the glasses Hal is wearing on this page are actually painted pink roses.

NOW I WONT
BE
LONESOME
ANY MORE

me either

53 YEARS A VALENTINE

Prince Valiant was a love story—not between Val and Aleta, for they were only minor characters, but between Hal and Helen. It was Hal's grand ballad to his lady fair, which is why he called it an "Illustrated Romance." For over three decades he lovingly shared his epic adventure throughout the countries of the world, and when he could no longer strum the cords he let others pick up the music, while he continued to sing the songs. Every day before going to his studio, Hal wrote a short note or poem to his "darling frump" and placed it on the saucer under her Irish teacup—every day. They played golf together, bowled together, and always ate dinner by candlelight together. Hal loved and adored Helen, and it is a truth against which there can be no doubt or debate. And they even hunted together—sort of.

> This duck hunting has become an obsession with Helen and I, for we have spent much time, much money and have twice nearly lost our lives for a mere handful of mallards and a few hangovers. I hunted wild doves in Kansas and for three days my shooting was brilliant. I got my limit of pheasants and even though I had to hunt with Herb Ulrey and his dog I got my birds and refrained from shooting Herb and his dog…no mean feat of repression too! For three days I shot quail and fairly distinguished myself (I am a naturally poor shot) but ducks! Goddam!
>
> I have a better hunting dog than Herb will ever get…my Helen. She can point out a convoy of quail, find the dead birds and spot where the convoy lands and kick over till she drops. She will sit in a windswept blind all day spotting approaching

THE PROP

Hal once said: "Helen is my secretary, housewife, treasurer, pet, business manager, companion in crime and even at times has been used as a hunting dog." The cartoon that he drew (left) is a true indication of how integral Helen was in Hal's life. Helen ran the household and kept order. Without her behind him, Hal would probably still have been able to create *Prince Valiant*, but it is unlikely he would have been able to sustain the high quality of craftsmanship he achieved for very long.

OH HELEN, SIXTY THREE ST VALENTINES DAYS HAVE PASSED UNNOTICED. I DO NOT ASK FOR LOVE, PURITY, VIRTUE OR FAITHFULLNESS, ALL I AONLY ASK FOR FRIED ONIONS AND BACON FOR EVERY MEAL !

RENEWAL OF LEASE ON ONE HEART

Harold R Foster
VICTIM

ducks while the water in the bottom of the boat slowly turns to slush and has never complained about anything but my shooting. Herb will never be able to train one like that. Even if he does it will never be able to cook![1]

Hal was a guest lecturer and would discuss the history of cartooning and presented "chalk talks" to schools and universities. He did author a book on trout fishing titled The Journal and, if he'd wanted, he probably would have made a good novelist since he was always throwing out two-thirds of his text on *Prince Valiant*. His own life's story can be found intermingled in Val's adventures; however, one thing which Val never did that Hal managed, was to go on a vacation to Nassau aboard the Queen Elizabeth. It was a Cunard liner. It was an ocean liner from the same fleet of ships that he had paddled his raft in front of in Halifax harbor when he was eight. He'd come full circle, but he still had many more stories to tell.

"My work is a means to an end. I go on the theory that we should get as much enjoyment as we can in this little toddle from the cradle to the grave. A number of people over the years have told me I am great. But I know myself better than anybody else does. I have to look at myself in the mirror when I shave, and I ask myself, 'is this fellow so great?' I don't know why it is that some people can draw a little kid like Charlie Brown with just a round head, round nose, and no particular body, and yet give the thing a personality. I still can't understand that and see where the little things he says and the funny illustration seem more real than some of the best-drawn strips."

"It startles me when I read long letters from fans who tell me in detail stuff I've forgotten about. One lady wrote and asked if a character whose name I'd used in the 1940's was back in the strip as a grownup. I hadn't remembered I'd used the name before. Every now and then I go back through my set of tabloid stats and it's

all new. I'll spend a whole morning reading old *Prince Valiant* and then I think, 'My God, did I write that—boy I was good back then.' I think the story is at least as important as the artwork."

"Now my problem in writing the strip is that I can't steal from myself. When you get 81, you realize you're no longer young. Ideas are harder to come by and your memory gets a little foggy. It's lonesome work, this cartooning. I know my faults and if I could get rid of them and acquire some courage and a good memory I'd be like Valiant. It would be nice to say I'd ward off the blows of my enemies with my 'singing sword' and it would be nice to be as brave as a lion—as long as you don't have to be."

It took a Man, a Maid and a Knight but we finally made it!

Hal also produced several birth announcements for the family. These were for his granddaughter Lucy's children.

MEET HAROLD R. FOSTER

By Edgar W. Brown for King Features Syndicate

Foster enjoys gardening, horseback riding and golf, while his favorite spectator sports are football and baseball. He enjoys music, although he can neither play nor sing, and he likes the movies. His favorite actor and actress are Leslie Howard and "any actress who has good legs."

Six feet tall, weighing 185 pounds, with platinum gray hair, he favors clothes that are neither overly conservative or nor exceptionally bold. He prefers to go without a hat and shuns a cane. He drinks nearly any type of liquid except milk and smokes vast quantities of cigarettes in addition to his pipes. In regard to food, he is slightly epicurean.

His greatest ambition is "to enjoy this life as fully as possible" and his plans for the future call for "more

This Is The Population Explosion ?

leisure and a little more money, if possible." He plans to retire only "when my work becomes a bore, because then I will have become a bore too, since my work is my own creation."

Perhaps giving a better picture of Foster than anything else is what might be described as his recipe for success:

"A varied knowledge that one may understand and enjoy a great variety of things—to understand is to appreciate, to appreciate is to enjoy. Success is not wealth and the accompanying approbation of people for whose opinion one does not give a tinker's damn, but the ability to enjoy every minute of every day. I would say that real success is earning a living at a job in which you are vitally interested, which is part of yourself, and having the deep satisfaction of seeing that work grow and improve.

HELLO!!

This is "Butch" Foster

and I wish to announce —

"The piling up of possessions is regarded with such approval that many incompetents strive to do so all their lives. Monkeys and blue jays also collect bright objects. So few people take time off to enjoy what they already have that trout streams and hedgerows are left for such leisurely incompetents as I. To contribute something lasting to the sum of human knowledge or enjoyment is, to me, the real success."

MRS. FOSTER
THANK YOU FOR
A VERY NICE
DINNER
I AM SLIGHTLY
FOND OF YOU
FROM THE DESK
OF HAL FOSTER

I HAVE ALWAYS LOVED YOU BUT HAVE KEPT MY PASSIONS UNDER CONTROL, SO WEAR THIS ESSENCE AT YOUR PERIL AS IT MAY AROUSE THE SLEEPING SATYR IN ME
HAROLD

Dec 1969

HAL FOSTER DERIDES SUPERSTITIONS:

"Primitive people are, as a rule, superstitious; a glance through this book will bear me out, I am sure. As one of the higher types, the product of millions of years of evolution, I feel qualified to inform the less fortunate of my contemporaries that there is no such thing as *luck*.

"As an artist of supreme talent, a philosopher of astounding wisdom and a poet equally mediocre, I am definitely the sensitive type…sensitive, in fact, that I have the clear vision of the prophet. For instance…you have all heard the saying, 'It is lucky to fall upstairs'. Not only do I disagree with that superstition but, with my gift of prophecy, I can predict just what degree of pain and misfortune will befall me if I happen to trip on the way upstairs!

"Say it happens at 10:30 P.M. I hear: 'Did you hurt yourself, darling?' The same occurrence at 12:30 brings forth a muttered 'Clumsy.' At 2:30 A.M. my ears might be assailed with a tirade that would not look well were I to repeat it.

"But to fall upstairs at 3:30 A.M.? Boy, IS THAT UNLUCKY!"

—Cartoon and text from *Jinxes and Jonahs*, 1943

THE PRE-NATAL INFLUENCE

To { LIEUT. ARTHUR J. FOSTER
{ DORIS DOUGLAS FOSTER

THERE HAS COME A SMALL MALE
BUNDLE, TO BE KNOWN HEREAFTER
AS;—
DOUGLAS FOSTER.
THE PARENTS WERE CONFRONTED
WITH THIS 6" 8¾ oz PROBLEM
AT 2.05 FRIDAY MORNING AUG.
20TH. 1943

DOUG. LOOKS LIKE HIS FATHER,
AND BOTH PARENTS AGREE UN-
ANIMOUSLY THAT HE IS THE
MOST WONDERFUL BABY OF THE
CENTURY. A BRIGHT FUTURE
IS PREDICTED.

"Okay! Okay! Go ahead and go to your old poker game!"

ABOVE RIGHT: Found in one of the Foster family's scrapbooks, Bill Yates' cartoon is a pretty good indication of just how much Hal liked to play cards. Original source unknown.

HAL FOSTER

THE TRUTH BEHIND YOUR HANDWRITING

by Agnes C. Lukens
(May 4, 1958)

Among the hundreds of you who have written in for your personographs, today is one who says, "I imagine it is quite simple to analyze popular and famous people with varied accomplishments, and then associate their successes with the crossing of the 't' and the dotting of the 'i's," etc...." Which is so true!

For this is the foundation on which Grapho Analysis was built. Certain types of strokes were found to appear in the writing of people who did things one way, until it was established, years ago, that making of a stroke one way indicated the brain of the writer worked one way, making the same strokes another way showed the brain of that writer worked another way. While talents are not always that apparent on the surface in a handwriting, they can be learned through evaluation, and the traits of character that enable one to become a success or to court failure are there to be read by the grapho artist.

By a signature, we generally think of a name written in script, but occasionally we come upon one, which is printed, as is today's specimen. And, since the characteristics are learned through a breakdown of each stroke, it is quite possible to point to the outstanding traits from the printed signature.

Noticeable, all at once, in the signature of Hal Foster, Connecticut artist whose *Prince Valiant* comic appears weekly in the paper, are the judgment and poise which will always rule against his emotions, the complete lack of ostentation which prevails, and the creative ability of the hands.

There is dignity in this signature and pride, which marks one who will never be satisfied to give less than his best. Determination is present, as is tenacity. And there is evidence that he has sought to overcome some habit he has found detrimental. He is definite in his thinking, likes to dictate to others, and is inclined to anticipate and resent imposition. He is not narrow minded or intolerant, and he keeps many things to himself.

See what I mean? The creative ability with the hands and the love of simplicity that mean so much to the artist are there, but without the other traits of character found in this signature, the man would not have been the successful artist he is.

Edward Lusher Foster
Prince of Thule

Edward Lusher "Ted" Foster went to Kansas University where he earned a degree in Engineering. It was there that he met Margaret Ermine Lucy who he married in 1938. After a short stint in the Navy, which was cut short when they realized he was still considered a Canadian citizen, Edward took a job with *"Hanna Engineering Works"* in Chicago where he worked his way up to the position of Sales Manager of Hydraulic Cylinders and Valves. Around 1952, the family moved to Michigan after he bought into *"Industrial Air & Hydraulic Equipment Company"* a hydraulic and pneumatic systems distributorship. The items that they sold went mostly to OEM's (Original Equipment Manufacturers). The OEM's in turn built machinery not only for all of the major automotive plants but also for the food and forestry industries. While he may not have been as comfortable at the drawing broad as Hal and Arthur, he was quite proficient behind the drafting board. He was a consummate engineer and he helped design one of the first pneumatic logic systems for the automotive industry.

Edward inherited Hal's love of the sea and spent a lot of time on Lake Michigan, Lake Huron, Lake Sinclair, and Lake Superior—even after he nearly lost his leg in a boating accident. Edward named his boat the "Lil ELF" (after Edward Lusher Foster) and designed a special logo, which Hal illustrated. Whenever Hal and Helen visited it was always understood that the trip would include some fishing.

Edward and Margaret had four children: Errol Edward "Butch", Robert James, Lucy Ann, and Mary Margaret. Edward died in 1985, almost two years after Helen.

The Lil ELF logo.

OPPOSITE RIGHT: Panels 2, 6, & 7 from page #674, January 8, 1950, detailing Hal's message to his son, Arthur. It got by King's editors.

Arthur James Foster
Prince of Thule

Arthur received a degree in Chemistry from Virginia Polytechnic Institute. He then went on to M.I.T. and completed a Masters Degree in Chemistry. While in Virginia he met and married Doris Douglas, of Roanoke. The couple had a boy named Douglas and Doris was pregnant with Suzanne while Arthur was serving in World War II. During the war he was made a 1st Lt. and saw action in North Africa, Sicily, Italy and it was while stationed in Germany that he received a "Dear John" letter. Devastated, Arthur returned from the war and left for California without telling anyone where he'd gone.

Hal turned to the only means at his disposal in tracking down his son. Foster knew that no matter where he was, Arthur would be reading *Prince Valiant*, so he changed Squire Geoffrey to "ARF," an old nickname of Arthur's, and in page #673, which appeared on January 1, 1950, he wrote: "Arf! Arf, my boy! My search is ended! I have found you! Come home with me...that awful woman is gone." Arthur returned home.

In 1952 Arthur began teaching Drawing, Painting and Composition at The Art Students League in New York where he was also President from 1958–1964. Arthur played golf up until the day Helen beat him and was an avid sportsman. He died in 1996.

THE RIOTOUS GREETINGS ARE FURTHER COMPLI-CATED BY A STRANGE VOICE CRYING: "ARF, ARF, MY BOY, THAT AWFUL WOMAN IS GONE. YOU ARE FREE TO COME HOME!"

"SHE CAUSED ARF TO RUN AWAY FROM HOME. A FEW MONTHS LATER SHE WAS PROVED AN UN-FAITHFUL WIFE. GALLANT SIR HUGO WISHED TO PRESENT HER WITH A HEMPEN NECKLACE BUT SHE DISAPPEARED!"

GEOFF, OR RATHER ARF, FEELS A GLOW OF HAPPI-NESS. HE IS, AFTER ALL, LITTLE MORE THAN A CHILD AND HOME IS A PRECIOUS PLACE NOW THAT THAT WOMAN CAN NO LONGER TROUBLE HIM.

MY VALENTINE! LOOK AT HER, SHE
HAS'NT CHANGED IN FIFTY YEARS!

*"He was great! What else can I say? Whenever anyone tells you
they came up with something new and innovative—Foster did it
first. I would have loved to have done* Prince Valiant *but you just
don't follow an act like Foster."*

—Al Williamson

KNIGHTS
of the
DRAWING
TABLE

Hal's son, Arthur J. Foster, had studied art and, starting in the early 1950's, assisted on *Prince Valiant*, inking backgrounds and coloring. Arthur and Hal had a "falling out" over Arthur's page rate, which never changed in the ten years he'd worked on the strip. For Arthur the situation was simply a matter of Hal not respecting his talent. Eventually the schism led to the two of them not speaking to one another except through Helen—even though they worked beside each other in the same studio. Arthur later referred to his situation with Hal as "The Norman Rockwell Syndrome" since "[Norman Rockwell's] son Jerry dropped out of [The Art Student's] League and went into TV because he had an icon for a father with whom he could not compete." To have followed his father on *Prince Valiant* would have been a thankless job and Arthur knew it. He never pursued inheriting the strip and keeping it in the family. It wasn't until Hal moved to Florida that Arthur and his father reconciled.

Beginning in the early 1960s Foster had started relying on Philip "Tex" Blaisdell to produce backgrounds for the strip and when he left, Wayne Boring picked up the pen. It's easy to distinguish between Foster's early pages and those in which he had assistants because Hal primarily inked with a brush and the others mainly used pen. Also, early Foster pages show a minimal use of white correction paint while the pages in the 1960's frequently have retouches. In 1971, Foster began actively seeking another artist to permanently carry on the strip. The decision was a hard one but arthritis had begun to affect his drawing and Foster refused to produce "amateurish work." Gray Morrow, Wally Wood, and John Cullen Murphy were all finalists and chosen to do tryout pages. All of the pages were beautifully crafted but only one artist could be chosen. Though Wood was seen by many as the leading exponent of the Foster style, Foster decided that Murphy, a former World War II field illustrator and creator of the strip *Big Ben Bolt*, would be his successor for reasons other than just carrying on the Foster art style. In an interesting tangent, Gray Morrow ultimately took over the *Tarzan* Sunday strip, which he produced for a record eighteen years.

"Gray Morrow and Wally Wood are both fine artists, I'd recommend them highly to anyone," Foster declared, "but as for *Prince Valiant*, they don't know the period, aren't familiar with the era and surroundings as Murphy is. Murphy knows the period, the background, and can execute what I want better. Morrow and Wood seem to be better for fantasy, which is what they've done the best. I just felt Murphy was the best." Murphy had been tutored by Norman Rockwell, and had studied anatomy under George Bridgman at The Art Student's League in New York. The one thing that really impressed Foster was how Murphy drew hands. "He gets so much expression in his hands. The expression on a face is confirmed by the hands." Foster's only advice to Murphy was that "Val should always appear royal, strong, and phlegmatic."

Foster originally wanted to finish the strip, bring it to an end, but since Murphy had eight children to support he decided to continue writing; he also took over water coloring of the strip from Hugh Donnell. "The first plan was that Prince Arn would grow up and that Val's father, [King Aguar] would die. He'd be killed in battle, of course, as that's the only thing that could be for a king like that. Val would inherit the throne and give

the Singing Sword into the keeping of Prince Arn. I kept delaying and delaying that because, oh, I expected to live a hundred years or something so I didn't want to get rid of him too soon. Artistically I should have ended the whole thing."

Arthur J. Foster

When I was asked to jot down what I thought Arthur was like as a person and as a friend, I immediately said "yes." That yes led me into a wonderful mind tour; I began reflecting about the many things that we had done together over the many years of our friendship. He was a gentleman. I never heard him swear, not even on the golf course after hitting a really bad shot. Instead he would make some long-winded remarks and his words were always far more biting than a few cuss words.

Arthur seated working with Hal to finish up a recent Prince Valiant *strip.*

We would each read the same book, one a week, then we would discuss what we read, in doing so Arthur made me become a better reader. He served in the Army, I in the Marines; we decided to read about the Navy. Morrison's *Naval History of WW II*, all 16 volumes, became a most enjoyable project. After that we read about the Civil War and we even walked the battlefields of Gettysburg together.

Architecture was of interest to both of us. Since I was in book publishing it was easy for me to get books we both enjoyed—Mumford, Sullivan, and Write were most notable. I rode with Arthur in his MG when he road-raced at Watkins-Glen. He, we, did not win, but instead spent the evening sitting in a restaurant/pub talking about Marcus Garvey.

One spring he invited me to join him in Central Park for kite-fighting. He had challenged some neighborhood men to a "duel". The "fighting" consisted of putting resin-grit on your monofilament line and cutting the other's line before they got yours. There were lots of words, mainly in Spanish, back and forth, which he understood and replied to.

He also invited me to scuba dive with him, I declined—I don't know how to swim. He did dive, however, with others, down to the Andrea Doria. I could go on and on, the beauty of it all was we enjoyed each other's friendship; be it sketching, talking over the dinner table, or just walking. He was a wonderful, wonderful person. May he be at peace.

—Geoffrey K. Mawby

Geoffrey K. Mawby succeeded Arthur as president of The Art Students League. He was the Vice President of Charles Scribner's Sons for many years. He and his wife, Jacquelyn, retired to Massachusetts where he continues to paint. He was the subject of a one-man show at the Summit Art & Frame gallery in New Jersey in 2000, and his works can be seen at the Chatham Art Gallery in Cape Cod.

Philip "Tex" Blaisdell

Tex Blaisdell did backgrounds for several comic strips, either to help out in emergencies or on a regular basis. Starting in 1967, I was a sometimes assistant to Tex. His most artistically rewarding—and time consuming—background work was for Hal Foster on his classic *Prince Valiant*. I had been surprised to see other comic book and strip artists' originals—whole acres of white out and corrections. Foster's were very clean, almost pristine works of art. The quality was truly impressive and not only his technique—the storytelling was first rate, too. How he sketched in the action, where he placed the body of view and the contrasts in his characters' body language—it was an education to ink him. Tex and I especially hated the battle sequences where everyone would be wearing chain mail! All those damn links. For decades after, when describing any difficult job. Tex would grumble, "It's one of those chain mails!" In the comics industry, gentlemanly behavior was absolutely not the everyday work pattern. Tex truly appreciated Foster's manners. His courtesy was such a pleasant relief to the usual New York abrasiveness."

—Lee Marrs

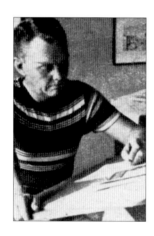

Wayne Boring

Wayne Boring was born in 1916, and studied illustration at the Chicago Art Institute and the Minnesota School of Art. After graduation, at the age of 22, he took a job with Jerry Siegel and Joe Schuster in their Cleveland, Ohio offices where he ghosted *Slam Bradley, Spy,* and *Dr. Occult.* When the demand for *Superman* became too great for its creators to supply new artwork, both Boring and fellow artist Paul Cassidy were the first to ghost the adventures of the "Man of Steel." Boring's melodramatic style played a major role in visually defining *Superman* and for the next 30 years he did almost no other work.

In 1968, when DC Comics fired several of the "old guard" artists, Boring began assisting Hal Foster by ghosting backgrounds for *Prince Valiant.* How Foster decided on Boring is still a question. Sylvan Byck, King Features' comics editor, tried to find a more suitable replacement and in 1969 sent Hal samples by a young artist named Gray Morrow. Boring continued on the strip until 1971 when John Cullen Murphy became the permanent replacement. After *Prince Valiant*, Boring worked for Marvel Comics on several titles including *Captain Marvel.* He died in 1982 after spending his final years as a bank security guard.

Wallace "Wally" Wood

Wallace Wood was born June 17, 1927, and studied briefly at the Minneapolis School of Art, and at Burne Hogarth's Cartoonists and Illustrators School (now SVA). His first comics job was as a letterer, inker and background artist on Will Eisner's *Spirit* in 1949. From there he illustrated romance stories for Fox and then went on to crime, romance, science fiction and horror for Avon. In 1950, he began working for William Gaines' EC Publications, and it was here that Wood's talents blossomed. He is considered by most as the greatest science fiction comic artist of all time and became the first star cartoonist at *Mad* magazine. He assisted Dan Barry on the *Flash Gordon* daily strip, and George Wunder on *Terry & the Pirates*. Wally also worked with Jack Kirby on the *Sky Masters* strip and at DC comics on *Challengers of the Unknown*. In 1965, he revolutionized *Daredevil* for Marvel Comics before going on to create the beloved *T.H.U.N.D.E.R. Agents* for Tower. The award-winning member of the NCS was instrumental in the creation of *Mars Attacks* for the Topps Co., and pioneered adult comics and self-publishing with *Sally Forth*, *Cannon*, *Vampirella*, *Witzend* and his Wizard King graphic novels. Wood cited Foster as his greatest influence.

—J. David Spurlock

Gray Morrow

Hal Foster was the man who brought illustration techniques to the comics page and influenced any number of aspiring artists determined to follow in his footsteps —a few succeeded in equaling that mastery—none have surpassed it. First he brought a realism and vitality to Edgar Rice Burroughs' *Tarzan* back in 1929 that eclipsed all other adventure strips. The jungle man has never been better served by an interpreter. I should know; then in 1937 came *Prince Valiant* and Foster literally topped himself with his epic saga of medieval times. And the quality of that feature never faltered—after 3 decades—a remarkable record.

I met the man briefly several years ago when he was auditioning for an assistant. Arthritis was hampering him and making meeting deadlines difficult. I found him to be charming, self-effacing and somewhat puckish. I look forward to knowing him better from the pages of this volume.

—Gray Morrow

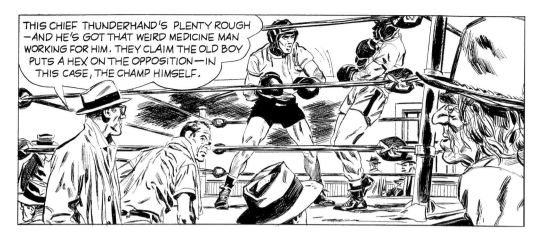

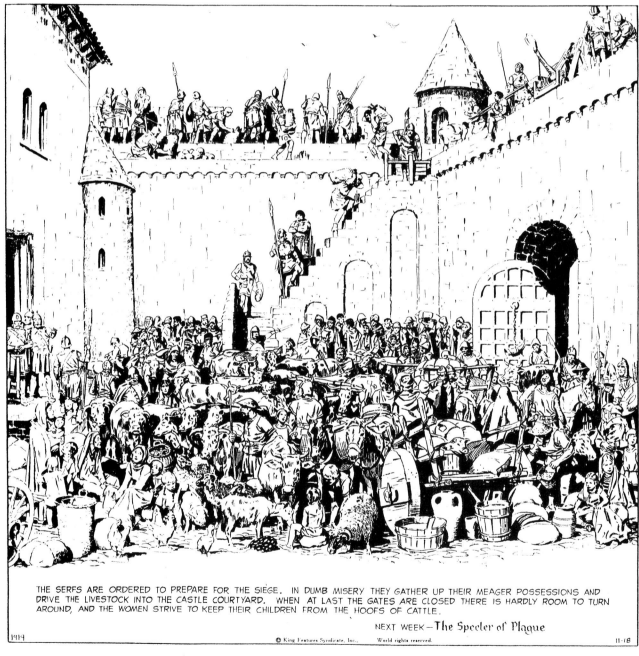

TOP: *A panel from Murphy's* Big Ben Bolt.

ABOVE: *When asked which panel in the past 30 years he was most proud of Murphy picked this one.*

JOHN CULLEN MURPHY

I had known Hal Foster for a number of years prior to working for him starting in 1970. My strip *Big Ben Bolt* was something that interested Hal because he had done some amateur boxing as a youth. When I first broached the idea of working as his assistant in 1968, he was concerned that continuity comics were in trouble, as I told him that 'Ben' was losing papers. He was not ready at that time, he told me, for my assistance with *Prince Valiant*.

Two years later he called me to visit with him at his home in West Redding, Connecticut. At that time he gave me a script for *Prince Valiant* and asked me to draw my version. I later learned that he had Gray Morrow and Wally Wood work on other pages too.

He liked what I drew, and had me do another and then another. Meanwhile, he continued alternately illustrating a page sandwiched between the pages that I had drawn. Eventually in 1971, he drew his last page while I continued to do all of the pages following rough sketches he made. He also did the coloring.

Around this time he and Helen moved to Spring Hill, Florida. On a trip up north I asked him if I was the "chosen one" to do *Prince Valiant*, since he had contemplated ending the saga completely. He told me that I was his choice; as he put it, I had many children to support and the story should continue.

We had a close relationship. He visited my wife Joan and I at our home and we spent a few days with Helen and he in Florida. His retirement was not all he had anticipated and he missed his mini-estate in Connecticut.

We collaborated closely through the years through the mails. He was critical at times, but always constructive.

Occasionally Hal bought narratives from my son, Cullen, who was a student at Amherst College at that time. He put these narratives into 'page form', and he and Cullen formed a good relationship. Upon the sale of *Prince Valiant* to King Features Syndicate in 1979, he recommended that Cullen write the stories and that I continue with the illustrations. We were both signed to contracts with King.

—John Cullen Murphy

Murphy inherited the strip May 23, 1971, and, except for some assistance from people like Al Williamson, has been its primary illustrator for the past thirty years.

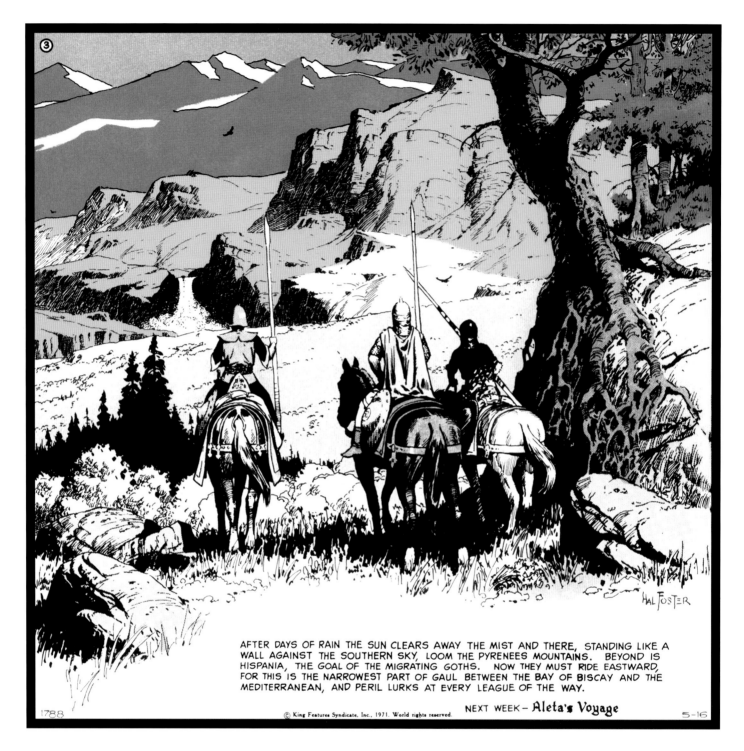

AFTER DAYS OF RAIN THE SUN CLEARS AWAY THE MIST AND THERE, STANDING LIKE A WALL AGAINST THE SOUTHERN SKY, LOOM THE PYRENEES MOUNTAINS. BEYOND IS HISPANIA, THE GOAL OF THE MIGRATING GOTHS. NOW THEY MUST RIDE EASTWARD, FOR THIS IS THE NARROWEST PART OF GAUL BETWEEN THE BAY OF BISCAY AND THE MEDITERRANEAN, AND PERIL LURKS AT EVERY LEAGUE OF THE WAY.

NEXT WEEK— *Aleta's Voyage*

1788

5-16

The Last

PRINCE VALIANT

PANEL WRITTEN AND ILLUSTRATED BY

HAROLD R. FOSTER

MAY 16, 1971
#1788

F • I • F • T • E • E • N

PASSING
of the
KING

1990 Mar. 30

Prince Valiant
IN THE DAYS OF KING ARTHUR

HAL FOSTER

227 2542

Although he said he'd return on occasion to illustrate *Prince Valiant* Foster never produced artwork for publication again. Page 1788, which appeared on May 16, 1971, was the last work completely written and illustrated by its creator. He had produced 1,764 *Prince Valiant* pages. Only page 2000, printed on June 8, 1975, contained any more Foster art. It was an overview of Val's life with reprinted panels from previous pages.

In 1971 Hal and Helen moved to Spring Hill, Florida. Part of the reason was due to lack of privacy. "The woods are now full of celebrities." Hal would complain. "You can shoot a gun in any direction and hit a couple of them…not a bad idea, I sometimes think. They're turning a delightful old woods road into a paved highway and somebody wants to build some more houses. This used to be a wonderful hunting territory." In addition to the lack of privacy Hal's health had begun to worsen and he was becoming too arthritic to maintain the six-acre Val-Hal-En, especially in winter.

"It was rather frightening to learn how the breaking of one little wire could render useless every blasted thing upon which we depend for existence," wrote Foster. "The oil-burner sputtered and turned cold, the pump did not pump, the refrigerator no longer refrigerated and the deep freeze…stocked for the winter and containing among other things, our bass, woodcock and pheasants was about to produce a tragedy! We would have been able to live in comfort were it not for the fact that our whole establishment is cluttered up with now useless laborsaving devices."[1]

• *195*

1 *The Caravel Letter-box*

OPPOSITE: *A sample of Hal Foster's layouts (for page #1990), which he'd give to John Cullen Murphy.*

bradbury : : los angeles, california 90064

August 3, 1982

Dear Mrs.Foster:

I have just learned about Harold's
passing, this week, and wanted to write
you this brief letter to let you know,
what you already know, but it's worth
repeating, how much he meant to me
through most of my life.

Starting when I was 11, in 1932, when
TARZAN first appeared in the Sunday
color comics sections of newspapers
around the country, I was totally
enchanted by Harold Foster's work. IT
helped change my life forever. I collected
every single TARZAN Sunday page, and
then commenced collecting PRINCE VALIANT
in 1937 and went on collecting it for a good
35 years or more. Your husband's work
was and is and will remain an inspiration
to all of us who care about quality and
imagination in abundance!

God rest his dear talented soul. I will
remember him always.

Yours,

RAY BRADBURY

After they moved to Florida Hal continued to write and color the strip for the next nine years. Every week he'd send the script, along with a detailed pencil layout, to John Cullen Murphy. At 79 Hal was the only person over 65 that King Features signed to a three-year contract. The move unfortunately did not turn out the way the Foster's had hoped. While Helen enjoyed feeding marshmallows to the alligators that came up to their back fence, the "lake" portion of their lakefront property evaporated, leaving it a dry bed.

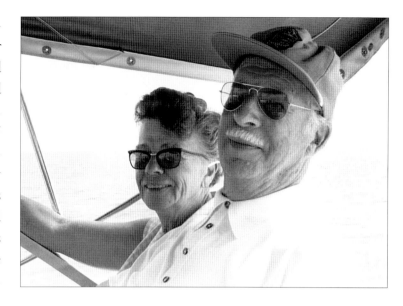

The lake was the main reason Hal purchased the home—so that he could be near the sea again. About this time, he began going lame and a vacation to Mexico resulted in his falling ill to "Montezuma's Revenge." The sickness left him so weak that he had to be brought back to Florida in a wheelchair.

Nearly three-quarters of a century sitting behind a drafting table caused Foster's hips to deteriorate. By June 1979 he was permanently confined to a wheelchair. That summer Foster began negotiations with King Features Syndicate to sell them the rights to *Prince Valiant*. King Features' initial offer was $100,000.00. The low sum drew the attention of a third party group who offered Hal more money and even suggested moving the strip to another syndicate. King Features refused to see *Prince Valiant* leave and in September they outbid their competition and purchased the strip from Foster for approximately $350,000.00. Two months later Hal consented to hip replacement surgery in the hopes of someday being able to walk again. The operation ran longer than expected and left Hal impaired. In a letter sent to Eric Bergman, Jr., dated January 25, 1980, Helen conveyed her fears concerning Hal's recovery.

> Hal had a hip operation on November 30th and is recovering very slowly. I guess at the age of 87 you don't come back very fast. The operation itself was quite successful and he has no pain, but either the shock or the anesthetic took its toll on his mind. He cannot remember moving here, being in the hospital or having the operation. The doctors' say: "give him time." I pray they are right.

The doctors were wrong. Hal never fully recovered from the operation and eventually spent his remaining days without the recollection of his 70-year career as an artist. Everything from the buttons and lace of women's unmentionables, the years at Palenske-Young, *Tarzan*, *Prince Valiant* and even his beloved Helen were lost to him forever. The operation left him as he began: standing in an imaginary attic in front of a cracked mirror learning to draw the human form and

NATIONAL CARTOONISTS SOCIETY

AUG. 13, 1982

DEAR HELEN,

WORDS CANNOT TELL YOU HOW MUCH WE IN THE NCS, AND ALL THE WORLD, WILL MISS HAL. HE WAS ONE OF A KIND, AND WE ALL ARE SO MUCH RICHER BECAUSE OF HIM.

OUR DEEPEST SYMPATHIES TO YOU. TAKE CARE AND KEEP IN TOUCH.

BEST WISHES,

BIL KEANE

dreaming of one day being an artist.

The last *Prince Valiant* strip written by Harold Rudolf Foster was printed on February 10, 1980, just three days before its 43rd anniversary. Hal passed away on July 25, 1982; he was 89. His ashes were taken to the Well's family plot in Topeka, Kansas and Helen, his "darling frump" and the woman who inspired Val's wife Aleta, Queen of the Misty Isles, joined him there two years later.

Hal Foster's work has inspired generations of artists. Without intending, he had created a bridge between the Golden Age of Illustration and the present. His originals are highly prized works of art, which sell for thousands of dollars, and *Prince Valiant* continues to encourage new artistic interpretations in other mediums. He was comics' supreme Classicist-styled illustrator. He was the creator of an art form; the definer of a genre yet today, over seventy years after fathering the "Adventure Strip", no one has surpassed him and it is quite possible no one ever will.

In his capable hands *Prince Valiant* went from premiering in eight newspapers to a weekly worldwide syndication of 350 papers and millions of readers at the time of his death. In one sense, art for Hal was a means to an end. From a very young age he did what he had to so that his family could eat. He finally made that wolf at his door go away, redeemed his family's status, and still had some time left over to hunt and fish. He lived by a humble credo, which only addressed Hal Foster the man and not Hal Foster the artist, but for him that was sufficient. It is a philosophy of life, a doctrine of principles, which speaks to the honesty, the integrity, and the very soul of the person he was. Simply put: "Never shoot a sitting bird, never take more fish than would fit in a frying pan; never take more liquor than you can hold like a gentleman." As James Bama said "...he was great."

"Old ghosts came to life and I had to set my fancy free to wander with these ghosts across windy marshes, quiet lakes, and eastern shores all golden in the sunset. Trees burning with the colors of autumn and swaying restlessly in a wind that brings a rumor of winter, and the all to be remembered music of water, little waves among the rocks, the murmur of ripples along the canoe, or the thunder of the falls.

"Tonight I shall dream of white caps at noon and a rushing wind turning up the gray underside of the leaves, and swaying pines…of evenings and a loon drawing silver lines across a polished lake; the hauntingly sweet and lonely notes of the Canada bird coming clear from distant hills, and the far away rumble of everlasting falls…of thunderheads, their feet in cool shadow and their heads all rosy in the light of a sun already set. *I have heard the pipes of Pan!"*

As ever,

HAL FOSTER

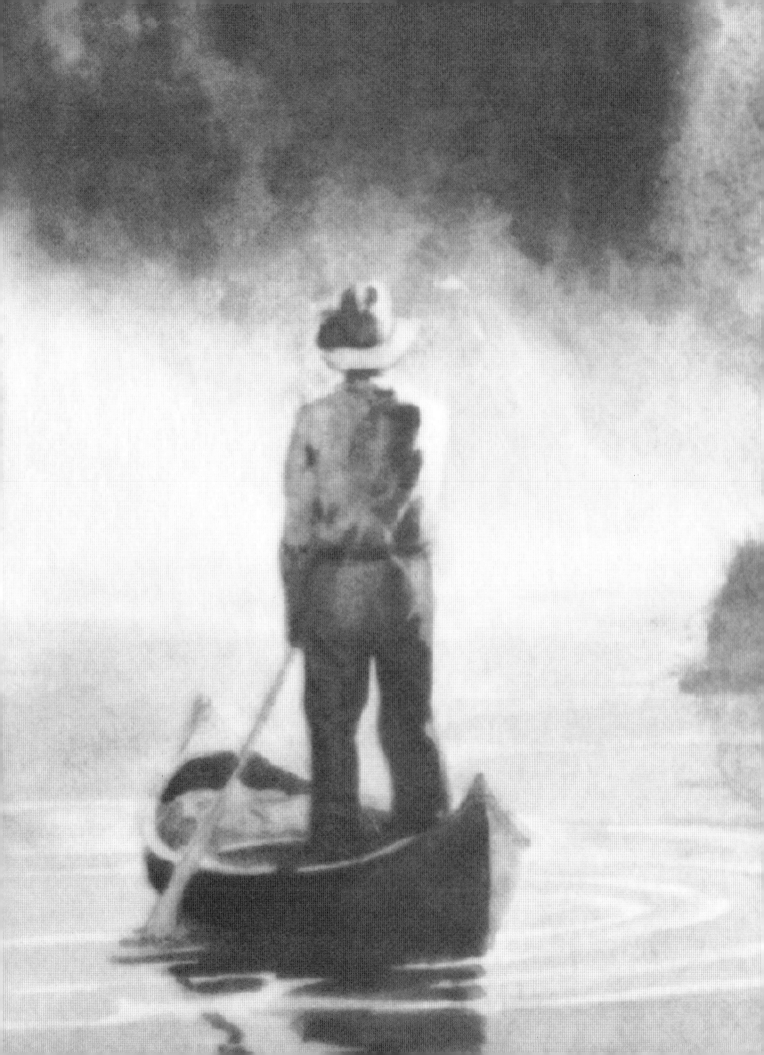

A KNIGHT *to be* REMEMBERED

HAROLD RUDOLF FOSTER

August 16, 1892—July 25, 1982

CARTOONIST OR ILLUSTRATOR?

Webster's Dictionary defines a cartoonist as "One who creates sarcastic drawings." This capsule definition may reasonably describe a great number of artists who have created pages, strips and panels for the funny papers. George Herriman's *Krazy Kat*, Billy DeBeck's *Barney Google*, Rube Goldberg's inventions, and scores of other ink-stained wretches have relied heavily upon the use of sarcasm, satire, and out-and-out burlesque to achieve the visual mayhem necessary for their character's activity. So much for the "comic" comic strip—what about the action/adventure strips? What about Milton Caniff's *Terry and the Pirates*? What about Alex Raymond's *Flash Gordon*? And what about Burne Hogarth, Noel Sickles and Lee Falk whose heroes battled their evil foes in the air, on land, on the sea, and sometimes in the jungle, sometimes in the desert and sometimes, etc., etc. These "cartoonists" rarely, and sometimes never, employed the use of "sarcastic drawings." Indeed, the question is: "Are they cartoonists at all?"

Perhaps the latter group may be best described as illustrators. We might be a bit more specific and refer to them as "sequential illustrators." These artists approach their work somewhat the way a book illustrator or filmmaker would. They are the aesthetic descendants of the great storytelling illustrators of the past. Some of he names that come to mind are Daniel Vierge, Howard Pyle, Joseph Clement Coll and N.C. Wyeth. These artists were master draftsmen, elegant yet dynamic composers and above all, consummate narrative illustrators.

At the top of the list of artists who worked in this genre is Harold Foster. Foster created *Prince Valiant* after a stint as an advertising illustrator and an auspicious entry into the field by illustrating *Tarzan*. The magnificent drawings that graced the weekly *Prince Valiant* page probably caused more interest in art than all the elementary school art appreciation classes and museum outings combined. I have spoken with dozens of illustrators who attribute their interest in the visual arts to early exposure to Foster's art.

His story pacing allowed for some panels to be less complex than others. Larger panels became extravaganzas with scores of armored figures and horses in full battle gear fighting in the shadow of a grand castle. There were no speech balloons to distract the reader. The text was integrated in the panels in a clear and dignified manner that echoed the fine illustrated books of the turn of the century. Taken by themselves the individual panels are beautiful, but it is only when you look at the entire page that you fully comprehend the stunning body of masterpieces that Foster created over the thirty-five years of drawing *Prince Valiant*.

So, how do you define this very special page that was delivered weekly with the comic section of your newspaper?

Perhaps the best way to describe Harold Foster's *Prince Valiant* is "Art."

Murray Tinkelman, Illustrator
Professor of Illustration, Syracuse University
President of The Society of Illustrators

• • •

Any attempt to review the work of Hal Foster as an illustrator by an illustrator would appear on the surface to be a bit one-sided, biased and redundant. The body of Foster's work stands on its own merits and no one can seriously challenge it. Hal Foster was a master draftsman and it is only logical that he would perform at a high level in the traditional world of illustration. Illustration is by its own nature narrative, particularly in Foster's day, therefore it is perfectly understandable that Foster's craftsmanship should allow him to succeed at a high level. This is evident in the examples we have of his work for such clients as Popular Mechanics and Union Pacific Railroad. The landscapes of the railroad pieces simply stated are beautiful. In the landscapes of the Grand Canyon and Zion National Parks, Foster's sense of color, design and composition show a natural flair for the dramatic, a skill that worked for him well in his best known series, *Prince Valiant*.

But let's go a little farther and look at his work for Popular Mechanics, specifically the July issue with the Battleship illustration (see Color Gallery). Note how Foster uses images in the foreground and the standing navy men in perspective and the gun barrels to draw the viewer into the picture. The values in the illustration create a strong sense of depth in the picture and the vivid color palette Foster used amplifies this creating a dramatic and beautiful illustration. The placement of the French flag is a wonderful design element the magazine's art director used well against the magazine masthead furthering the sense of depth Foster created in his illustration.

Of course there is a part of me that wishes there could be a larger body of this kind of work to enjoy and study, but that would be at the expense of less *Tarzan* and *Prince Valiant*. I do not wish to speculate on how many would care to make that trade. So just enjoy Foster for Foster and celebrate this creative genius for giving us this enormous body of work. Whatever you choose, his black and white feature comic art or his traditional commercial illustration, recognize and delight in the talent, craftsmanship and artistry that was in this artist.

C.F. Payne, Illustrator

• • •

My first influence as a cartoonist was the great Milton Caniff! But one Sunday I picked up the Daily Mirror featuring Hal Foster's *Tarzan*. My allegiance switched immediately. Foster's

artwork on *Tarzan* was elegant, graceful and captivating. It became my lifelong influence. I was quite fortunate to have met this gentle genius and he is one of the very few comics artists, whose original art I've collected. Hal Foster, the king who produced a prince, you have my eternal gratitude.

Carmine Infantino, Illustrator
Former President DC Comics

• • •

When I was a kid I used to read *Tarzan* in the New York Daily Mirror. Hal Foster was one of a trio of great cartoonists who were responsible for helping to create an art form. Because of the work of Foster, Caniff and Raymond a generation of young would-be artists were inspired to greatness. Illustrating *Tarzan* for me was the culmination of my career because it was a dream for me to draw, that which inspired me.

Joe Kubert, Illustrator

• • •

Too often one reads of Foster's *Tarzan* and *Prince Valiant* strips damned with faint praise as illustrated texts as opposed to sequential narrations employing the unique storytelling language of the comics page. While it is true that his penchant for eschewing dialogue balloons in favor of captioned text, as well as his classically constructed, often still panel compositions, do link his work closely with traditional illustrated storybooks, these are only surface traits; obvious stylizations that deflect the eye from appreciating the real goods underneath. Whether Foster consciously recognized the advantages inherent in a sequential narrative is unknown, but he at least had an instinctu-

Tarzan by Joe Kubert

al understanding of the possibilities in the narrative flow between panels; employing it elegantly and knowledgeably where he found it appropriate.

Foster told his stories in an 'epic' manner, which is not to say he preferred to dramatize larger than life moments. Quite the opposite, he excelled at carefully observed depictions of the details of everyday life, done more precisely, more skillfully than any other comics artist before or since (in this skill alone he is revealed as a master storyteller). Rather, I use the term "epic" to refer to the great amount of detail, and of suggested time passage, he could choose to fit into any one of his panels. This was a conscious choice on Foster's part. All comic artists must make decisions as to how much information they want to deliver in a single panel, as opposed to spreading that information out over a sequence of panels. Within the space limitations of the comic strip information spread out over a sequence by necessity reduces the scale of the story being told. You cannot tell as eventful a story and you cannot cover as much time passage if you choose to employ a greater number of panels to convey a single action – a distinct bit of information. Conversely, by compressing information into one panel you risk sacrificing a certain intimacy with your character's actions, and loosing a certain narrative fluidity.

Foster's typical modus operandi kept with the "epic" use of panels, with specific units of information conveyed within a single panel, allowing him the space to tell the "big" stories. He was, however, fully capable of breaking down his information into panel sequences when he decide it was in his story's best interest. Specifically, he used panel sequences to heighten emotional resonance. One example that springs immediately to mind: early on in *Prince Valiant*, Foster has his young hero return home from adventuring to discover that his mother has taken sick and died. Breaking with the more typical, self-contained nature of the first panel in this particular strip, Foster devotes the next six panels, all of approximately the same size and dimensions, to a sequence following Val from his docking in front of his home, to his father's announcement of the death in the family stronghold's great hall, to his mother's death chamber. It is a very fluid sequence, every panel featuring Val as the central player, moving with him constantly, keeping him vital and prominent until the last panel, in which he crumbles, heartbroken, over his mother's still body. Foster could have gotten across all the necessary information here in two carefully constructed panels. Instead he chose to spread out the telling, to involve us more with Val on a personal level in order to increase the emotional impact of this defining moment in his hero's life.

Mark Schultz
Illustrator and writer

Sir Galahad © 2001 BWS. A.R.R. Used with permission of the artist.

Barry Windsor-Smith on Hal Foster

The comics work of Harold Foster epitomizes an age when craft and draftsmanship were perceived as forms of truthfulness. His *Tarzan* and *Prince Valiant* strips, along with lesser-known material, were imbued with a master's touch. He blended factual realism and fantastic adventure into a wholeness of startlingly detailed verity—as if seeing the commonplace through the wondrous eyes of a gifted child.

Foster's unerring transferal of intangible thoughts through ink onto the surface of blank white paper represents the epitome of the comic artist's creative endeavor. His storytelling was filled with knowledge and experience, while his complementary drawings evoked a timeless wonder of all that is fantastic in our world.

For the comics artist it isn't enough to possess a sense of wonder. Nor is it sufficient to love figure drawing, or to enjoy creating comics, for that matter. These attributes and others besides have to be integrated into a greater whole where extremes are balanced by subtleties just as blacks are countered by whites. Hal Foster's work possessed these symmetries.

From his elegant mastery of drawing to his erudite narrative compositions, these twin pillars were not so much art and story but marvels of engineering. Uniformed, balanced, poised, and so well crafted as to stand the tests of time. Harold Foster's work is from another era, one where art and craft were forms of truth. He was a master.

Barry Windsor-Smith, Storyteller

Harold Foster—An Acquired Taste

Harold Foster, for me and many others, was and will continue to be an experience in learning. I didn't come easily to Foster's work. On first exposure I was amazed to see and try to absorb *Prince Valiant*. But as with the work of others, I soon put it aside.

It was too quiet, intelligent, sophisticated and too different for me. I was a kid. I read comic books. They made my heart leap, made me laugh, made me imagine and want to contribute my own imagination to these crude, simple, little comic books.

Foster was different. He put so much into the work, there was nothing for my mind to do, or so I thought. Because he drew everything, I found it boring. Looking at Foster was like listening to Beethoven and I preferred Rock and Roll.

Foster broke all the common rules. He refused to use balloons, the crutch that we all needed. Foster didn't draw fantasy except as Rockwell, Parrish, Mucha and Gibson drew fantasy, as reality. I wished only to see Superman. Then someone told me Foster had done *Tarzan*.

Tarzan! And had given it up to draw *Prince Valiant*, with that stupid pageboy haircut, whose face only now and then showed the iron of a man? I suffered *Tarzan* under Hogarth and imagined *Tarzan* under Foster had been subtly visceral, as in reality.

I read Foster because it was there, every Sunday and as time went by I grudgingly knew he was getting under my skin. I didn't like Valiant as a character, but I couldn't miss a Sunday page.

I began to realize that everything I learned, Foster already knew, like Rockwell and only few others knew it. Many were simple things that should be known by all artists. Such as, each tree is different from every other tree; you must research the era for your story to be well told; muscles are not always flexed; anatomy is not simply muscles and bones but, the density of it all and then interpreting it as line and color.

Also that you must ignore the commonness of a form, however humble, and imbue it with every quality that you can. The more I learned the smarter Foster became. My greatest error was thinking he left nothing to the imagination. What a poor idiot I had been. I realized everything that happened between each set of drawings was there for my imagination to fill in. His drawings drove me to raise the level of my own imagination. They made me expect more of myself.

I began to suspect that he not only drew from reference, but traveled to draw and take photos of the lands he drew. No artist put that kind of research into his work. His standard was higher than anyone's. What great world could have surrounded a man that he could set such high goals and reach them? There are very few great artists and great artist's stories. Harold Foster's is one of those stories, excuse me, Hal Foster, the man whose work I had to better myself, in order to see.

Neal Adams, Illustrator

Harold Rudolph Foster is America's great, underrated Master Storyteller, our Bard of the mid-20th century.

His compelling stories, although set in Tarzan's Africa and Prince Valiant's medieval past, touch upon human conditions that all of us share. Through his exhaustive research, his work also educates us while it entertains.

There is not a contemporary "realistic" comic artist alive that hasn't been influenced either directly or indirectly by the great Harold Foster.

Without delving into the hundreds of breakthroughs that Harold Foster pioneered within the very form of comics itself (for awhile, until it became obvious it was always going to happen, every time I thought I had made some new breakthrough in comics storytelling I would call up Al Williamson to express my excitement. Al would calm me down and tell me which 1930's or 1940's sequence in either *Tarzan* or *Prince Valiant* that Foster had accomplished the same 'breakthrough' first), I have to say that the thing that most immediately impresses me about his work is the single thing that Frank Frazetta was able to observe in Foster and absorb into his own work, soul, or, more accurately, duende. Duende is a mystical Spanish word that encompasses not only 'soul' but also means 'the power to attract through personal magnetism or charm.' Harold Foster had duende in spades.

Hal Foster had this amazing Zen ability to distill to the visual essence of recognizable objects, creatures, textures and phenomena and render them simply in ink with pen and brush. By doing so he was able to graphically charm his readers to their very core.

Hal Foster was the modest Master of It All. Whether it be clothing texture, such as Val's chain mail, the Viking furs, the slinky silks of Morgan Le Fey or the rich, dark velvet dress of the Witch Woman (*Prince Valiant*: 4/18-5/7 1939), or animals (look at his magnificent great apes from *Tarzan* or the monumental elephant, wallowing crocodiles and ferocious gorilla from the *Prince Valiant* African sequence); be it beautiful women, ancient trees, the many moods of the sea, impossibly lush jungle vegetation, powerful horses, the goblins of the supernatural, period architecture or whatever Foster attempted to portray, he was able to do it brilliantly each time. He captured his subject matter with minimal rendering in a way that couldn't have possibly been more inspirational, romantic or emotionally breathtaking.

The world of comics is fortunate to have known and to continue to know the genius that was expressed in the work of Harold Foster.

William Stout

I became a Hal Foster fan the very first time, on a Sunday morning, that I crawled into my father's lap and he read me *Prince Valiant*. This was in the early 1940s and I've never ceased to marvel at Foster's abilities. Growing up, I little realized in those early days that there were years of Foster's work moldering in newspaper and comic book back issues. Work that I was to discover, in my opinion, was better executed than what I was familiar with.

It wasn't until Hal Foster appeared on Ralph Edward's *This is Your Life*, in the mid-1950s, that I found out that he had drawn *Tarzan* for several years before creating *Prince Valiant*. Having become a fan and collector of the works of Edgar Rice Burroughs, I was determined to collect all of this work: both the daily strip and the Sunday pages.

It had been stated many times in the past that Hal Foster brought illustration to the comic page. I certainly can't dispute that opinion. And whereas Foster denigrated his *Tarzan* work in favor of his own creation of *Prince Valiant*, there is such exuberance in his drawings of the ape-man, such freedom of movement in which Foster did not labor over the drawings (as he did later in *Prince Valiant*), that this work has become the favorite among many of Foster's fans.

It is my opinion that the earliest work by an artist, whether writer or illustrator, is often more fondly remembered than that which they have created after they have reached a certain level of ability. Certainly they have improved the more they practice their craft, but the early work contains a certain ingredient, call it a sense of wonder, that the excitement of what they are doing is expressed in that work at the beginning of their careers. And this is what is so obvious in Foster's work on *Tarzan* and the first few years of *Prince Valiant*.

Not only did Foster inspire scores of later cartoon strip and comic book artists but, also, those of us who admire great illustration. I never tire of looking at his work and, though gone, he continues to exert his influence. No one has ever surpassed his work on *Tarzan* or *Prince Valiant* and probably never will.

Robert R. Barrett
Wichita, Kansas
March 21, 2001

VILLARS-SUR-OLLON,
SWITZERLAND,
OCT. 29 '52

Dear Hal –

Congratulations – you had it coming! I'm so sorry I won't be able to attend the Banshees Luncheon. especially this year, when the Committee was so inspired as to select you the winner of 1952 award.

I'll be sitting on top of an Alp on Nov. 6th and Athel and I will open a bottle of "Johannesburg" and drink to you for all the pleasure you've given the young family. for so many years. with your magnificent artistry.

Here's to you and wonderful "Prince Valiant"!

Sincerely,

CHIC YOUNG

Mr. Harold Foster.
K.F.S. New York N.Y.

ALEX RAYMOND

The Banshees
235 East 45th Street
New York 17, New York

Gentlemen:

As a cartoonist I am proud that my profession boasts such an outstanding craftsman as Hal Foster. As an artist he has for many years been among those who have striven to raise the standards of the so-called comic strip medium. He has succeeded admirably to the enduring credit of himself, his brother artists and the highly significant medium of entertainment and communication he serves.

The Banshees Committee is to be complimented for honoring Mr. Foster with the highly deserved "Silver Lady" award.

Cordially yours,

65 South Street
Stamford, Connecticut

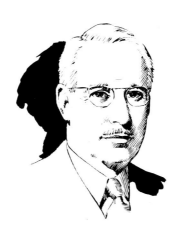

Final Word

My father used to read the Sunday comics to me. He would lay on the couch with the paper in the air and I'd sit on the floor listening to every word. I honestly don't remember any of the stories anymore, or the jokes, or the artwork, but I do remember the time my father spent with me, and his gold tooth, as we'd laugh at the strips. That's how I fell in love with the "funnies". Thanks, Dad.

It was my father who introduced me to *Prince Valiant*, but it wasn't until 1974, when Nostalgia Press published their first hardback color volume, *Prince Valiant in the Days of King Arthur*, that I was introduced to Hal Foster—sailor, boxer, prospector, and artist. It didn't matter that the colors weren't right, or that the art was small, or any of that production stuff—this was pure inspiration. That year the book spent more time in my home than on the library shelf, and it wouldn't be until years later that I would buy a copy for my own.

In 1979, I went with several college friends to my first comic book convention in Cleveland. I was determined to buy a *Prince Valiant* page. I had a friend who owned a Kirby page and another who owned a Ditko page, so I figured I had enough with me for a Foster. I was wrong. One vendor had a panel—a panel!—and it was well over my entire budget.

I still don't own a *Prince Valiant* page, and if I've done my job well, and if Hal Foster is recognized for the extraordinary illustrator he was, then I will never be able afford one. So be it. In the past four months I have held more original Foster artwork than many people see in a lifetime. The Foster and Bergman families have shared their stories, their lives, and their confidences with me and I have gained a new respect for both Hal and Helen. Mysteries were solved, histories revealed, and new companions were met and made. It may not have been on horseback or under forty pounds of chain mail, but it was an adventure and I found my Grail.

—Brian M. Kane

MANY KNIGHTS THRONG THE ROADS UNTIL A SP
PROCESSION WITH BANNERS FLYING AND TRUM
SOUNDING, MOVES ON TO CAMELOT, CITY OF W